EXPRESSIVE
NATURE
PHOTOGRAPHY

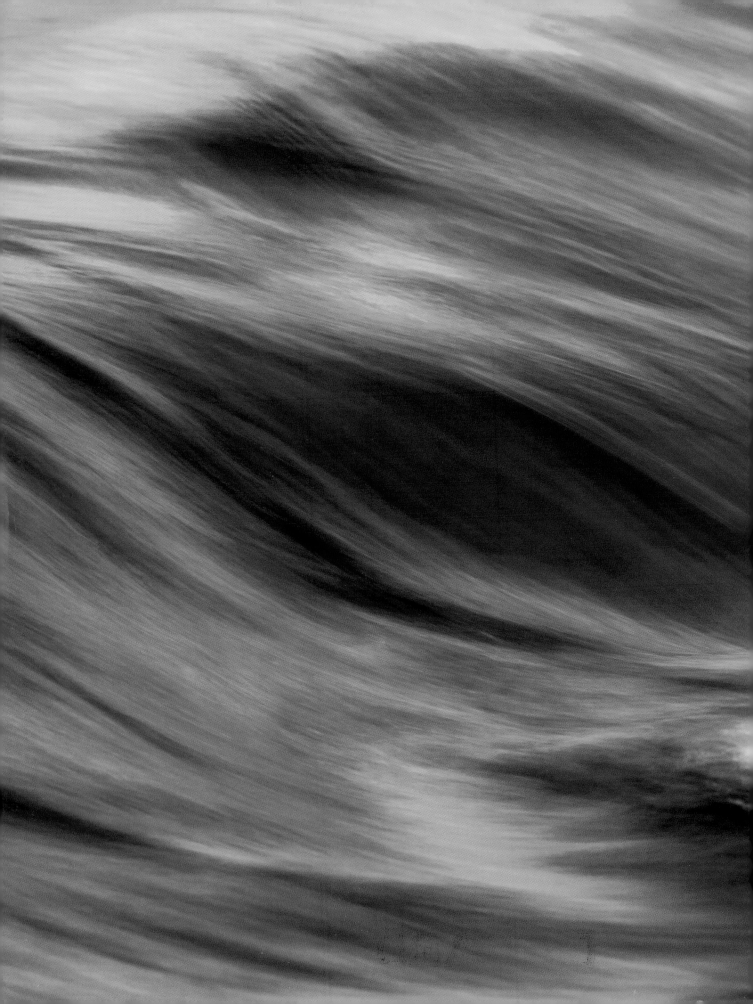

BRENDA THARP

EXPRESSIVE NATURE PHOTOGRAPHY

DESIGN, COMPOSITION, AND COLOR IN OUTDOOR IMAGERY

MONACELLI STUDIO

Published in the United States by Monacelli Studio,
an imprint of The Monacelli Press

Library of Congress Cataloging-in-Publication Data

Names: Tharp, Brenda.
Title: Expressive nature photography : design, composition, and
color in outdoor imagery / Brenda Tharp.
Description: New York, New York : Monacelli Studio, [2017]
Identifiers: LCCN 2016049621 (print) | LCCN 2016049936 (ebook) |
ISBN 9781580934671 (trade pbk.) | ISBN 9781580934893 (ebook)
Subjects: LCSH: Nature photography. | Outdoor photography.
Classification: LCC TR721 .T434 2017 (print) | LCC TR721 (ebook) |
DDC 778.9/3--dc23
LC record available at https://lccn.loc.gov/2016049621

ISBN: 978-1-58093-467-1
eISBN: 978-1-58093-489-3
Printed in Singapore

Design by Jennifer K. Beal Davis
Cover design by Jennifer K. Beal Davis
Cover illustrations by Brenda Tharp

First edition

MONACELLI STUDIO

The Monacelli Press
6 West 18th Street
New York, New York 10011

www.monacellipress.com

This book is a collaborative effort, as all books are. I'm so grateful to Victoria Craven for reaching out to me once again to write a book, to Stephen Brewer, my editor, for making me sound ever better, and Jennifer Beal Davis, the designer, for finding a way to work with the variety of images to make a wonderful layout. A multitude of thanks also to Jed Manwaring, my proofreader, image consultant, and partner in photography and life.

PAGE 1:
The sculpted slot canyons in northern Arizona are fantastic to experience and photograph. The light glows within them when the sun bounces off the walls high above.

📷 *24–105mm lens at 40mm, f/16 for 20 sec.*

PAGES 2–3:
Sunlight reflecting off the orange and yellow leaves of autumn created a vibrant reflection in the moving waters of this fast-flowing stream in Maine.

📷 *70–200mm lens with 2x teleconverter at 255mm, f/13 for 1/8 sec., ISO 200*

OPPOSITE:
The dolphin created a pressure wake above its body just before breaking the surface. The pure and calm waters of Johnstone Strait off the coast of Vancouver Island, British Columbia, allowed me to see down into the water to capture this special moment.

📷 *17–40mm lens at 40mm, f/7.1 for 1/200 sec.*

OVERLEAF:
Dawn on the lagoon on Madeline Island, Wisconsin, was magical the morning when I took my workshop group there to photograph. The change in the weather had created the alto cumulus clouds that I love so much, as they often catch the color, if the horizon is clear, at dawn or sunset. The lagoon surface was so calm it provided a great reflection, so I didn't even try to fit all that sky into the picture, as it was all about the water for me in this image.

📷 *150-600mm lens at 150mm, f/14 for 1/60 sec.*

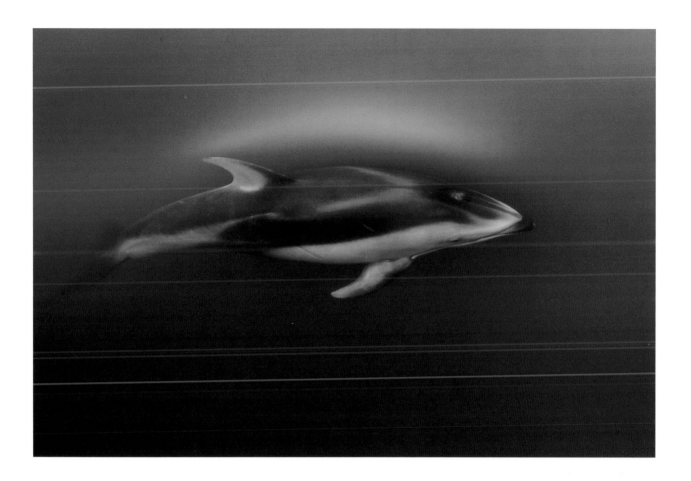

To all my students, past and future, for their enthusiasm
and thirst for creative vision.

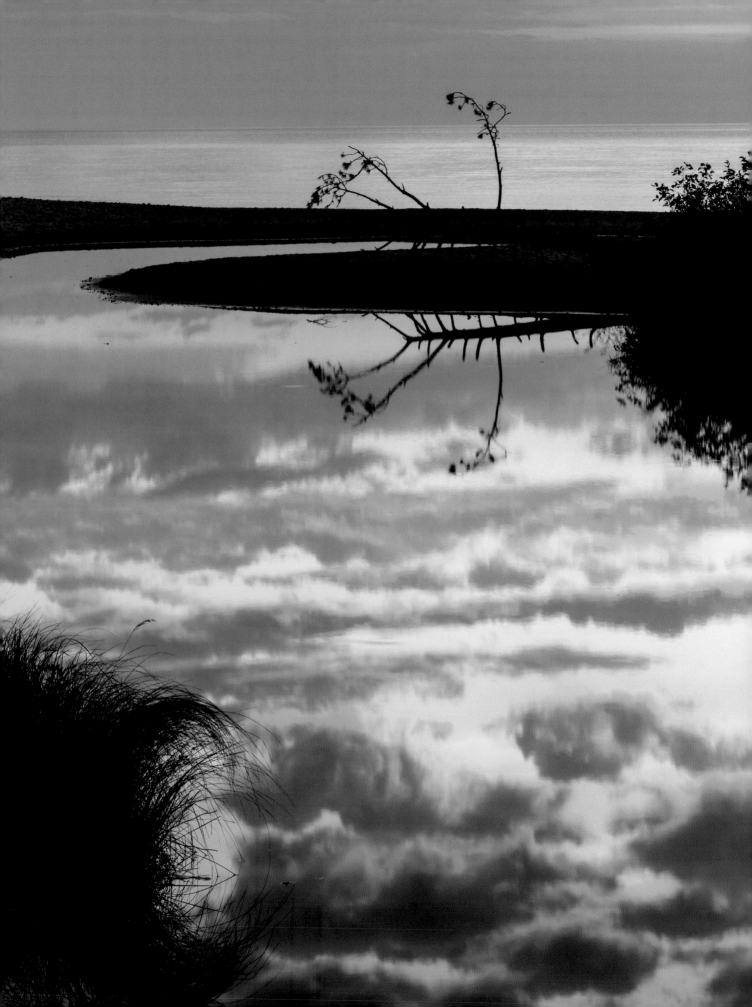

CONTENTS

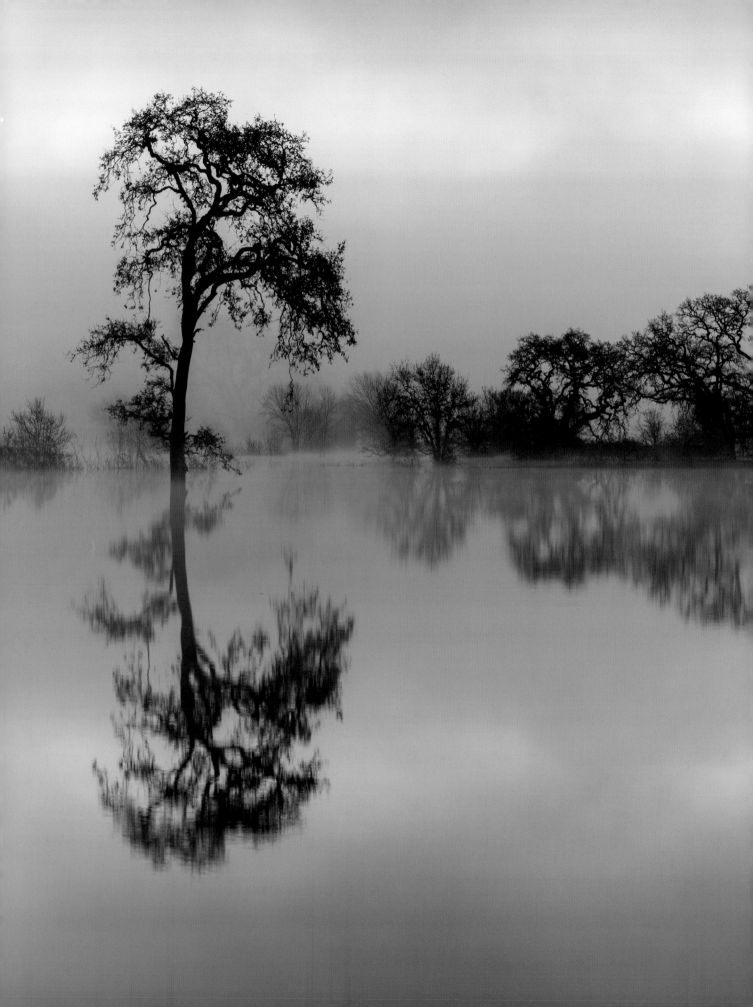

INTRODUCTION

"To see we must forget the name of the thing we are looking at."

— CLAUDE MONET

Photography is pure joy. The ability to see something special and capture it in the camera is nothing short of amazing for me, even after all the years I've been a photographer. From the tiniest detail of a flower to the grand expanse of the Milky Way stretching overhead at night, our world is an outstanding place, providing countless opportunities to experience beauty. To be out photographing in nature is truly the best job one could have, at least according to the many who wish they were doing my job. Never mind that I received 45 mosquito bites while standing in the woods to get the perfect photograph of a moving stream of water. (I hadn't planned on stopping, so I didn't have repellant or the right clothing.) And never mind that I've hiked three miles to get "the shot," only to have the weather go bad leaving me empty-handed. To go out and *be* in nature is reward enough, but it can often reward you all the more with great light and great moments. That's the proverbial carrot that keeps me pursuing my photography. When the weather, light, composition, and moment all come together into a great photograph, I realize how truly lucky I am to be there, and to be a photographer.

OPPOSITE:
Foggy dawns are so wonderful. In winter months, the Laguna di Santa Rosa Watershed near my home often floods, but it's not easy to predict whether rains have been substantial enough for the river to overflow its banks. You have to keep a close watch on the reports, and visit a web page that tells you flood levels, etc. Sometimes, though, your gut just tells you the Laguna is full, and you go in search of dawn reflections. And when you get there, it's *so* foggy it's a disappointment; then suddenly you can see the trees just slightly, then a bit more, and then color starts to come, and you end up with a picture that becomes a favorite! It's that simple. You just go with what's working!

📷 *70–200mm lens at 116mm, f/14 for 0.3 sec.*

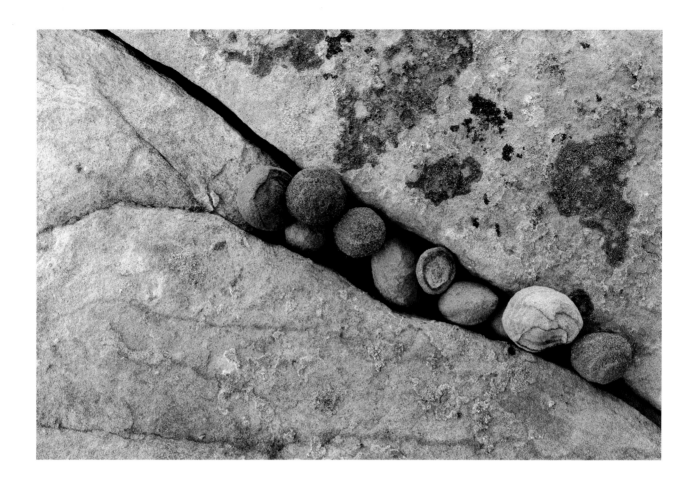

REFINE YOUR VISION

Photography is a marriage of vision and craft. You really can't have one without the other if you want to create memorable photographs. Plenty of books get you started in understanding the basics. This book takes off where basic photography books end. It will help you refine your creative vision, while learning techniques and concepts that can also help you hone your skills. Using the advice in this book, as well as working with the exercises, will help you learn to see light better and understand how to utilize light to make your pictures more dynamic. You will learn to create visual flow in your pictures and to arrange good compositions. You will improve your ability to choose an appropriate shutter, or aperture setting for creative expression and depth in your pictures. You'll learn about the power of colors, and when to consider black and white as an alternative. In the last chapter, we go out into the night to marvel over the night skies while we

ABOVE:
After teaching a workshop in Zion National Park in Utah, I headed out with a few students for some cross-country exploration, looking for new subject matter. One area I explored was covered with moqui marbles, eroded concretions of sandstone that had fallen down onto the plateau from the hills above. They had likely rolled into this crevice during heavy rains. I liked how they were nestled in there, and chose a position that used the oblique line of rocks to guide the eye across the frame.

📷 *16–35mm at 35mm, f/14 for 1/8 sec.*

OPPOSITE:
While exploring a salt marsh in the Mojave Desert, I discovered this wonderful pattern in the shallow water. The salt was pushing to the surface, emerging from the mud as the area dried, and before the sun came up, the white salt was reflecting the blue light of open sky more strongly than it was affecting the mud around it. I liked the color contrast, but mostly I loved the mysterious pattern that this intimate view created. You really don't know if this is a close-up view or an aerial view, and I like that about this photograph.

📷 *24–105mm lens at 47mm, f/18 for 1/6 sec.*

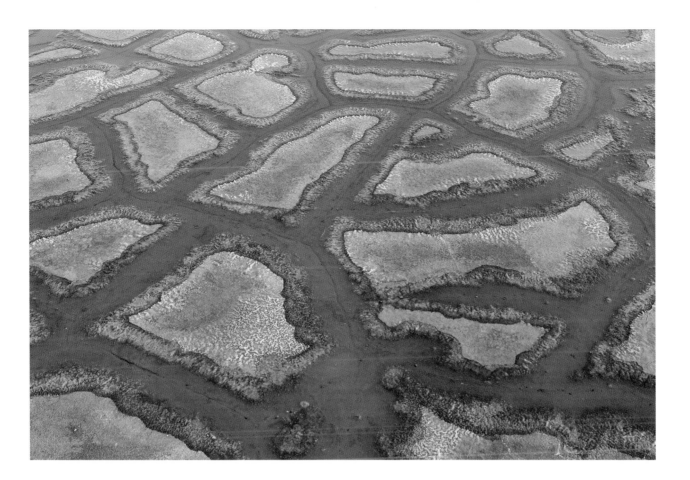

photograph them, and to photograph by moonlight. By the end of the book, you'll have learned useful techniques to accompany the creative insights you've gained. All of this will help you make creative images that express you and how you see the world.

BREAK AWAY FROM THE ICONIC

True creativity comes from a willingness to step out and find your personal vision. It's very easy to make the same photographs everyone else is making, especially when going to the same locations. So I present this challenge to you: When you visit somewhere iconic, make photographs that are *not* of the icons. Sure, you want to have the iconic images, as well, especially if you have never experienced seeing those beautiful scenes—maybe the light falling on El Capitan, or the fog rolling into valleys and over the ridges of the Smoky Mountains. Photograph those, to get it out of your system, then seek out locations within these iconic spots that will provide you with fresh, unique material that resonates with you. Don't just stick to the well-trodden pathways and lookouts. Get in touch with what the place means for you, and photograph from that perspective, that personal point of view. Trust me, your photographs will be more meaningful. If executed well, using the principles of composition, design, depth, and light, you will make beautiful studies of the natural world that will very likely resonate with others as well. Create your own journey through personalizing a place you visit, and your pictures will be more compelling.

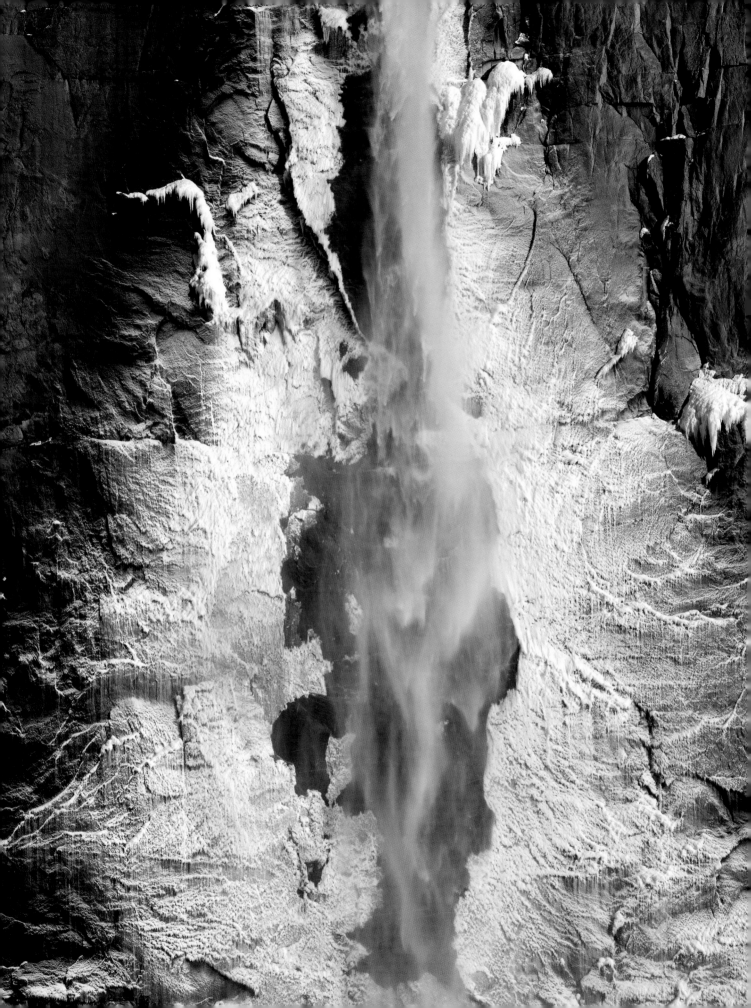

CHAPTER 1

THE HEART OF PHOTOGRAPHY

"Look and think before opening the shutter. The heart and mind are the true lens of the camera."

— YOUSUF KARSH

This book is about making your best photographs of nature. It's also about being present in the moment when making a picture. I'm asking you to delve more deeply into the natural world, then to photograph with a purposeful intent to express what the experience means to you. This is the heart of expressive photography, what will make your pictures unique. We see the world through a filter of life experiences; if you want to create great nature pictures, then find meaningful experiences out in nature!

OPPOSITE:
I was heading out to photograph in a meadow one morning when I looked up and saw this beautiful scene. A cold night had frozen some of the water that was flowing over Yosemite Falls and left a frosty "apron" around the falls, as the wind moved the water around. I stayed put, and using a super telephoto lens, I tried to capture a section of the rock and falls that expressed the beauty of winter that I was experiencing.

📷 *150–600mm lens at 350mm, f/11 for 1/640 sec.*

LEARN TO SEE THE WORLD AROUND YOU

If you pay attention to the world around you, you can't help but fall in love with nature. The rhythms, the beauty on a vast and a minute scale, the triumphs of life: It's all laid out around us, and if we choose to be in touch with all this richness on a deeper basis, we'll be better photographers. Learning to see is, after all, about learning more about yourself as you connect with the natural world around you.

Here's an idea of what I mean. I took a road trip through the northwest part of Wisconsin and Upper Peninsula in Michigan during autumn. Seeing the brilliant red and yellow leaves as I drove the country roads tugged at my heartstrings, as I had grown up in the East and was reliving how special fall in the deciduous forests can be. Autumn is definitely my favorite season. One day after I made lunch, I sat near a lake and wrote down random observations and reactions to what I had been experiencing:

- sound of a loon in a lake hidden from my view
- leaves rustling in the breeze
- light glowing through trees
- translucent leaves of brilliant red
- the crunch of leaves underfoot on the trail
- whitecaps on the lake
- a stiff breeze
- rain, wind, incessant wind!
- fresh air
- sun bursting through clouds
- a rainbow
- liquid light on the lake
- wild turkeys

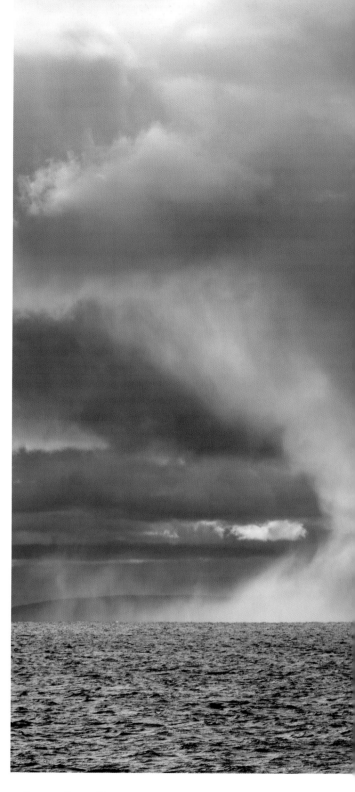

- chipmunks scolding
- biting cold fingertips
- did I say wind?
- an eagle's cry
- a babbling brook

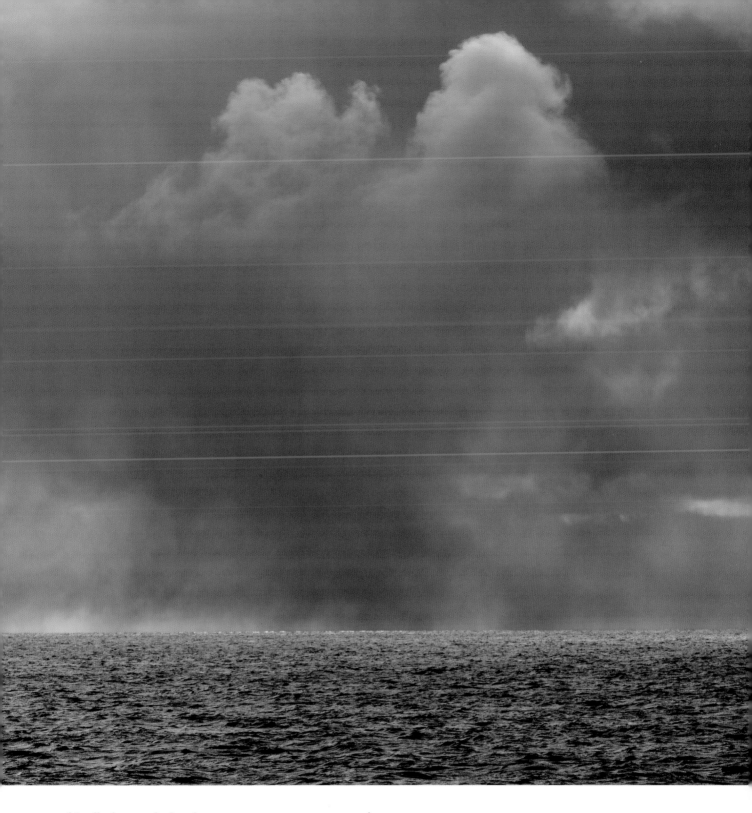

- friendly dogs on the beach
- grouse!
- deep blue water

ABOVE:
Storms on Lake Superior can become massive squalls. I love the play of light on the lake and clouds when these storms build and pass by on the horizon like a large ship sailing slowly along.

📷 *70–200mm lens at 150mm, f/16 for 1/100 sec.*

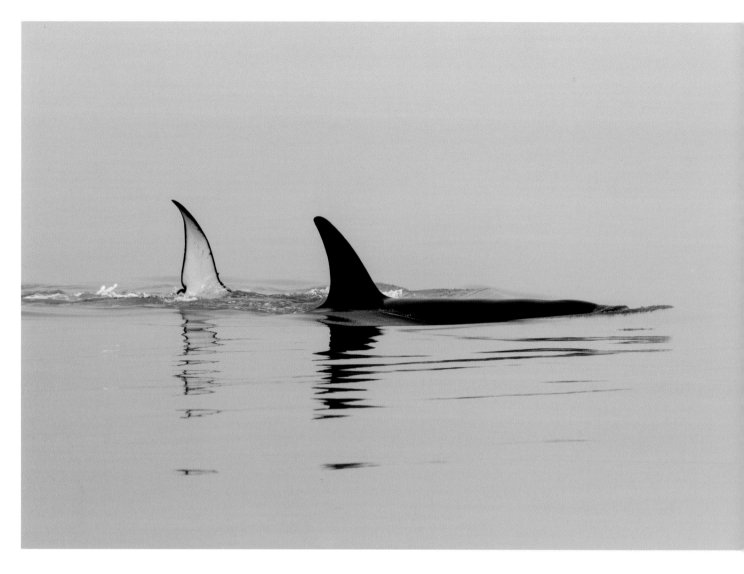

SHOW YOUR PASSION

It is not enough simply to take a picture; we have to somehow express what we are feeling when we make the photograph. Wildlife photographers who are concentrating on "getting the moment" will make a better picture if they are passionate about the animal, or animals in general. That passion gets into the camera and is laid upon the sensor just like light is, because seeing the animals through passionate eyes can help you see something different that others may miss, the tiniest gesture,

perhaps. You are going to use what you feel when looking at a landscape that thrills you to answer the questions of where you need to stand or kneel to bring out the visual impact and what you need to include or exclude to make others feel what you felt was so magical about the place. It's really just about feeling something and letting what you feel guide you into making the most expressive image you can in that moment or situation.

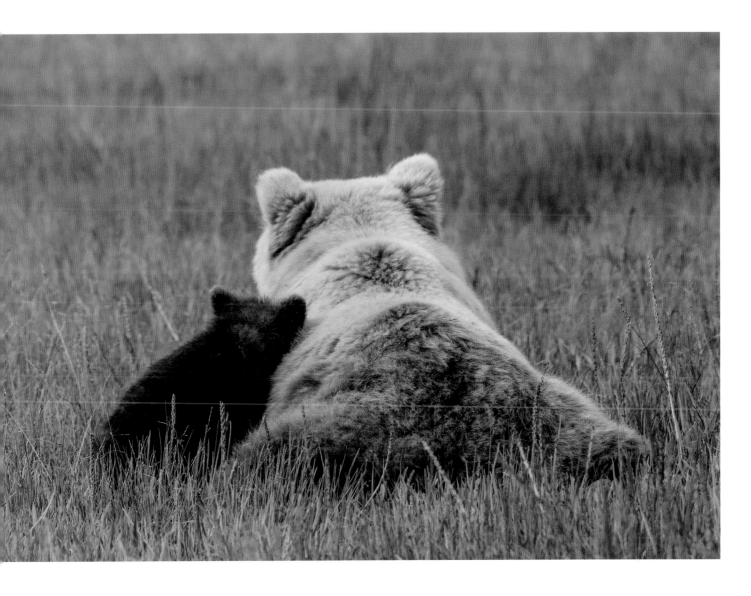

OPPOSITE:
This moment genuinely moved me, and I hope it does that for you when you look at the picture. It's enough to see orca in the wild, but to discover some floating placidly through the calm waters of Glacier Bay, in teal-hued water the result of glacial silt . . . well, it was just magical.

📷 *100–400mm lens at 400mm, f/6.3 for 1/800 sec.*

ABOVE:
When I saw this mother bear lying in the meadow, at first I thought the photo would just be funny, with her legs splayed so she could place her belly on the cooling grasses. But when the little cub walked over, sat, and leaned against her, that was a special gesture. This photograph draws out the "ahhh" from just about everybody who sees it because of the emotion it expresses.

📷 *150–600mm lens at 552mm, f/13 for 1/1000 sec.*

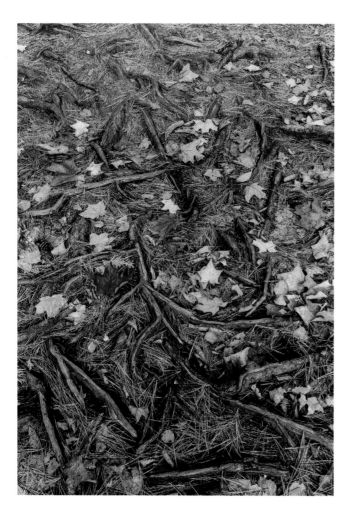
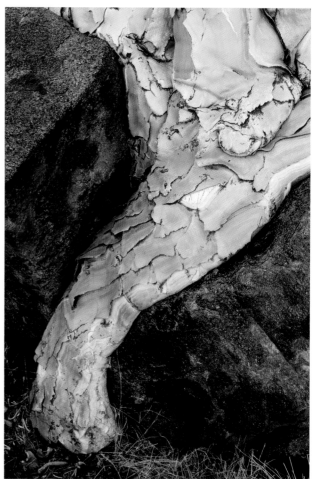

NURTURE YOUR CREATIVITY

I often hear people say, *"But I'm not creative."* Nonsense. Each of us has the seeds of creativity within us, and those seeds just need to be nurtured. Once you learn to create compelling photographs, you can begin to reach others with your personal experiences, expressed in your photographs. In the process of sharing your good photographs you may impact someone's life, bringing tears of joy, wonder, and laughter. How powerful and exciting that is!

To be creative at anything you must practice. Very few people can sit down at the piano and start playing like Mozart. Sports champions don't set new records by lying on the couch. The more you practice whatever it is that you want to do or improve upon, those areas of the brain associated with that mental or physical activity expand.

You don't have to go to a remote wilderness or somewhere impressive to practice making meaningful pictures of nature. In fact, the most meaningful ones may well be in a nearby park or even your yard, because these are the places with which you are most familiar and have the most connection, and that connection helps you see more deeply. Go sit by a pond for an afternoon. Walk around the block during lunch. Write down your observations of nature, making a journal entry once a day, or every week, or at the end of the month. Give yourself the task of taking a nature photo a day. The structure of having a project may be just what you need to keep things alive and will get you out the door when you might otherwise settle into the couch.

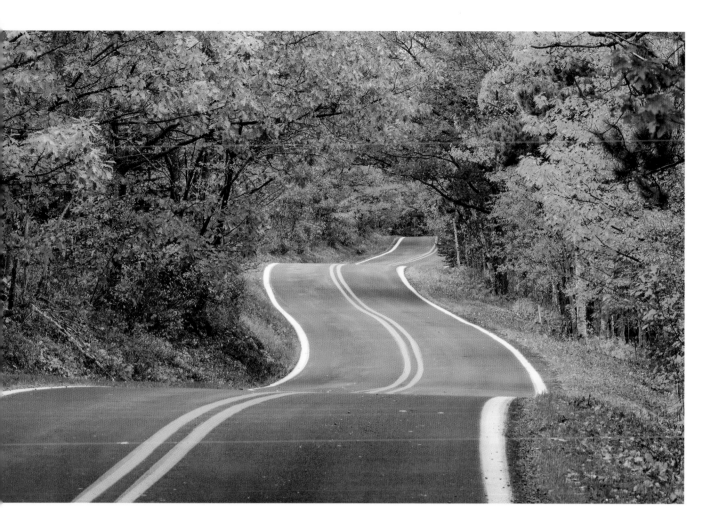

OPPOSITE, LEFT:
In autumn, it seems that everything is more colorful, even the forest floor with roots running through the pine needles along this small river in the Keweenaw Peninsula of Upper Michigan. I was drawn to the strong lines of the roots spreading out through a carpet of pine needles and fallen leaves.

📷 *16–35mm lens at 35mm, f/11 for 1/10 sec.*

OPPOSITE, RIGHT:
As I walked around the Quiver Tree Forest near Keetman-shoop, Namibia, I was thinking about how expressive the unusual trees were, almost like creatures. With that in mind, what did I spot but a "lion's paw"? Without the rest of the tree included, it became one of those photographs that look at first glance like something else, and I love those kinds of images!

📷 *24–105mm lens at 55mm, f/20 for 0.6 sec.*

ABOVE:
Wandering the country roads and lanes in Michigan's Upper Peninsula, the UP as locals call it, was a wonderful exploration during the magic of autumn. The air was crisp, the leaves were vibrant, and the roads were gentle and curving, following the undulations of the land.

📷 *150–600mm lens at 200mm, f/16–35 for 1/20 sec.*

Work Through the Dry Spells

Photographers often hit plateaus of creativity; all artists do, actually. If we are not challenging ourselves regularly to learn new techniques, or finding inspiration around us, we can hit a wall, and our creative juices go flat. How do we get them flowing again?

Put the camera down, and take a hike or a walk. Breathe deeply, and take a long look at things around you. By not having a camera, you can focus on what you are seeing without the distraction of actually having to make a picture. See how many patterns you can spot. Notice the light falling all around you. Is it warm? Cool? Strong? Soft? How does it make you feel? What is that amazing tree bark? Is that a butterfly or a moth? Does it smell like rain?

The mere act of leaving the camera behind may be just what you need to ignite your spark again. I know that when I *don't* have a camera with me, I will see many things. Not having the camera means you get to be in your right brain for a while longer, where passion and inspiration live. Don't worry, you soon will find your way back to the camera, with a renewed purpose and inspiration, and you'll realize that your mojo actually never left, it was just buried under a few pressing things. True creativity doesn't wane, it just needs a break now and then to recharge. Make time to read, write, hike, cook, bike, or do whatever brings you joy. A well-rounded life generates fresh vision and ideas. Be driven by your passion for life; let it open your eyes so you can see with a fresh perspective.

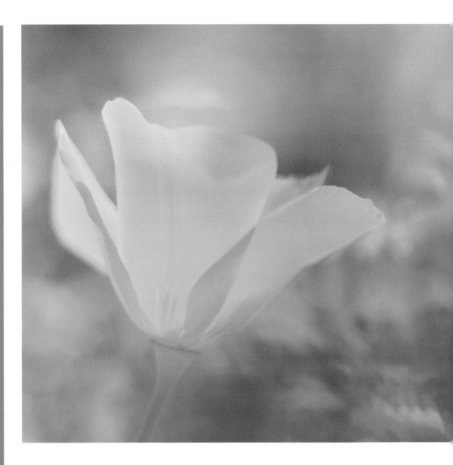

ABOVE:
I love flowers, and I love wildflower meadows. When California's wild meadows explode in color, after good winter rains, the effect is a kaleidoscope of color. But rather than just capture it straight, as I have tons of those pictures and so does everyone else, I chose to play with selective focus and shoot through some flowers to others, to create the wash of color you see here overlaying the poppies. The result is a dream-like effect, and it's just how I felt: like I was in a dream filled with color.

📷 *90mm lens f/3.5 for 1/640 sec.*

OPPOSITE, TOP:
A friend and I decided to hike and explore this side canyon near Moab, Utah. We weren't looking for great photographs, but we decided to take our cameras "just in case." I'm glad I did, because we found this neat white mark that lead to an eroded hole, and it was just one of those photographs that you make because it makes you look and wonder about what's going on in the picture.

📷 *24–105mm lens at 105mm, f/14 for 0.4 sec.*

OPPOSITE, BOTTOM:
When a flowing stream of water rushed through this wash, it created ripples in the sandy mud, and they were in the process of drying when I discovered them. Unless you walk the washes a lot so you understand what happens when waters rush through, you might not understand the story in this picture. With only the pattern of the waves of mud, the image becomes abstract. The sand layers were deposited in a way that they resemble the plates of pinecones to me.

📷 *24–105mm lens at 92mm, f/11 for 1/13 sec.*

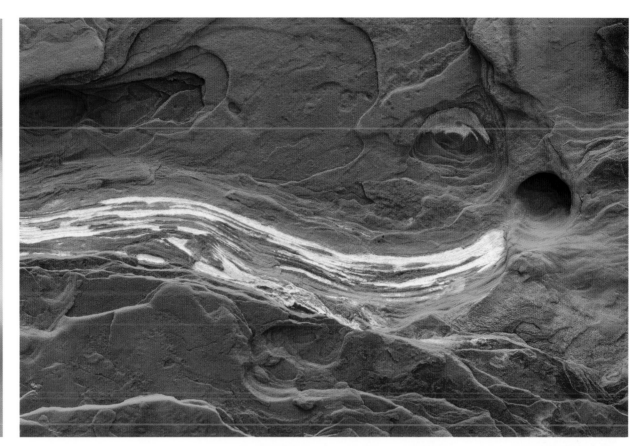

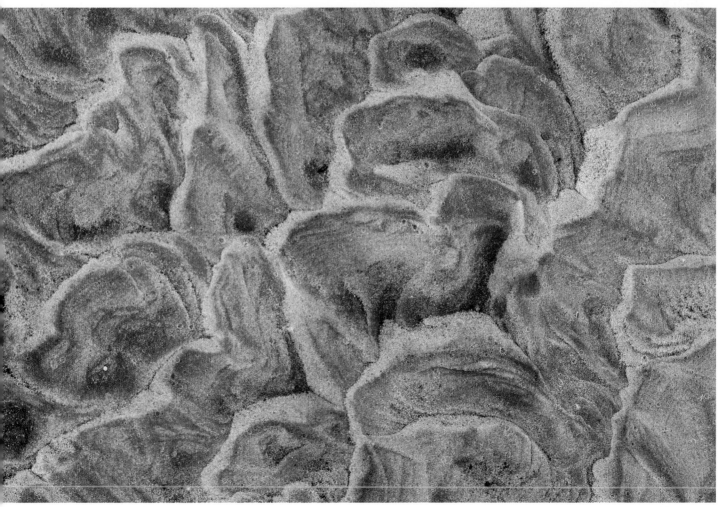

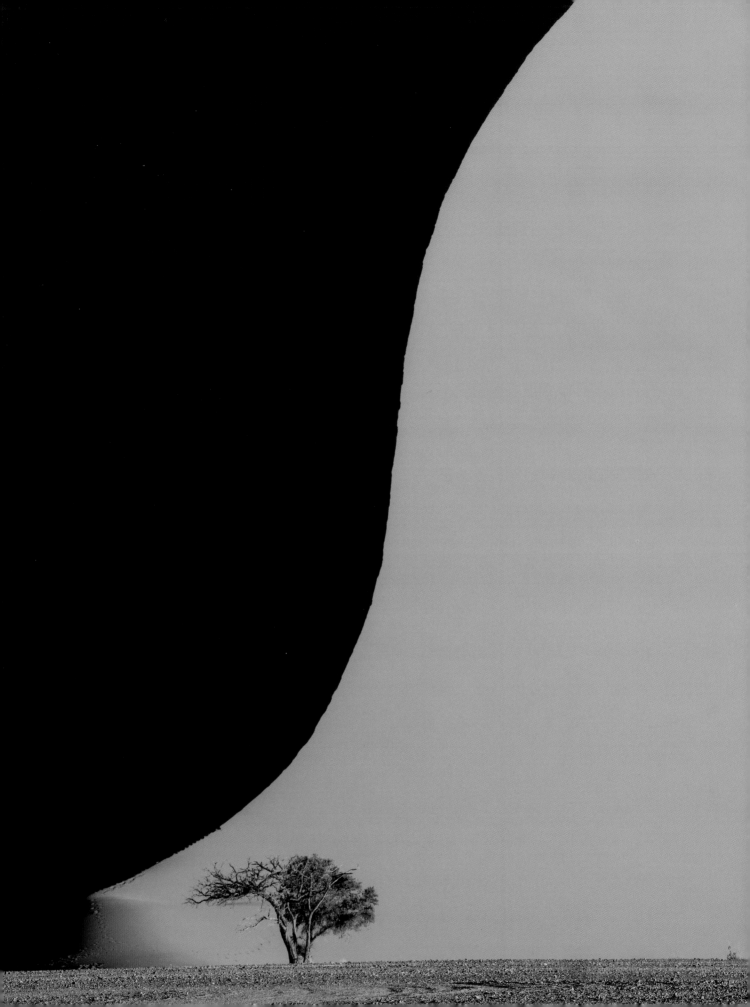

CELEBRATING LIGHT

"A painter should begin every canvas with a wash of black, because all things in nature are dark except where exposed by the light."

— LEONARDO DA VINCI

By its very definition, photography is writing with light. Light is the essential raw ingredient in all photography, and the more you learn to see light and work with it, the stronger your pictures will become. Light illuminates, defines, and expresses; light is often what makes us take notice. Consider the way the light skims the surface of sand dunes and shows off their form, shape, and texture, or the way light from a setting sun strikes mountaintops with warm colors. Used well, light will transform a scene from ordinary to extraordinary. This chapter explores ways to see light and how to use light creatively to make your pictures more expressive.

OPPOSITE:
The sweet light on this dune in the Sossusvlei within Namib-Naukluft National Park in Namibia was incredible. The light/shadow from sidelight highlighted a wonderful **S** curve, a sensual line that divided the space gently, while leading the eye to the tree. I was lucky; the next day was hazy, and the dune images were not as dynamic. Work the light when it happens!

📷 *150–600mm lens at 309mm, f/16 for 1/80 sec.*

CAPTURING LIGHT

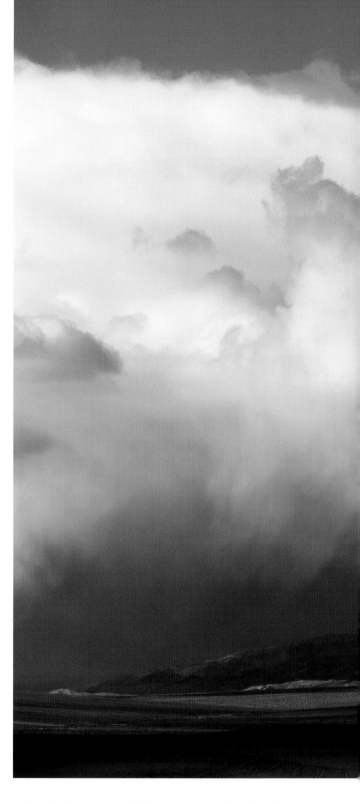

It's four in the morning! Aaaggh . . . I've gotta get up, gotta get out there to capture the first light of dawn, the rosy pink and blue hues in the sky. Hmmm. Is it cloudy? Maybe there won't be a sunrise that I can see, today. . . . Get up! Time to go!

For landscape and nature photography it's all about capturing available light, and some of the best opportunities for capturing the grand landscape are early or later in the day. Dedicated outdoor photographers are always on the hunt for magic light. We know that the warm light and longer shadows of morning or afternoon add a special impact to a grand landscape. Yet some landscapes and other subjects photograph well under other lighting conditions, too—in the light associated with storms, fog, and clouds, for instance, and some scenes even photograph better in this light than they would in strong sunlight. So if you decide to sleep in, you'll just have to plan to photograph in the light you have once you get out there.

Photographers use the phrase "magic light" a lot, but what is it really? It's when the light breaks through clouds and God beams (technically, crepuscular rays) shine on the land, when sunrise or sunset lights up the sky in brilliant colors, or when the fog rolls in and the forest transforms into a tranquil place. It's when light skims across the surface of sand dunes, or backlights a colorful flower. This is magic light, but let's not forget that all light is magic, as photography wouldn't be possible without light.

A popular belief developed years ago that photographers shouldn't photograph during the middle hours of the day, because that was "bad light." We could blame it on film's inability to handle the contrast of midday, or photographers' lack of understanding of how to work within the limitations of film. But even with a digital sensor's capability to record a greater range of light, some images don't look as pleasing in the high contrast and cold color of midday light. It's not that the light is bad; it's just not right for those situations.

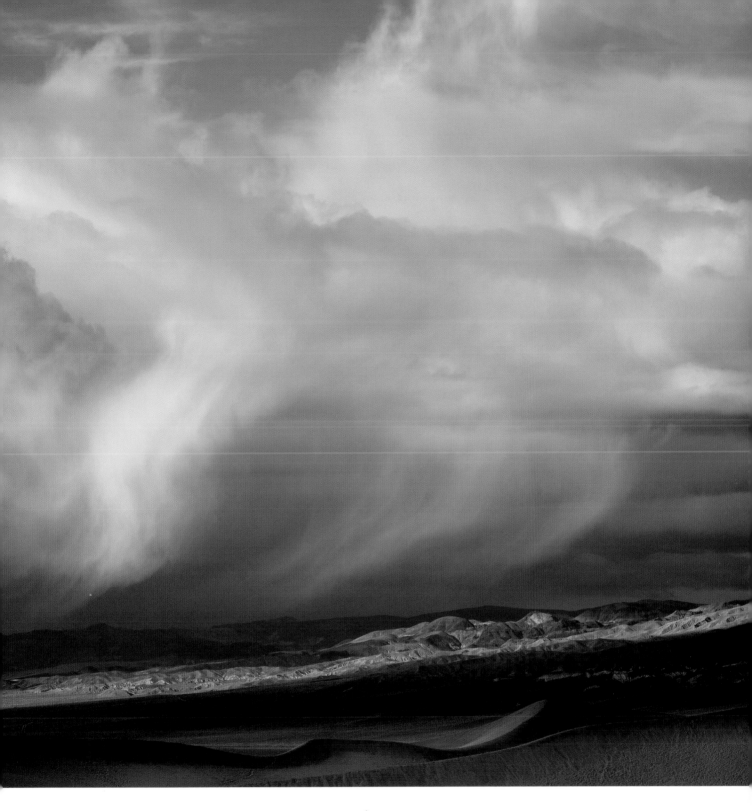

Thinking back to some of my favorite *National Geographic* photographers, they knew how to use any kind of light, and had to, to get the job done. Not all their images were made in the early or late hours of the day. They learned to use the light they had.

ABOVE:
With clouds and sun breaking through, you get dappled light on the land, creating drama in a photograph. In this image from Death Valley, California, I loved the play of light and shadow in the clouds, and the land below echoed that. To emphasize and celebrate the sky, I composed with just a small portion of land to anchor the scene.

📷 *70–200mm lens at 180mm, f/10 for 1/50 sec.*

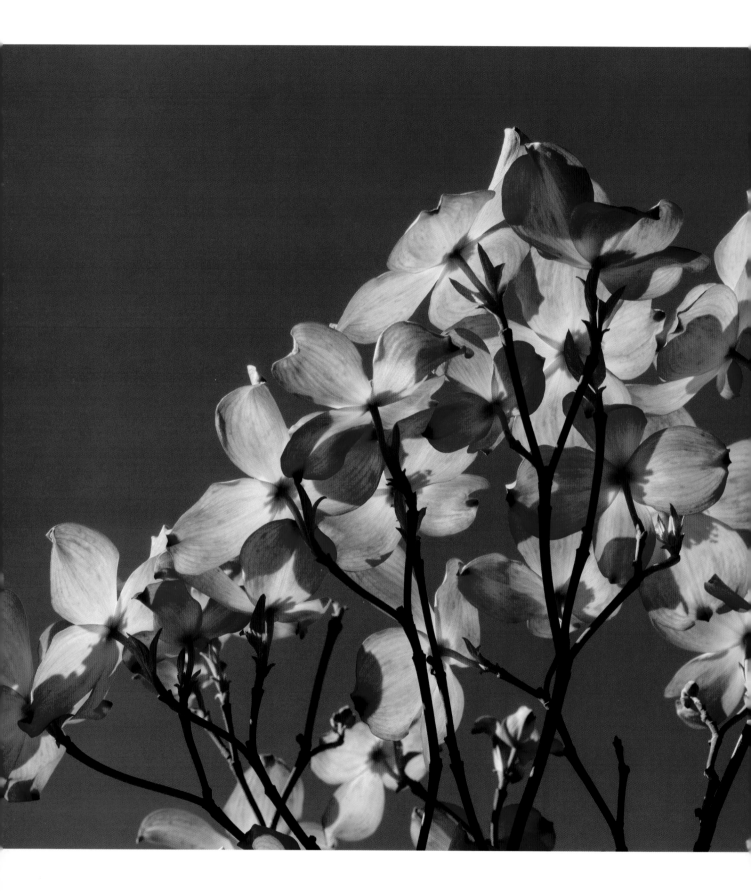

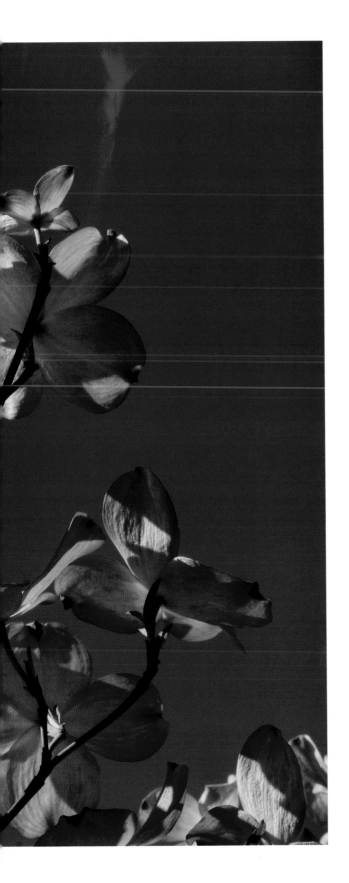

ALL LIGHT IS GOOD LIGHT

There is no such thing as bad light; there is only light. Think about that for a minute: When the sun is overhead, it backlights blossoms and leaves on trees. How can that be bad light? Or when mid-afternoon light strikes the wall of a red-rock canyon, and bounces light into shady parts, creating a warm glow, how can someone say that it's the "wrong time of day" to photograph? And what about the light on a cloudy day? You can use that all day long to make certain pictures. Light is just light. In fact, by paying attention to the light all the time, you can learn to see things that you might otherwise miss if you hold tight to the belief that outdoor photographers only work in morning or late-afternoon light. I still prefer the longer shadows and the warmth of morning or afternoon light for my grand landscapes, but there is more to nature photography than just the big picture.

Natural light has three important properties: quality, direction, and color. These characteristics have a great impact on your photographs as they define the land-scape, illuminate the subject, and express the mood or an emotion. If you find your pictures are lacking visual impact, it may be because you aren't paying full attention to the properties of light and are using the "wrong" light for a situation, or the wrong direction of it.

LEFT:
An effective case for the idea that there is no such thing as bad light: Strong top-down lighting was perfect for backlighting these dogwood flowers facing the sky. Jux-taposed against a brilliant blue sky, they make a glowing cheerful photograph that celebrates the onset of spring.

📷 *70–200mm lens at 135mm, f/16 for 1/200 sec.*

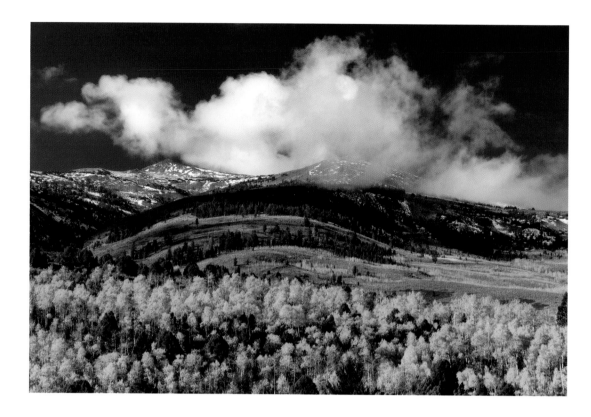

THE NATURE OF SUNLIGHT

Natural light exists in two forms: as strong, direct sunlight, known as specular light, and, if softened by clouds, diffused light. Both types of light are sourced from the sun. With nothing standing between your subject and the sun, the light is direct and produces sharply defined edges. Emotionally, this direct light expresses vitality, hope, and joy. People go out to sit in the sunshine because being bathed by the light of the sun can bring a feeling of happiness. Our existence depends on the sun, and emotionally we know that, so sunlight inherently expresses life. Sunlight is bold and aggressive. It can be wonderful for dramatic landscapes, and for times when you want to create strong contrast in a photograph. Yet sunlight is not appropriate for every subject. You wouldn't express the peacefulness of a forest in the high contrast of full-on sunlight, but you could use that light on a landscape of sand dunes, or to capture the intense glow of backlit flowers or leaves.

The range of contrast from direct sunlight will vary with atmospheric conditions. High humidity and smog, smoke, and haze will reduce the contrast of full sun. Seasons also lower the intensity of sunlight, as the sun drops closer to the equator in fall and winter. Dry desert areas will typically have clearer light, unless strong winds kick up a lot of dust that hangs in the air, weakening the sun's strength. Understanding a little bit more about the environment of places where you'll be photographing will help you be more prepared for the light you may encounter.

Working with light, it's important to recognize some differences between how we see light and how the camera sees it. Our eyes can read a greater range of contrast than the sensor in our camera can. As we scan a scene, our pupils are constantly opening and closing to

ABOVE:
Fall in the eastern Sierra ranges can be stunning at any time of day. This image was made just after sunrise, when the light was still low and warm. The sunlight brought a cheerfulness to this landscape beneath beautiful clouds, and the angle of the light brought out the form and texture of the scene.

📷 *70–200mm lens at 100mm, f/16 for 1/20 sec.*

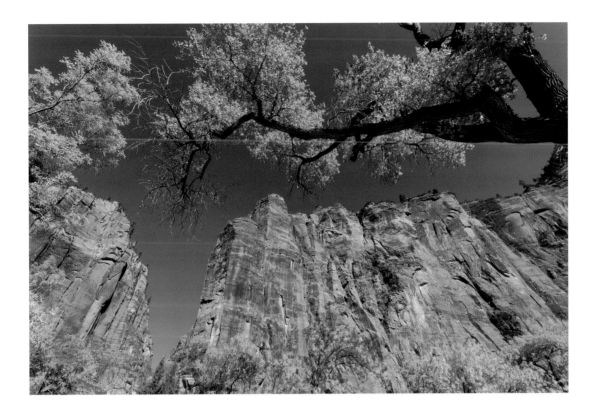

adjust for the amount of light so that we can see detail in everything. We are looking here, then there, and the eye is constantly adjusting to the light and shadow present. The camera can't do that. It simply grabs a moment in time, the one you've chosen, and tries to capture as much range of light as it can, but that can be a big compromise. Because of this, a scene might look good to our eyes, yet the results may be a disappointment. The more you realize this difference, the better you'll become at analyzing the contrast of light in any situation and deciding how you'll manage it.

Harsh, high-contrast light presents a challenge to outdoor photographers, because it may be too extreme for the camera sensor to record at full tonal range. This is partly why many landscape photographs are made in early morning or late afternoon, when the tonal contrast is lowered as the light passes through denser atmosphere than it does when the sun is higher overhead.

BLUE SKY BLUES

Non-photographers must think we are crazy when they hear us complain of a cloudless blue sky. We beg for some clouds to fill in that solid shape of sky when others are thrilled to have it. Why is that? Because any solid shape in a photograph carries visual weight, and the sky appears as a solid block of color at the top of our frame, pressing down on everything below it. Being middle-tone, it carries more weight than a lighter hue of blue. You can minimize the effect. For instance, tree branches juxtaposed against the sky can help reduce that visual weight and keep the eye on other things in the frame. Or, eliminate the sky from the composition and instead find things to photograph that benefit from the light of a clear

ABOVE:
This picture is an example of how you can deal with a cloudless blue sky. By including overhead branches of the cottonwood trees, I was able to fill in the bold empty space. I positioned myself so that the branch coming in on the right aligned well with the top of the cliff, while having the end of the branch point into the V-shaped space between the two cliffs.

📷 *16–35mm lens at 17mm, f/14 for 1/50 sec.*

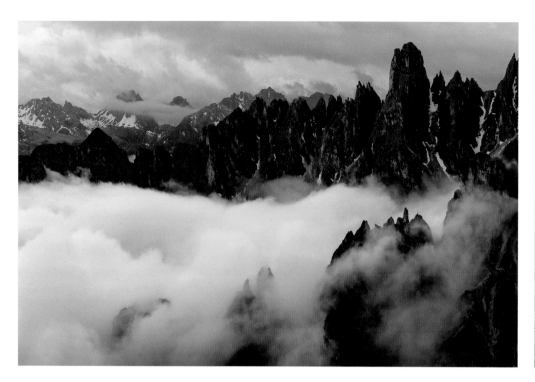

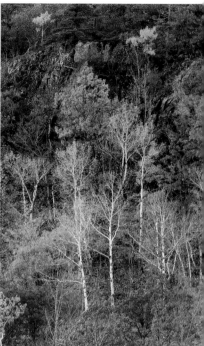

sky, such as a shaded stream reflecting the color of the sky.

BRING ON THE CLOUDS

A landscape is usually just nicer with the addition of clouds. Clouds reduce the visual weight of the sky and add visual interest in a photograph. They can soften the overall contrast of the scene, too, if the light is passing through clouds. This can make it easier to capture the complete tonal range of light in the landscape. That's because diffusion broadens the spread of light from the sun, resulting in reduced contrast. This allows for more detail to record in both the highlight and the shadow areas, yet a landscape can look dull under too much overcast. Emotionally, diffused light is calming, due to the even contrast, and it's a perfect light to express the tranquil beauty of a forest or to photograph a flower, where fine details are so important.

ABOVE:
While walking back from the sunrise location in the Dolomites in Italy, low clouds suddenly rolled in, filling the steep valley below these jagged peaks and expressing the dramatic nature of storms. As one area of rocks was covered, another was exposed, and I simply had to decide when to press the shutter to capture what I wanted.

📷 *70–200mm lens at 79mm, f/8 for 1/80 sec.*

ABOVE, CENTER:
When it's cloudy outside, it's time to head to the woods! Although the colors of the leaves are bright and energetic in autumn, their true colors are best seen under the blanket of clouds. Full sun diffracts the light and washes colors out, but in a large landscape that can be okay. When you get in closer, though, the shadows become larger and the contrast harder to manage. I liked how the white trunks stand out against all the colors, giving the scene structure.

📷 *100–400mm lens at 260mm, f/10 for 1/125 sec.*

OPPOSITE:
An afternoon of stormy skies opened up, creating a wonderfully ethereal atmosphere over the Alaska Range near Denali. As the afternoon sun broke through clouds, rays reached obliquely across the scene. I composed the scene to include a small border of the forest between me and the mountains and let the sky have more proportion, as the show was up there.

📷 *150–600mm lens at 150mm, f/14 for 1/60 sec.*

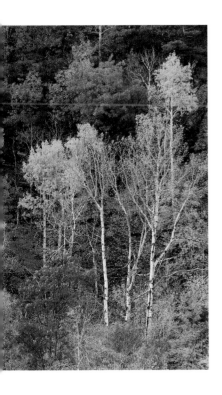

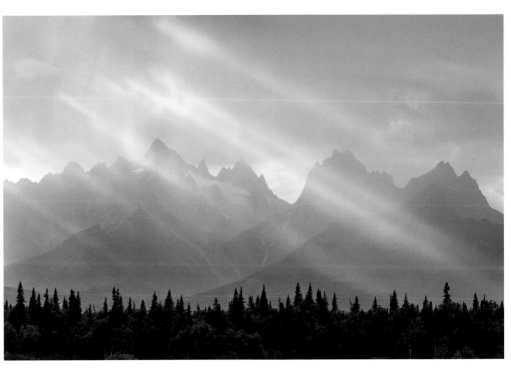

Diffused light differs in the amount of contrast or lack of contrast it contains. A thin layer of clouds will still produce *some* contrast, creating subtle texture and dimension while still allowing you to record good detail in highlights and shadows. You can even get lovely backlighting with bright yet diffused light. This light has a little more energy than a thicker cloud cover, but it is still calm light. A thick layer of clouds that block most shadow feels cold emotionally. It, too, is quiet light, but lacks the visual impact that a thinner layer of clouds has, and details may look too flat under this thick diffusion. It's important to learn the differences within diffused light, to decide what subjects might work best under each condition.

Sunlight that shines through the gaps in the clouds can create interesting and dramatic dappled light. When a solid layer of clouds fills the sky, the sky can become too harsh and distracting, bright and glary to our eyes. That being said, on the western coast of Ireland, many days are cloudy with little sun, but the skies are very moody, and the clouds usually have a lot of shading, creating texture in the sky space. That moody light just fits a land that is defined by unsettled weather. If you don't have interesting skies like this, though, you may want to rethink your compositions, and it's usually best to avoid including sky, or at least keep it to a very small proportion.

ATMOSPHERIC CONDITIONS

If you are lucky to live in an area where you get fog, or where you have low clouds that form after storms, then you know what I am talking about when I speak of the magic of atmosphere! Fog, mist off lakes and rivers, rain, and snow all create opportunities for a photographer to capture some great moods of nature. With luck on your timing, and a little planning, you can be prepared for including atmosphere in your pictures.

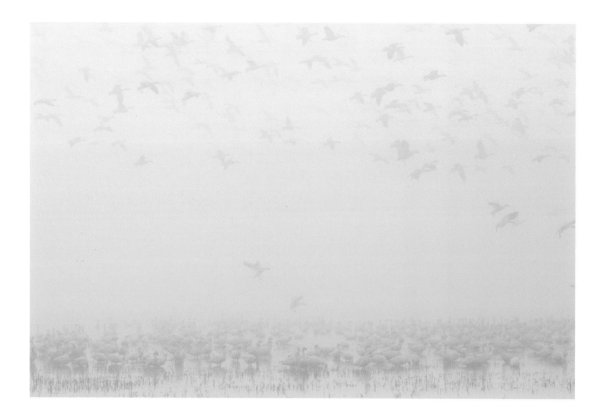

FOG

Fog presents incredible opportunities to capture the world in a different way than we normally see it. Clouds collide with the land and swirl around objects to isolate them from their often-cluttered backgrounds. Trees stand out in foggy meadows, with the background muted; mountains are encircled with a "necklace" of low clouds; the forest becomes an ethereal place. As elements appear and disappear in the ebb and flow of the fog, you have wonderful opportunities to create a variety of photographs with simplified compositions and moods. That said, fog that's high overhead and not swirling around my feet or through the trees in front of me creates the light of a cloudy day, and it dulls the landscape with it's heavily diffused light. It's my least favorite type of fog, yet if I can get above it, on hills and mountains, then that fog can become magical as it swirls around peaks and redwood trees.

Fog expresses different emotional qualities. Dark, thick, gray fog can make you feel like you're in a cobblestone lane in England in the early 1800s, with a sinister character lurking around every corner. It's emotionally heavy and has a middle tone or darker tonality. Light fog, with some light coming through it, expresses tranquility, peace, a "going toward the light" feeling. It has a brighter tonality. Photographically, though, unless we overexpose this type of fog, it often comes out dark and somber.

ABOVE:
Fog is great to work with photographically. It isolates busy backgrounds, and infuses a scene with mood. When I arrived at this spot, I could hear the cacophony of thousands of geese. I just couldn't see them! With fog that thick, I thought my morning might be a "bust," but I know it's worth waiting to see what might happen. As I stood there listening to the geese, I began to notice that I could see a slight hint of them, and then more, and then finally this scene made itself visible to me, just as two birds were coming in for a landing! This is not the typical scene of a mass liftoff in stunning light that many photographers seek out when visiting the refuges in the migratory path, and therefore it was a special one for me to capture. Normally, the background trees and power poles don't add much to the scene here, but with the fog, all that disappeared into a magical moody image.

📷 *150–600mm lens at 150mm, f/8 for 1/2500 sec.*

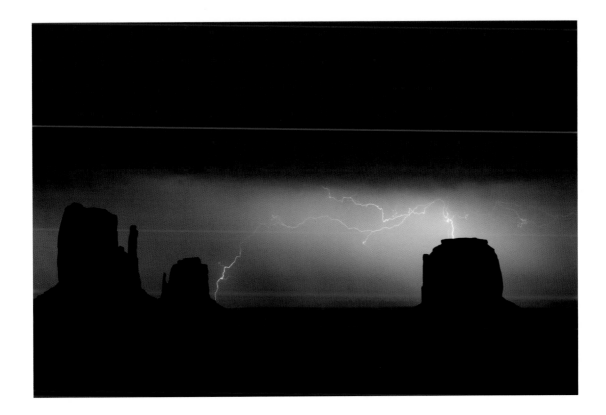

Rising mist on lakes and ponds is another special atmospheric effect that is really just ground fog. When the land is warm and the air has suddenly cooled, which often happens overnight in late summer and early autumn, a ground fog occurs and hangs above the water surface, provided there's not a breeze. Like water, this kind of fog, too, can ebb and flow with the air currents. Mist hanging low above a pond adds a tranquil, ethereal mood to a photograph. If backlit by the rising sun, the scene can be quite dramatic. If the ground is saturated from rain and is warm, but the air temperature is much cooler, ground fog will likely form, just like it does over a pond.

STORM LIGHT

It's exciting when nature expresses her power through wind, rain, thunderstorms, hail, and snow. That power, often something to be in awe of, provides great opportunities for photography. Emotionally, storms are like a tug-of-war game. The danger expressed in dark stormy clouds, and the hope expressed in the sunlight, make the mood ever changing. Dark, ominous clouds can contrast with sunlight striking a mountain or other land formation to create a wonderfully dramatic scene, and express a lot of energy. After it rains, storm light has a unique quality to it, too. The particulate matter—dust, smoke, smog—has been "knocked" out of the sky with the rain, and the air is cleaner, and the light more crisp, and more special.

ABOVE:
After being fooled by the weather into thinking I might have a great sunset, I was stuck camping out overnight atop the rim of Monument Valley. It had been an unsettled day, and more storms were building, but that's when I realized the potential for lightning was present, and that could mean something different for a photo of the Mitten formations. As darkness fell, so did the hail, and the thunder and lightning were intense, too intense to go out and photograph safely. As the storm passed over, I waited until I saw a few others venture out with their cameras, before I decided it might be safe to set up a tripod. Yes, I may be timid, but I wanted to live to tell people about the incredible experience I had! Since it was dark at that point, it was easy to leave the shutter open and get some strikes. Then it was just a matter of where they were in the frame and whether they were in a place that made the image work. A lightning-trigger accessory would have likely helped here, but without it, I just kept photographing until I got an image that I liked.

📷 *24–105mm lens at 45mm, f/5.6 for 80 sec.*

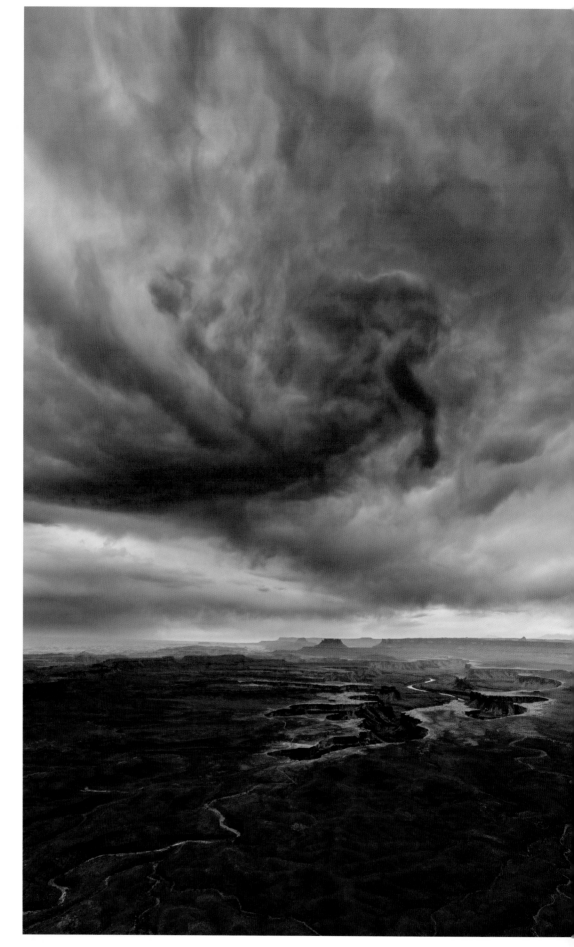

RIGHT:
Storms are a great time to be outdoors! If you are prepared to stay dry and keep your equipment dry, you can risk being out during the buildup and the clearing of storms, and you'll get dramatic photo opportunities like this one. The sky was very menacing, and I loved how the clouds looked like the snake in the Harry Potter movies. The exposure was extreme, and if I exposed for the sky, the land was too dark, and vice versa with the land exposure losing the detail of the sky. I decided to create a bracket series of exposures that I could then use either in HDR software or blend together manually in Photoshop.

📷 *16–35 lens at 16mm, f/16 for various shutter speeds.*

 ## Exercise: Become a Weather Watcher

Knowing a little bit about your environment and how weather conditions form goes a long way to helping you predict the potential for your photography. For example, in the San Francisco area, if the Central Valley gets really hot, the heat rising off the valley floor will draw in the cooler air off the ocean. As that air hits the hills at the Golden Gate, it becomes fog, and that fog will get pulled up and over the hills as far as 10 miles from the coast. So if we want to predict fog, we can check the temperatures in the Central Valley, or listen to the news, as fog is a common topic of the weather reports around here. I've spent a lot of time in the outdoors, and those moments in nature have taught me a lot about weather and the potential that brings to photography. When I once saw a weird yellow-gray sky in Colorado, I realized it meant *tornado*, because of being near one as a kid. I can smell rain when it's coming, because of the change in the ozone content of the air. When I see altocumulus clouds in the sky, I know there might be a great sky at sunrise or sunset, because these clouds form at a certain altitude and can light up with color from the rising or setting sun. Through observing and experience, I know that August is a great time for dew in the prairie meadows in the upper Midwest; September and October are great times for ground fog and rising mist in Ohio, Virginia, New England, and in April and May, the low ground fog adds mystery and magic to the rolling hills in Italy, Slovenia, and the Great Smoky Mountains in Tennessee.

ABOVE:

It was a very strange sky as I drove to a scheduled appointment, and when I returned home, later in the afternoon, the sky was still churning with amazing clouds. I knew the scene had the potential to become very colorful as I could see the horizon was clear, so I grabbed my gear and ran to the nearest parking garage to get on the rooftop for a view that would clear all the power lines, trees, and rooftops. The sky began to change colors, and the formations changed suddenly, too. It went on for about fifty minutes, and I made all sorts of compositions. While it would have been terrific to have a great landscape to put this amazing sky above, it wasn't meant to be that day, and I was just glad to witness and capture the changing canvas that was being painted before me every few minutes.

📷 *55–200mm lens at various focal lengths and apertures.*

SNOW

Like fog, snow has the ability to isolate a subject, and simplify a composition. Snow covers up a lot of less-than-pretty things in a winter landscape, such as bare dirt, dormant plants, and dead snags. Snow is an ephemeral element and emotionally expresses a quiet energy. Timing is of the essence when photographing fresh snow. If the temperature rises, the snow melts off the trees, and the scene changes right before your eyes, making the snow dirty and the scene messy again. This fleeting aspect of snow can pose a challenge, but the effect can be so beautiful. Snow is a rare occurrence in the San Francisco area, where I live, so I track winter storms in the Sierra throughout the season, then drive the four hours into the mountains to photograph. I try to time my arrival to create photographs with virgin, trackless snow. If you travel in search of snow, you play a guessing game of trying to be there at the perfect time.

ABOVE, LEFT:
As I was arriving in Yosemite Valley the snow was falling, covering everything in a beautiful layer of fresh white. But the problem was it was still snowing, and that often means you'll have wet blobs hitting your lens, or worse, showing up in the frame. But I decided it was worth risking that to try to capture the storm in the act of storming. For me, that expressed something different from the typical snowy scene. It took many frames to get one where you could see the snow coming down yet the snow didn't obscure too much of anything important, or stand out too strongly in the scene. Trying things like this makes photography fun. Just keep a dry microfiber towel inside your pocket to keep dabbing off the lens!

📷 *24–105mm lens at 40mm, f/10 for 1/250 sec.*

ABOVE, RIGHT AND OPPOSITE:
No matter how sweet the light is at sunrise or sunset, you can't be fooled into thinking that this is always going to be great light for your subject! I was jumping up and down with excitement over this sunrise in Death Valley, but the right side of the famous Zabriskie formation with Manly Beacon gets hit with straight-on front light at dawn, sadly, and it's flat light, no matter how pretty the color is! As I looked to the left, the scene was becoming even more incredible, and the angle of the light, even though still diffused, brought out form in the landscape.

📷 *24–105mm lens at 24mm, f/16 for 1 sec.*

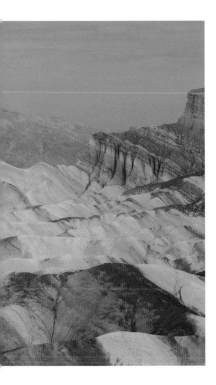
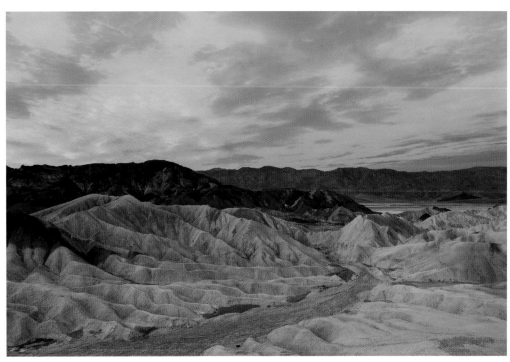

THE ANGLE OF LIGHT

The angle of light from the sun changes throughout the day as the sun tracks through the sky and plays an important role in defining your subject or scene. Remember that seasonal changes affect light. In late autumn, winter, and early spring, the light is farther away from the equator and your angle of light will be lower for longer hours during the morning and afternoon. When the sun sits just at or above the horizon, you will have sweet low light for much of the day.

TOP-DOWN LIGHT

When the sun is high overhead, you have top-down light, which for most photography is not exciting, to say the least. It creates harsh shadows on faces of animals and birds, and shadows directly below trees and rocks, flattening their form. This cold, midday light results in pictures that are "flat" and leave your viewers feeling "flat" as well. But there are ways to use this light. Think about photographing tall trees with the sunburst and God beams streaming down through them.

FRONT LIGHT

When you photograph with your back to the sun, the light is from behind you and the scene before you is front lit. This puts the shadow behind objects, and texture and form are reduced. The image is flat, as it is with top-down light. Even at sunrise or sunset, the light falling on your scene will be behind you, and no matter how beautiful the golden light is, the scene will still be dimensionally flat and typically uninteresting.

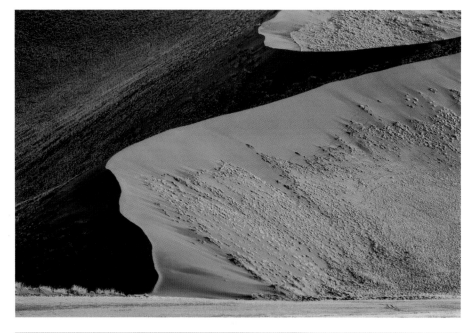

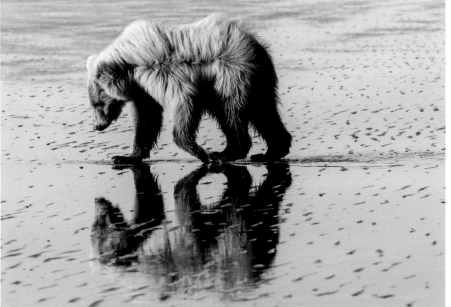

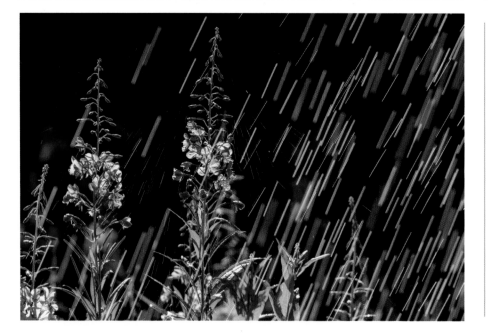

TOP:
The sun rose red and warm on this morning in Namibia, as we photographed some of the world's tallest sand dunes. It's a photographer's delight when you have great subject material and great light combining in an image. The sidelight brought out the shape and form of this dune, as well as the texture of the grasses on the side of and below the dune.

📷 *150–600mm lens at 600mm, f/14 for 1/13 sec.*

CENTER:
The late afternoon sunlight shone straight into the bear's face, but from my position, it was great sidelight. It brings out the texture of the bear's fur so well. It also defines the form of the bear. It didn't hurt that I had a great reflection, too. Sometimes we really do get lucky in the field!

📷 *150–600mm lens at 256mm, f/9 for 1/640 sec.*

BOTTOM:
Walking back from my cabin in Alaska, I passed the lodge chef's kitchen garden, and the sprinkler was on. I loved how the sun backlit the drops of moisture and the flowers, setting them off in high contrast against the darker background. It's a good thing I always keep a camera with me.

📷 *150–600mm lens at 600mm, f/10 for 1/100 sec.*

OPPOSITE:
A girlfriend and I were practicing photographing birds in flight at her home in Arizona. These finches were so fast, and they would often squabble in midair. It was tricky to get the timing right as they flew in and out of the area near her feeders, but the backlight on their wings was simply beautiful! You make a lot of exposures to get just a few that work, and I really liked the spread of the wings on the finch on the right. In a setup like this, I prefocused on the cactus and used a small aperture to have enough (hopefully) depth of field to render the birds sharp when they flew into the scene. Shutter speeds were kept high, too, to freeze the wing action.

📷 *150–600mm lens at 256mm, f/10 for 1/4000 sec.*

SIDELIGHT

If you turn 90 degrees to the right or left of the sun, your scene is side lit. During the Renaissance, painters noticed that scenes came to life with depth and texture when lit from the side, and they began to paint what they saw.

This light expresses a strong energy as it shines onto the scene at an angle and can be assertive, creating contrast that's often dramatic. Outdoor photographers use sidelight a lot, because we've learned that it defines the form of rocks, trees, and other objects within the landscape and gives dimension to a scene. Sidelight works for intimate landscapes, close-ups, and wildlife photographs, too, since it emphasizes the texture of curling mud, sandstone, grasses, and animal fur.

When working with sidelight, keep in mind that the higher the sun is on the horizon, the whiter, or colder the sidelight may be, though you'll still achieve dimension and possibly texture in your photograph. The lower the angle of sidelight, the warmer the color of the light will be, yet the shadows become very long and may shade too large of an area of your scene. This is a challenge in making photographs at sunrise and sunset

At any time of day, you can probably find something in your frame that is being struck by sidelight. A canyon wall will exhibit texture when the midmorning light skims down the surface; the light bouncing off a sloping meadow or a rock wall can "kick" light into the shaded side of a scene, enhancing the light of open shade in that

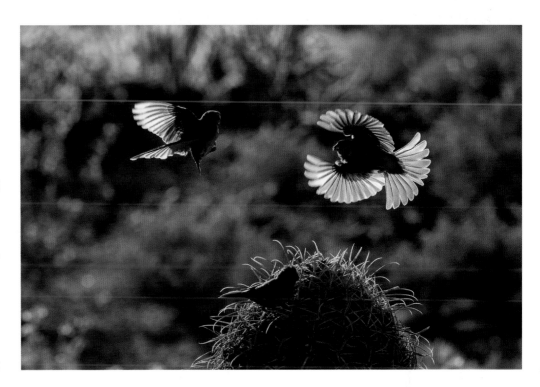

area. Even a slight bit of sidelight can make a photograph much more compelling. As you move from total sidelight to total backlight, a cross between sidelight and backlight can be very effective, too.

BACKLIGHT

If you face the sun, the scene before you, and objects in it, are backlit. Photographing in this direction is referred to as *contre jour*, a French phrase meaning "against daylight," which is simply the technique of pointing the camera in the direction of the sunlight.

This produces backlight on subjects, and typically creates silhouettes, but backlight is great for more than just silhouettes. Backlight produces a dramatic interpretation of the landscape, and has a strong energy to it. This is direct, in-your-face light, and we all know how intense that feels. It's wonderful for capturing the rim lighting on an animal's fur, the light coming through feathery grasses, or the light glowing through translucent flower

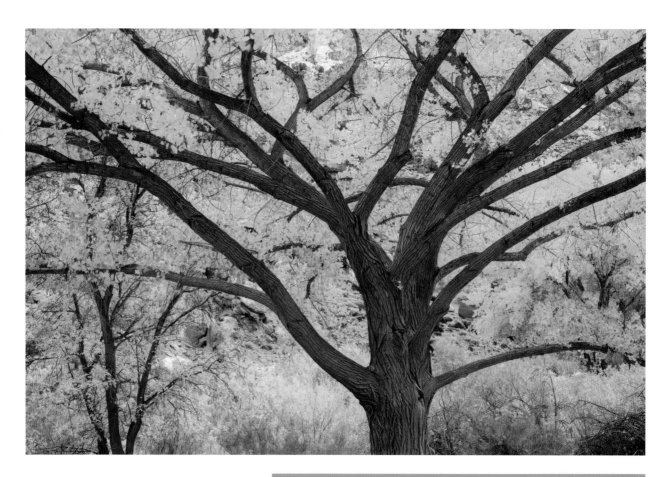

petals and leaves. You can also use backlight creatively in a larger scene. A backlit sand dune illuminates the texture of the surface of the dune if the sun is high enough to skim the surface. A backlight mountain scene, if there are clouds, can be dramatic, and you can even create a starburst with the sun as it crests a jagged peak. Backlight is great for accentuating fog, haze, or smoke and can define layers of mountain ranges, isolate a tree in a meadow against the shaded forest in the background, and add mystery or mood to a picture.

ABOVE:
Even though it was a cloudy day, the bright overhead light shone through the golden leaves of the cottonwoods and bathed everything beneath the tree in a warm light. Most amazing was the way that leaves on the ground behind me received light from the sky and bounced golden light back into the tree, lighting up the trunk and branches.

 24–105mm lens at 73mm, f/16 for 0.5 sec.

TIP

Of all directions of light, backlight is the more challenging to expose properly. To meter for a silhouette, you can meter the scene just to the right of your subject, and use that exposure. If you want some detail, but not a lot, try metering with the subject in place and see how that looks. If the subject is large in the frame, this might give too much detail, and you then may need to split the difference between subject and backlit space to the side. Generally speaking, a good exposure for rendering some detail in a backlit object would be about 1 stop under the evaluative meter reading of the scene with the subject in it, but that will still vary for each situation. With some experimentation you'll find what works best for the moment. Remember that creative results come from trying different things and being willing to fail and evaluate and try again. Working against the light can be exciting once you get the hang of exposing it creatively. Remember to remove all filters, as light coming through them can hit the front lens elements and cause some flaring. Keep the front of the lens clean from dust, and also use a lens hood.

BOUNCE LIGHT

Bounce light occurs whenever the light bounces or reflects off something. When light bounces off a sandstone wall, for example, the objects in the shade receive a directional-yet-diffused light in the shaded part of the wash. Things just glow with this light, perfect for photographing leaves and rocks. Light-colored sand will bounce light up into an animal's face, or lighten up their fur in the desert. Bounce light can reflect off the ground and bounce up into trees, lighting up bark.

CORRECT VERSUS CREATIVE EXPOSURE

We work toward getting technically good exposures, ones where the tonal values of lights and darks are all within the limits of what the sensor can record. In other words, we strive for exposures with detail in the whites and highlights, and if possible, good detail in the shadows. Technical photography books often refer to a "proper" histogram as one that displays a bell curve. Have you created an image with a perfect bell curve that often? I haven't. If I am making photographs using light in an interesting way, with scenes that have a lot of tonal range or contrast, my histogram will often look like an abstract skyline instead of a bell curve.

The key is to evaluate the range of light on the graph, and see where the brightest and darkest areas are, as those may be problem areas. I will even adjust my point of view and framing using the histogram, if I see a large spike in the highlights area. This indicates a bright spot in the composition that, even if not clipping detail, will potentially be distracting, such as a big white daisy in the background of a close-up scene, or a white egret standing behind a seal on the rocks.

On most cameras, the RAW file will contain more information than you are shown on the histogram on the back of the camera and in the histogram on the computer. I have successfully recovered blown whites and highlights on a scene in post-processing, and by making those mistakes—er, creative experiments—I figured out how much wiggle room I had to be "off" in my exposure and still have a usable image.

Once I learned how much I could "push it" on each of my cameras, I worried less about a little overexposing, although I still make sure I'm not overexposing beyond recovery. If the areas of whites and highlights are small, such as sparkles on water, I'm not going to sweat it. The same is true for the blacks and shadows. I try not to clip those, too, yet if there are small areas of shadow or blacks, under a rock, or in the deepest recesses of an animal's fur, I am not worried about those little things.

If you master the craft of reading light, and gain an intuitive knowledge of how to meter for some basic situations, such as open shade, cloudy, full-sun sidelight, etc., you will be able to get a better exposure more quickly. You can also prepare by setting up your exposure in the light you have ahead of time, so you're ready for the moment, provided the light doesn't change, or your subject's size doesn't affect the meter reading too much. Sometimes, manual exposure is safer. My partner once photographed white-water rafting for a summer, and he

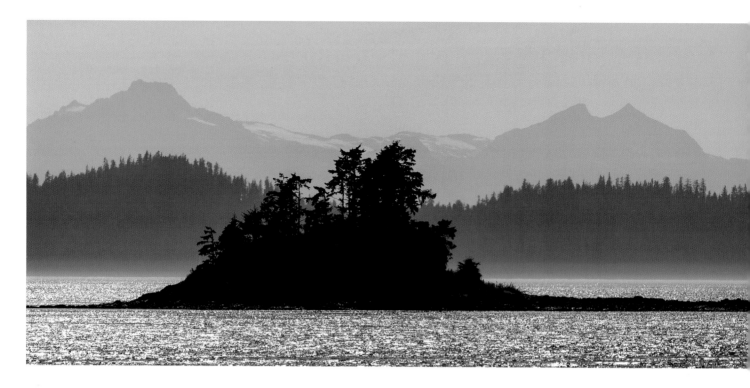

quickly learned that auto-exposure did not work well, as the reflected light changed when the bright yellow or dark gray raft passed through the scene. The meter reading he'd taken off the river alone was no longer valid. As he followed the raft through a stretch of the rapids, the rocks, water, and raft proportionally changed in size within the frame and that affected the meter, too. He finally realized that by setting his exposure manually and taking a reflected reading off a middle-tone rock in the scene, he could photograph with abandoned concern for the exposure. His pictures were much better after that shift in his technique. We use this same approach when photographing dark whales in water in Alaska. Once we've set our exposure manually, we're ready for most anything! It sure beats having the metering changing wildly in reaction to the large dark surface of the whale. We try to convince our tour clients to do this, too, but it's hard to wean people off auto-exposure!

What about *creative* exposure—that is, exposure that technically may not be correct, or use the full tonal range, but is still effective? If you want to render a feeling of moonlight, you can underexpose your picture made during full sun. This is an old technique and

ABOVE:
While the backlight was bright and glaring, I saw something of a silk screen in this scene. I knew that using a telephoto lens would optically compress the layers of mountains and the island, flattening the appearance of depth, making it more graphic. I decided to expose to let the highlights and brights overexpose just short of clipping on the histogram, and then in post-processing, I brought the darks down to make the island "flat," without detail, not caring if I clipped the shadows. That resulted in the effect I wanted. It may not be a correct exposure, but it's a creative approach.

📷 *150–600mm lens at 273mm, f/8 for 1/3200 sec.*

moviemakers used to do it to create "night" in a scene. While not technically a correct exposure, this might create the mood I want. You can increase the energy and the stark mood of something by using a slight underexposure to make the shadows heavier.

With fog, you can overexpose (or adjust later in the computer) one to two stops to brighten the scene to the point where it feels ethereal. To make a wildflower meadow feel more painterly, try overexposing in the camera, or in the computer.

Many photographers have learned how to get the special effect they want by learning how to create an exposure in the camera that works toward the end goal,

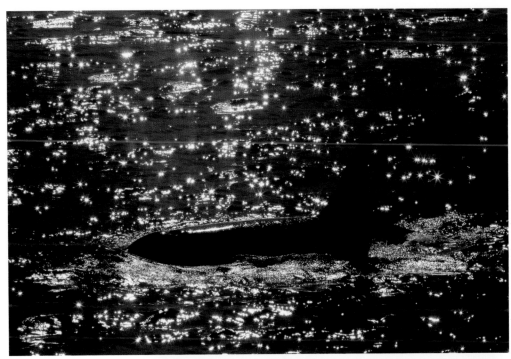

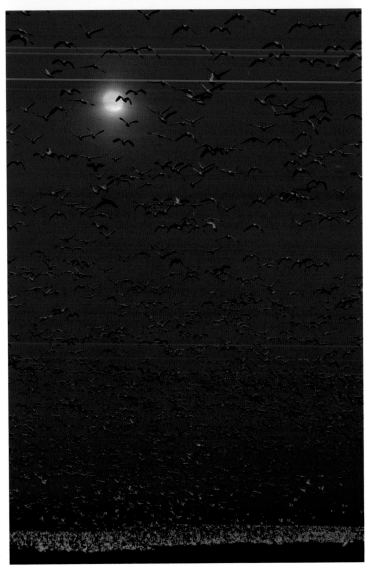

ABOVE:

What is correct exposure, really? If you want to create a different mood, you can often change the correct exposure into something that is more dynamic. I wanted to make this scene feel like it was in moonlight, so I deliberately underexposed the image in the camera. I've clipped my blacks, but I wanted a silhouette, so that didn't matter; and I just barely clipped my highlights, but since those are the tiny sparkles in the water I wasn't too concerned. While not every photograph can be successfully underexposed, try working with those that can to create a different mood. It's your interpretation of a scene, after all.

📷 *100–400mm lens at 120mm, f/18 for 1/1600 sec.*

RIGHT:

Just because the sun is down doesn't mean you can't photograph anymore! With many digital cameras, sensor quality is such that you can boost your ISO higher than you might have felt comfortable doing in the past, and that creates new opportunities for unique photographs. The moon was already up as the sun was still setting at this refuge, but I hung around anyway. I was chatting with another photographer out there and dusk began to fall. I thought, Why not photograph the geese, still flying all around, by the light of dusk and the near-full moon? To keep my shutter speed fast enough to render birds sharp enough to call them birds, I had to boost my ISO to 3200. This image captured the mood of the moment—and the story of unsettled birds as dusk falls.

📷 *150–600mm lens at 150mm, f/5 for 1/250 sec.*

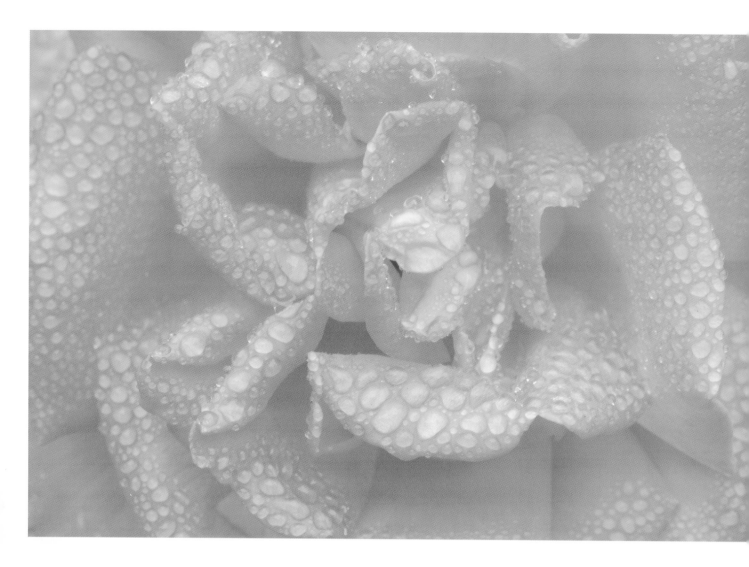

and then take it into the digital darkroom to finish. The only way to really learn how to make creative exposures is to try them. Start with a correct exposure, then push it darker or lighter and see where it takes you.

In the end, it's up to you as a photographer to determine what the best exposure might be, and what the most appropriate light might be for your scene or subject from a creative standpoint, not just a technical one. As you learn light's qualities, you will gain the ability to recognize the potential of any scene. There is no rule to follow in terms of the right light for a subject; using the "wrong" light can produce some interesting effects, as there are many variables that make each situation unique. Spend time getting to know how light affects the world around you, and you'll figure out what quality of light works well for your landscape or close-up photographs. Don't miss out on an image because you didn't get the light you hoped for. Find a way to work with the light you have. Discoveries await you.

ABOVE:
This deep coral rose in my backyard was covered with water drops from a steady mist. I loved the look of it, but decided to make the rose color pastel instead, to lighten the overall feeling. I made these adjustments in the computer, because overexposing in the camera would have clipped the highlights too much.

📷 *18–135mm lens at 203mm (effective focal length), f/11 for 1/125 sec.*

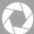 ## The Color of Light

The color of light is based on a Kelvin temperature scale, and simply put, the warmer the light (think of reds and yellows of sunrise or sunset) the lower the temperature on the Kelvin scale; the cooler the light (think of the blue hour, twilight) the higher the temperature. As a quick reference, sunrise and sunset are usually in the range of 2000–3200 Kelvin, midday light is 5500–6500, and twilight will measure above 10,000. Why does knowing about the color of light matter, when a digital camera can set auto white balance (AWB)? Because sometimes, auto white balance can mitigate the color shift that you might actually like. Under a cottonwood that is full of golden leaves, the light falling on you is yellow. AWB will try to remove the yellow cast by cooling the temperature of it. While you can put the color back in post-processing, it's not always easy to recall the exact hue or intensity of what you saw with your eyes. How about a winter scene in shade? Your scene will have a cool color temperature, a blue cast to the light. But this cool blue shift helps make the picture feel cold. If AWB cancels that out, completely, then you may have to put it back in later. AWB might cause a cascade of pure white water to look really yellow, and yellow water is not inviting. You know where I'm going with that.

It's important to consider the effect the color of light may have on your subject or scene. I once headed out to photograph giant Saguaro cacti in sunset light, and when I got the film back, the cacti looked brownish! The rich red shift in the light had mixed with, or rather messed with, the color of the light on the cacti.

Think of mixing paints. If you blend red or red-orange and green, you get a brownish hue. This is great for certain situations. In early evening, in open shade, blue morning glories seem to become iridescent with the addition of the blue shift in the light; and orange poppies do the same with golden light. So it's not all bad; you just want to be aware of the color shift that occurs with the color of light, and make creative decisions based on that. If you don't shoot in RAW, changing your white balance makes sense in the camera rather than the computer later.

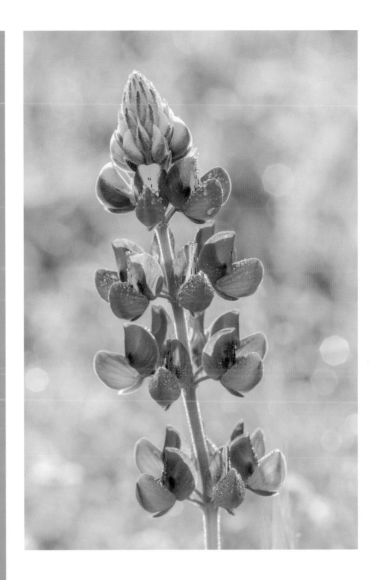

ABOVE:
The feeling of delicate beauty is all around me in a summer's meadow. Although many flowers are deeply colored and vibrant, I wanted to express the more ethereal, light feeling of this backlit lupine, so I adjusted the image in the computer to be more pastel. Thought not a technically correct exposure, it's definitely more expressive.

70–200mm lens at 100mm, f/16 for 1/50 sec.

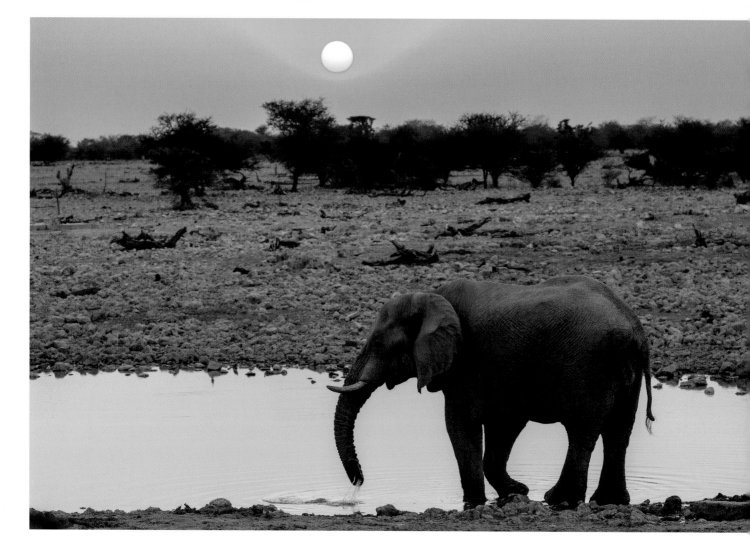

ABOVE:

Is it too clichéd to finish off the chapter on light with a sunset image? I don't think so. The color of light plays an important role in expressing an emotion of a picture. Here, the end of a day at the waterhole in Etosha National Park in Namibia typically means watching a richly hued ball of sun going down, through the dust layers, and that lowered contrast allowed me to capture a reasonably easy exposure to process for both the sky and the shaded side of the animal. I waited for the elephant to pull its trunk out of the water for a strong moment.

📷 *150–600mm lens at 150mm, f/7.1 for 1/400 sec.*

OPPOSITE:

Although not a pure image of nature, who could resist capturing a scene like this while driving in the early morning through freezing temps along western Utah's farmland? I couldn't. The field irrigation had apparently been running for some time, and was still running when I approached the field. Actually I screeched to a halt when I drove past and saw what was going on. I composed the scene and waited for the water drops from the spray to reach my field of view, and pressed the shutter. I kept pressing the shutter each time the water sprayer would enter my field of view, and I varied the shutter a little bit to get different effects. At one point I noticed that my LCD images looked very cold, and realized that my white balance was still set to about 3600 Kelvin from the star photographs I had done the evening before! But in the end it was a "happy accident," because I really liked the scene cooler rather than warmer, which it was from the morning sun. While one may be more "correct" or accurate, the cooler temperature version for me expresses the cold of that morning and why ice was forming.

📷 *150–600mm lens at 350mm, f/14 for 1/500 sec.*

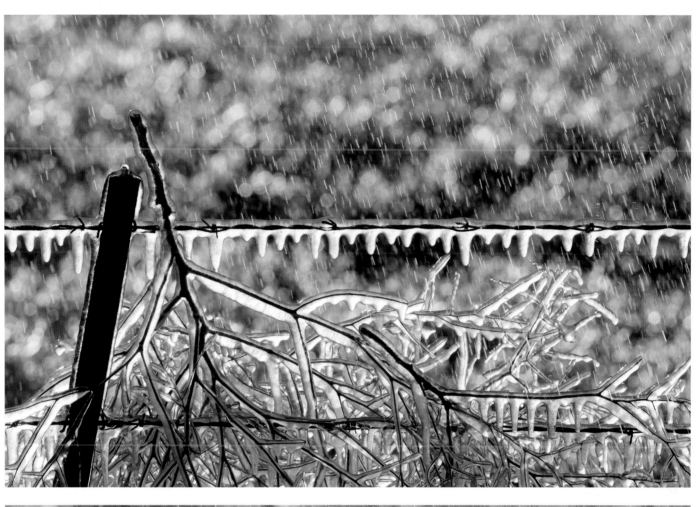

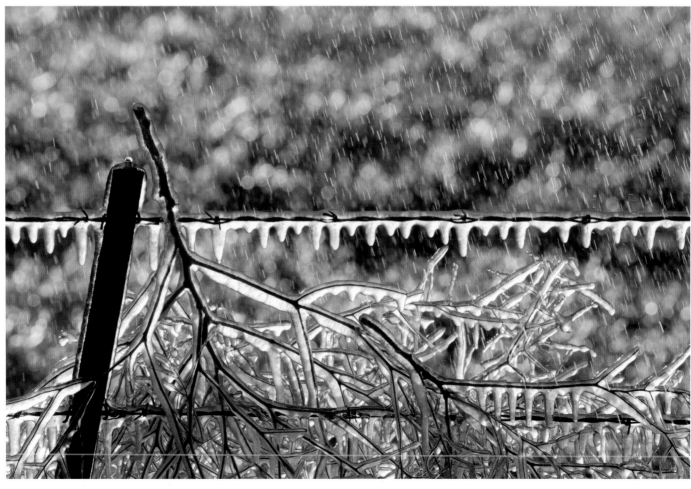

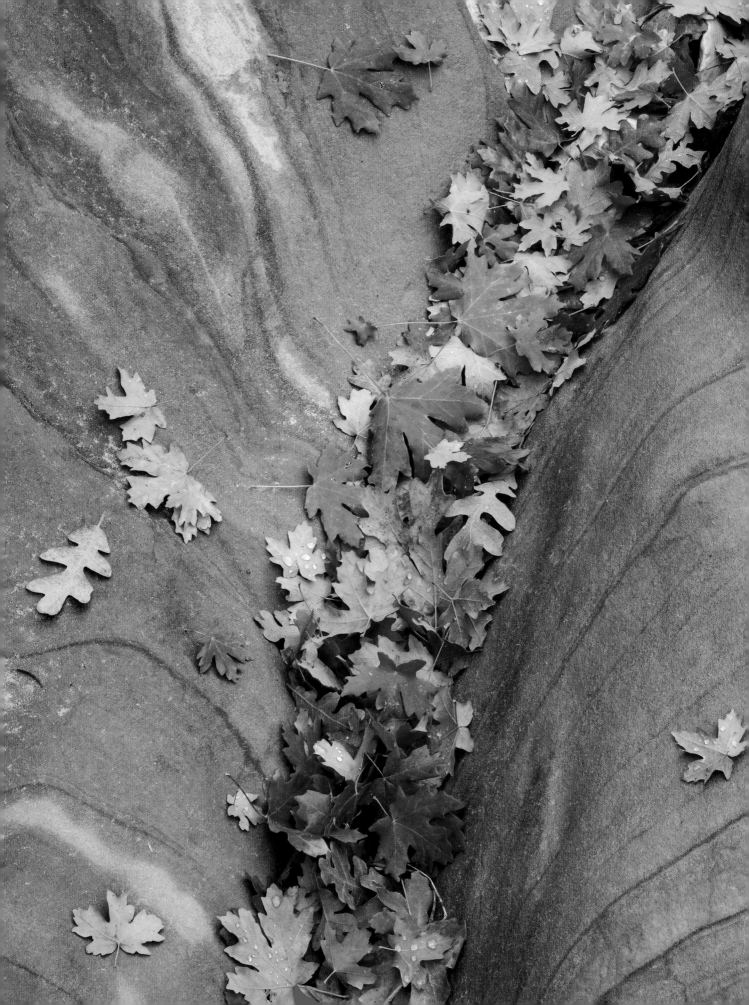

CREATING VISUAL FLOW

"Learn the rules like a pro, so you can break them like an artist."

— PABLO PICASSO

Composition, or the visual flow of a photograph, creates impact, draws attention, and engages the viewer. Composition involves choosing a strong point of view, and positioning yourself so the main elements in the frame are working together to guide the viewer's eye through your image. A weak composition, no matter how great the light or moment, will fail to capture interest and engage your viewer.

Creating visually compelling photographs with composition is actually more important than content—composition is about *arranging* that content in the most impactful way.

OPPOSITE:
Water carving through rock over the ages created this natural depression and S-curve in Zion National Park, Utah. When autumn leaves drop, they naturally gather in these low areas when pushed around by the breeze. Mother Nature created this story for me to discover, then she rained on the scene just a little bit to add water drops!

📷 *18–55mm lens at 83mm effective, f/18 for 1/10 sec.*

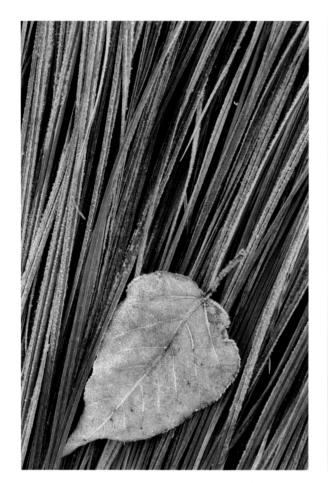

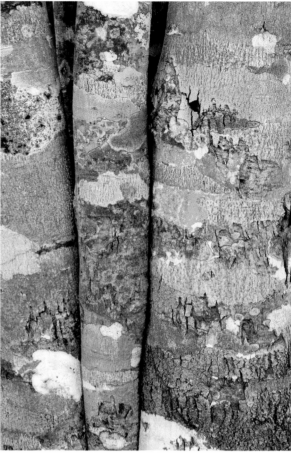

Exercise: Practice Composition

As a simple exercise, collect a rock (about the size of a potato), a tennis ball, and a salt shaker. It really doesn't matter what you choose, as long as the objects are somewhat similar in size. Set up your camera, and put the objects on a table, and spend some time moving the objects around, pushing them closer together, putting two on one side and one on the other, and pushing them closer to or farther away from the lens. Notice how when their relationship to each other changes, the impact of the view through your camera also changes.

ABOVE, LEFT:
Walking around in high-country meadows of Yosemite National Park on a frosty morning in autumn yields photographic treasure. I spotted this frosted leaf and grasses and was on my knees in an instant. Using my macro lens, I fussed with the composition until I found a compromise that worked for me, placing the leaf low in the frame, and on an angle, which also then angled the grasses a bit more, too. I didn't dare try to move the leaf! I once tried and realized, of course, that this will melt the frost in an instant, and there goes the photo opportunity.

📷 *100mm lens f/16 for 0.4 sec.*

ABOVE, RIGHT:
Nature is wherever you find it, and I found it in this interesting tree at an old coffee plantation in Cuba's countryside. I loved how the central trunk appears squeezed between the others. The diffused light brought out the form of the trunks, and the pattern of the bark was amazing, too. With more time, I would have made a dozen different close-up compositions of these trees! We didn't have tripods with us, so I used the effective technique of stretching my camera out to tighten the neck strap to create tension. Even with image stabilization, I wanted to ensure sharpness, and I captured several sharp frames this way.

📷 *24–105mm lens at 80mm, f/11 for 1/40 sec.*

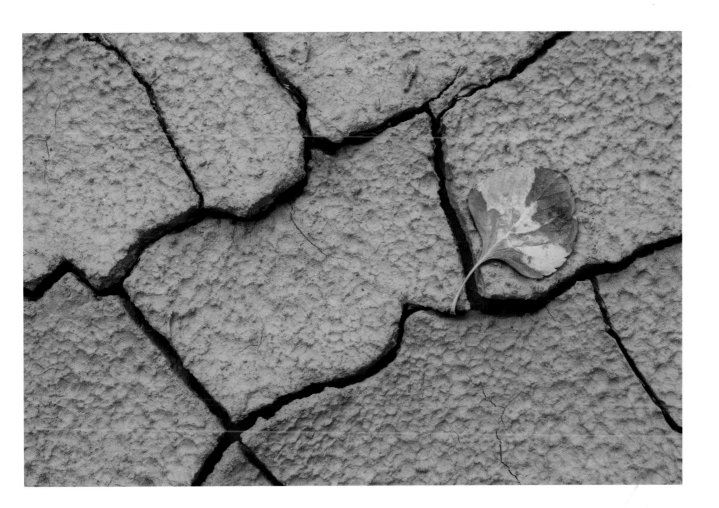

THE VALUE OF PRE-VISUALIZING

Unlike artists who begin with a blank canvas and add elements to create a painting, photographers begin with a *full* canvas, and have to take away what we don't want, as much as is feasible. The picture is, in most cases, not given to us as a perfect composition. We have to find it in the chaos of the scene. We need to pre-visualize, taking a visual inventory of what we have to work with, as our eye moves around the scene. Make note of the waterfall, the boulders, the mountain, the trees, yet rather than looking at them for what they are, look at them for what they represent: lines, shapes, colors, textures. Visualize how those elements can work together in a composition and how they relate to one another as you change your point of view. Look at the scene from the standpoint of perspective (depth) and scale, too. Remember that everything

has a visual weight, and balancing your composition with the right proportion of shapes can help make it more effective.

Getting beyond the literal aspect of the elements takes some practice, but you will learn to see more creatively if you can learn to look more abstractly at the scene before you. Imagine a scene with trees on the left in the middle ground, a stream flowing from the

ABOVE:
The cracks in this drying mud puddle were dramatic, and as I was photographing the pattern, I noticed this tiny leaf that was changing from yellow to orange, essentially matching the color of the earth it was decaying into. I positioned my camera to use the cracks as leading lines to bring the eye to the leaf. The oblique angle of the lines adds a dynamic energy to the composition.

📷 *24–105mm lens at 105mm, f/16 for 1/4 sec.*

front-left toward the background right, a mountain in the not-too-far distance, moss-covered rocks in the foreground. As you take inventory of all these things, you can also see that the trees are lines, the mossy boulders are circular shapes, the stream is a curving line, the mountain somewhat of a triangle, and the sky, well, it's a shape, too. Pre-visualizing, you decide that the pretty boulder-lined stream is a great curving line to lead the eye to the mountain and blue sky with clouds, past the aspen trees on the left.

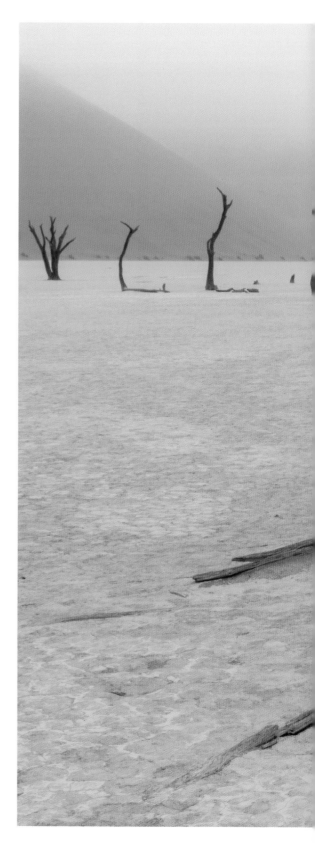

 TIP

I find pre-visualizing to find my composition is pretty easy after years of practice, even without looking through the frame of the viewfinder. But if you are struggling to see the possibilities, make a 4x5 frame from mat board or a plastic notebook cover and cut an opening that matches the ratio of your camera's sensor and is big enough to look through easily. Use this as a framing aid as you walk around. By looking through the opening, you are isolating your view and reducing distractions. This can help you see the potential for a composition. After a time, you'll learn that when you hold the card at various distances, it corresponds with certain focal lengths.

RIGHT:
This area in Namibia's desert had been a lake, but as it dried up, the trees died. The lack of humidity in the air has preserved them for hundreds of years. I wanted to express how these trees had lived, by spreading out their roots to take in water. I took a lower point of view, deliberately cutting off the top of the foreground tree to keep the emphasis more on the roots. I placed the tree just off center, as this actually gave the image more impact. I kept the horizon line in the background higher in the frame to offset the close-to-center foreground tree. The morning fog added an ethereal mood to the scene, perfect to describe the spirits of the trees.

📷 *24–70mm lens at 54mm (effective focal length), f/18 for 1/10 sec.*

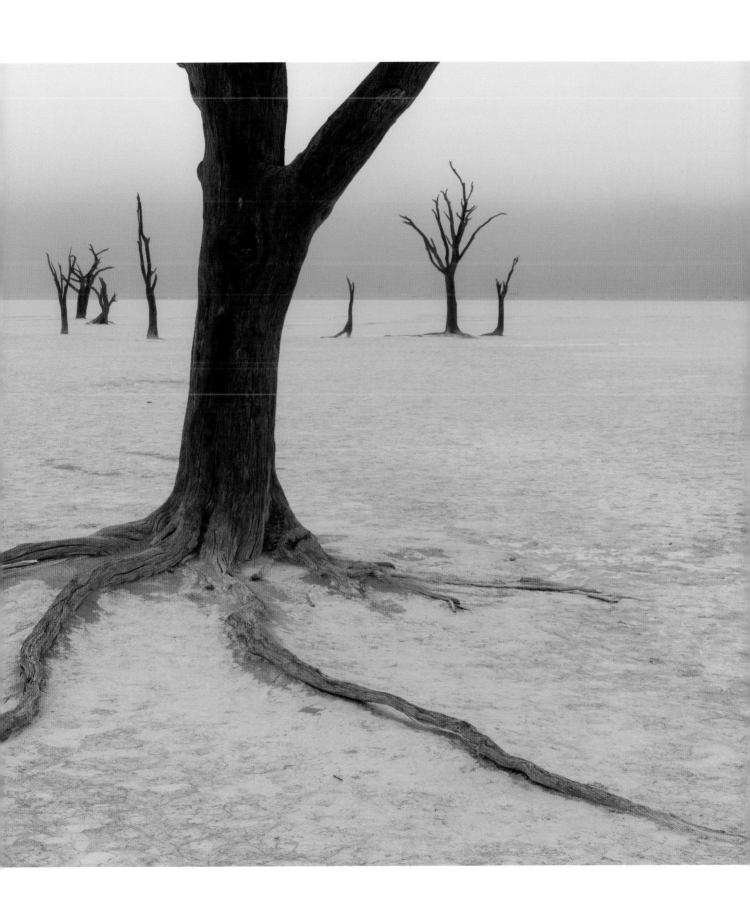

 # Left- Versus Right-Brain Thinking

I've heard it all in the critique sessions at my workshops. "I thought I had the whole flower in the frame," or "I never saw that tree jutting into the edge." The list goes on. When caught up in the moment of passion for what we are seeing or experiencing, we sometimes forget that we now have to work to express that effectively by carefully composing the scene, which means we first have to compose ourselves and get into the left-brain mode of arranging the frame. So let's take a look at what happens when we see a scene:

Right Brain: *Wow, look at that beautiful flower! I love the color, the texture of the petals, look at the bee covered in pollen . . . oh, look at the S-curve in the sand dunes!*

Left Brain: *Um, let's see, so I have to get the right white balance to be sure the color looks good; and I need to get the right position for the angle of light to bring out the texture, and choose an aperture that will give me depth of field so the bee and the flower are sharp, and yes, better make sure the shutter speed is also high enough to freeze any wind movement or bee movement or camera shake! Better use a tripod, should I raise my ISO? Do I need a diffuser? Remote release cable? How's my exposure looking?*

When the left side of the brain feels it's finished with the technical process, the picture is ready to be made. One last look around the frame edges for visual intruders, and we press the shutter. Have we, at that point, lost the magic of the moment? Not if the technical process becomes second nature, and that goes back to the concept that photography is a marriage of your vision and the craft of making the picture. Perfect your craft, and you'll be able to celebrate the moment, light, etc. (i.e., stay in the right brain) more. An internal dialogue occurs with all photographers. It just works that way. If you want to express more creative vision, learn to spend more time in the right side of your brain.

Left/Right Brain Characteristics:

Left	Right
Analysis	Imagination
Logic	Creativity
Linear	Intuition
Math	Arts
Language	Rhythm (Music)
Facts and Rules	Feelings
Thinking in Words	Visualization

As this chart shows, the left brain is busy working out the how, where, and what of making a picture, while the right side is effusing over the wonderfulness of it all. As you learn to use both sides of your brain, you'll make the best pictures.

OPPOSITE, TOP:
While hiking in the Swiss Alps, we were treated to amazing landscapes, and occasionally very cool clouds. I love how these reach out expressively to the right of the peak, telling the viewer that they were formed as the winds moved over the snowy peak.

📷 *70–200mm lens at 286mm (effective focal length), f/10 for 1/1600 sec. (exposed to the right)*

OPPOSITE, BOTTOM:
The oblique lines of this sandstone wall would dominate in terms of space in the composition if it weren't for the leaves on the lower pile that break them up. The leaf at upper left serves as a counterpoint to the pinecone in the leaves below, and a little visual tension is generated because of it.

📷 *55–200mm lens at 174mm (effective focal length), f/14 for 2.3 sec.*

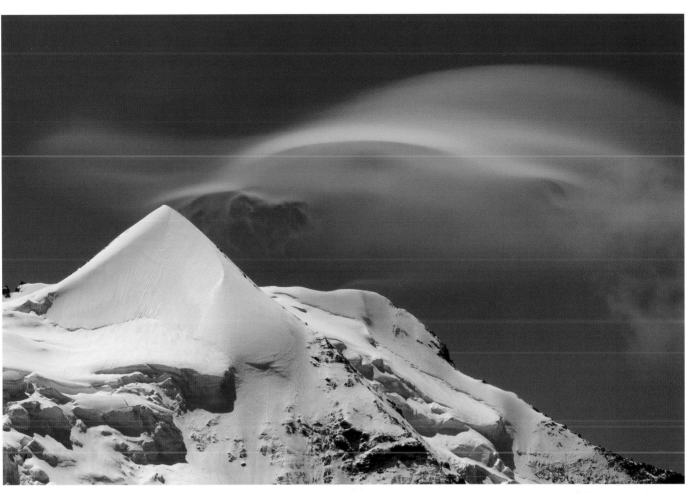

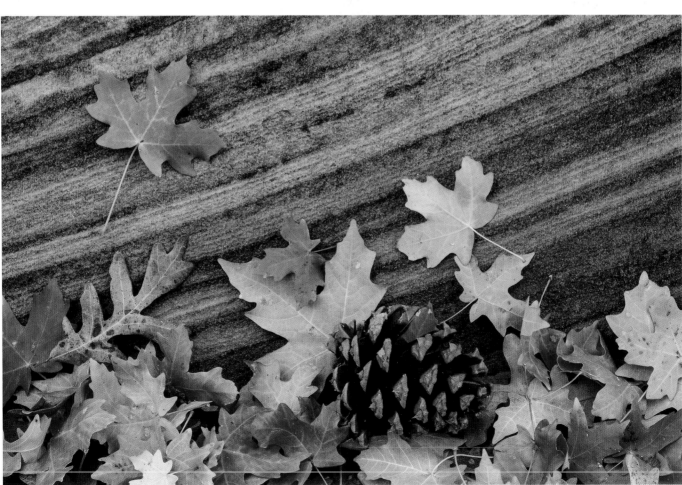

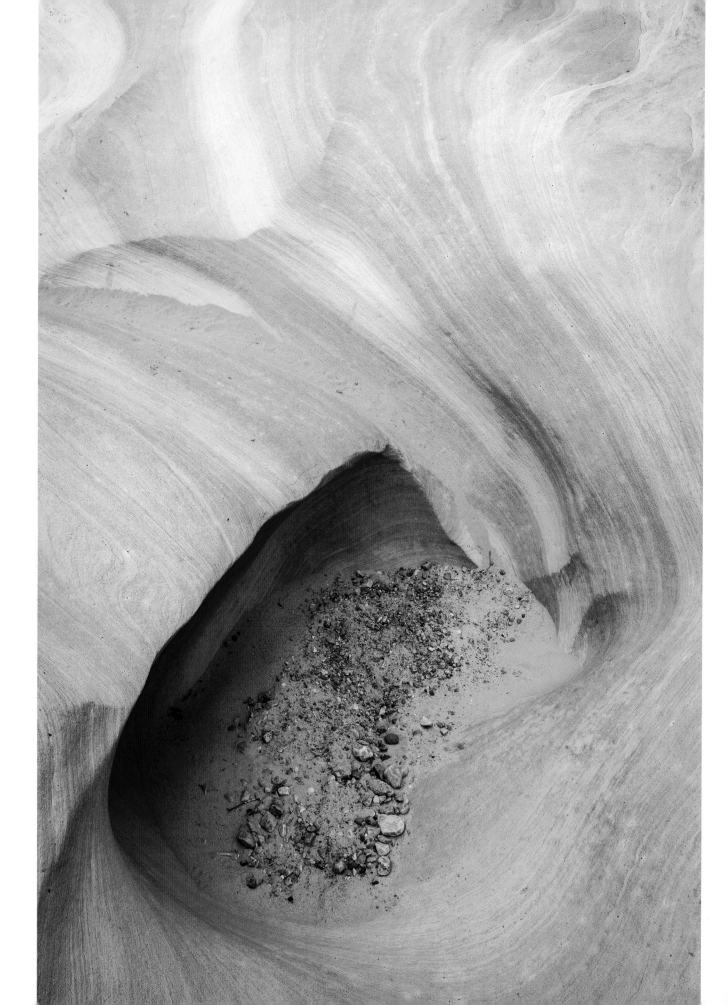

SUBJECT PLACEMENT

Mother Nature has done a great job overall, but she's still a little like some chefs in a home kitchen: focused on the ingredients but not necessarily the presentation. As you get down to the serious business of composing, it's just a matter of fine-tuning by paying close attention to the elements, how they play or don't play off one another, and how the eye moves through the scene. Boulders might block the foreground of the stream, or merge with the trees; maybe the boulder should go on the right, or the left. Mergers, visual obstacles, edge intrusions, and the visual clutter that is often present in nature must all be addressed.

Way back in history it was found that a 2:3 ratio of elements, or proportioned space in the frame, is very pleasing to the eye. This concept eventually evolved into the "rule of thirds" as photographers know it today. Put simply, if landscape photographers want to emphasize a wonderful sky, they devote two-thirds of their composition to sky and one-third to the land beneath it. The rule works to create strong, dynamically balanced compositions, and a rule of thirds concept is still prevalent in photography.

You are, however, often remembered by the rules you break: Fresh viewpoints and creative expression come from breaking the rules, and you'll probably want to stray from the rule of thirds to create more tension and interest. But as you play with composition, try this: Imagine your scene with a simple tic-tac-toe grid of lines overlaying it; in effect you'll be dividing it into nine squares, with three rows of squares horizontally and three rows of squares vertically. Where those lines intersect are positions of significance; you'll see that placing something on or very near these positions creates a stronger impact.

Beginners often fall victim to *centeritis*, a disease of centering your main subject in the frame. Even when you *know* you shouldn't, it's easy to rely on the center spot in your viewfinder for auto-focusing. Unless you consciously recompose after focusing, when you press that shutter your subject will be in the middle of your frame. The resulting image is static, because the space around your subject is too even.

You'll create greater visual impact when you place your main subject off center in the frame, especially on or near one of the intersections of the grid. But to get your subject out of center stage, you'll need to focus manually or move your focus point in the viewfinder to be on or near one of the intersecting points of the grid.

The goal is to produce a stimulating picture, and asymmetrical placement helps to do that. As a guideline, consider this: If there is information around the subject that helps tell the story, then lead the viewer's eye over that information on the way to the subject to tell the story. Conversely, if you visually hand the viewers your subject as soon as the eye enters the frame, they might not have a reason to go beyond that point, and the rest of the frame is underutilized, or wasted.

OPPOSITE:
The swirling sandstone of a unique area within Valley of Fire State Park in Nevada is a photographer's paradise. In this one wash, the swirling lines lead the eye down to the waterpocket, now filled with sand.

📷 *24–105mm lens at 32mm, f/16 for 1/10 sec.*

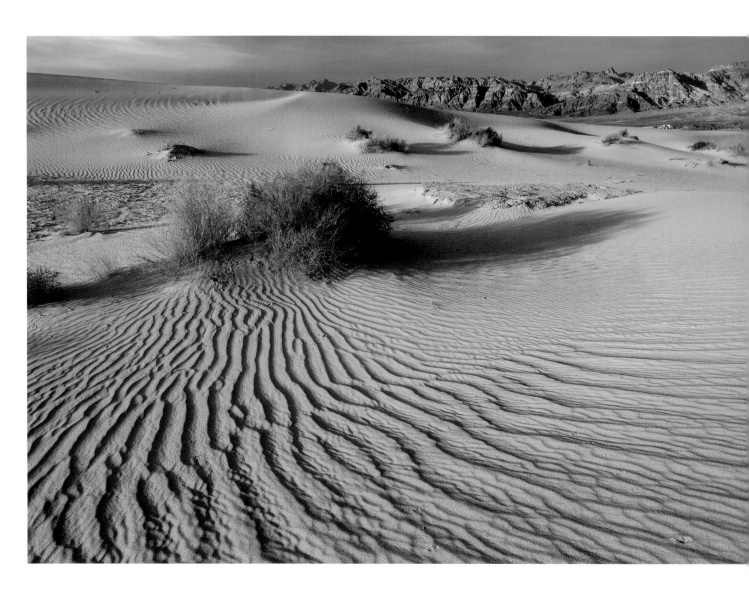

 ### Exercise: Evaluate Composition

It's important to experiment. For each of four pictures, try putting the same object in one area of the rule of thirds grid and see how it feels. You will see the impact this has on the composition right away in the viewfinder, but take the pictures and evaluate them later, to really study the effect each position has on the composition. Soon, you'll find it easier to decide on the position that just feels right in your gut for each situation.

ABOVE:

Leading lines are a great way to guide the viewer's eye into your image. Low-angled afternoon light defined the wind-sculpted ridges of the dunes, creating numerous lines that swept toward the bushes in the middle. These serve as strong lines to invite the viewer's eye to enter the picture and go toward the bushes, as all lines lead us there in a sweeping fashion in such pretty light. Once at the bushes, you find yourself wandering up and down dunes, checking out the light and shadow.

📷 *24–105mm lens at 24mm, f/16 for 1/13 sec.*

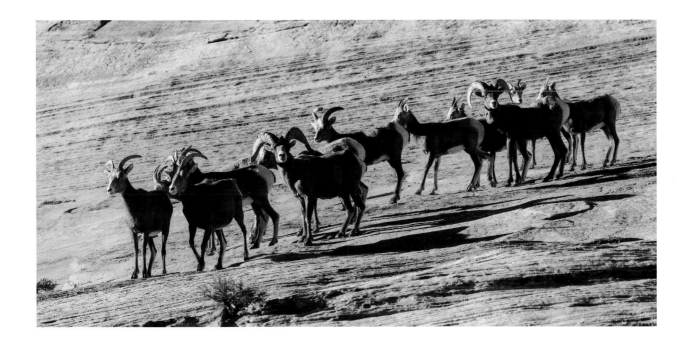

THE ELEMENTS OF DESIGN

Line, shape, pattern, and texture add visual strength to your composition, so use them whenever you've got them. These design elements contain powerful symbolism, too, which inherently adds to the picture.

LINE

Lines help create structure in a photograph. They can direct the eye through the frame and can create an exciting dynamic to the photograph, though they can just as easily lead the eye astray! Consider how the eye moves along any obvious lines in your scene when composing. Used well, lines can create an exciting dynamic in the photograph.

There are essentially just two types of lines, curving and straight. Curving lines are less direct than straight lines, and maneuver you through a scene more gradually. They express a more relaxed purpose and energy. Straight lines take you directly from one area of the frame to another, and express a stronger purpose and a more rigid structure.

With straight lines, you can have a horizontal, vertical, or oblique angle, and each orientation has a different attribute of energy to it and evokes a different emotional response. Horizontal lines express calm, stable emotion. The flat horizontal line where sky and ocean meet is peaceful. The division of land and sea is a horizontal line, as is the horizon on a prairie, or across flat agricultural fields where they meet the sky. When framed horizontally, this division emphasizes the breadth of the scene, making it feel wider, and more expansive. If you want to create a little more tension, place the horizon

ABOVE:
This herd of bighorn sheep in Zion National Park was waiting for the crowd to disperse, so they could cross the road. But that's what made us all stop: Seeing this many sheep at once was so exciting! They stood on this angled slope of sandstone, watching us warily. I like how the lines of the layers of sandstone added a visual support to the oblique line of bighorn sheep. I cropped this image to emphasize that. Though not a steep angle here, just a slightly sloping line in an image can add energy. The lower angle of light added a texture to the scene.

📷 *150–600mm lens at 226mm, f/8 for 1/1000 sec.*

higher in the frame to give the land or sea more emphasis over sky. Or, consider framing the scene vertically to constrain the spread of the horizon.

Vertical lines express more energy than horizontal lines do. They evoke ideas of strength and power. An upright tree expresses more strength than a tree lying on its side on the ground. Straight, vertical lines appear throughout nature—in waterfalls, birches, aspen, lodge pole pines, stalks of flowers, grasses, basalt columns, and icicles. When framing a vertical line, or series of them, you can impart a sense of strength and height by the proportion you give the line or lines in the frame.

Oblique lines impart a strong energy and can direct the eye rapidly through a scene. An oblique line appears as a vertical line that is falling or has been knocked off balance, and that imbalance creates visual tension. With such strong energy, oblique lines can dominate a composition, so you need to take care with including them. Consider a stand of trees in which one tree has fallen and is leaning on the others. The visual power goes to the leaning tree because of the oblique angle of it, and because it stands out in contrast to the others. If that isn't your intent, then you will have to consider a different composition to eliminate that oblique line. The sharp edges of steep sand dunes, the outlines of mountain peaks, and crepuscular rays in the sky are other examples of oblique lines occurring in nature.

Curving lines provide an organic, relaxing way to move through a scene. They possess a calm energy,

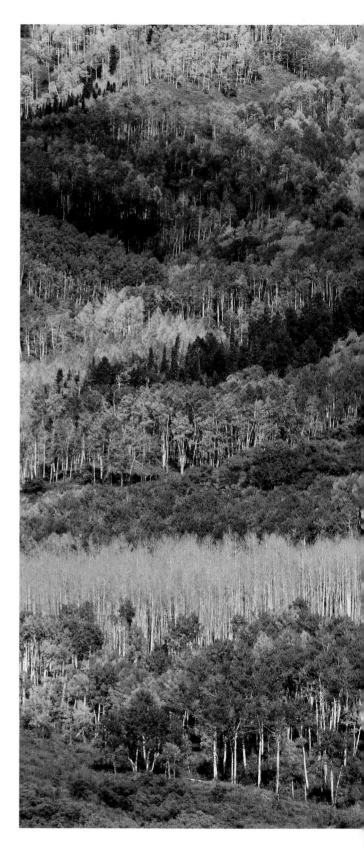

RIGHT:
The bands of bare trees in these groves of aspen create visual pathways that take you from left to right in the scene, up over hills and down. The bands are wide pathways, made up of a lot of vertical lines. There is visual movement to this scene, because of the way the bands of trees divide up the space, and the design is strengthened by the repetition of the thin vertical lines within each band of trees.

📷 *70–200mm lens at 176mm, f/11 for 1/60 sec.*

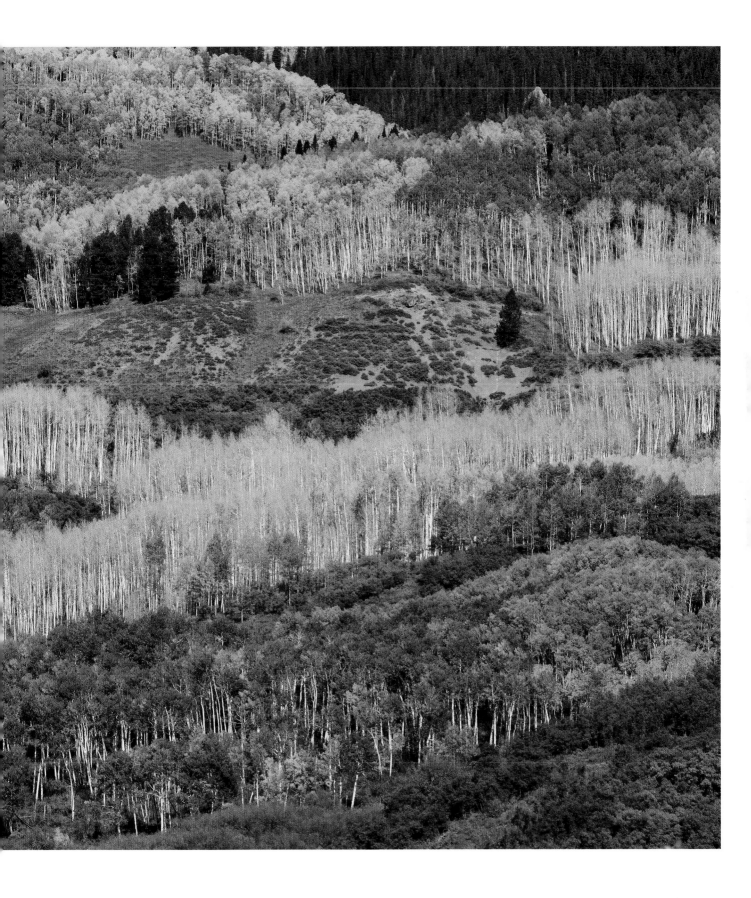

and they gently move the eye through the composition. Like a meandering river, a curving line can evoke calm and peacefulness and is often sensual. A curving line needs room to move in the composition so that the line undulates enough to express its emotional qualities. Curving lines are especially appealing to us because they remind us of the human figure. When you begin to look for curving lines, you'll find them everywhere, even if the curve is very subtle: in the gentle S-curves of rivers and streams; in the sensual lines of rolling hills and sand dunes; in the curve of a flower petal and the way grass bends under the weight of water drops.

ABOVE:
The dark volcanic rock served as a strong contrast against the desert gold sunflowers backlit by the afternoon sun. Growing in erosion channels where the most water gathered during rains, they spread down the slopes of the hill in repetitive oblique lines. To visually compress the distance between the rows, and emphasize the lines, I used a telephoto lens. The yellow color adds energy along with the strong oblique lines the flowers created.

📷 *150–600mm lens at 350mm, f/16 for 1/40 sec.*

OPPOSITE:
Nature has some wonderful vertical lines. This ephemeral waterfall in Zion National Park in Utah created a beautiful opportunity for me to express the scale of the tall cliffs towering above the valley floor and the cottonwoods below. The line of the falls is a connecting thread between the cliffs and cottonwoods, and mimics the lines in the desert varnish.

📷 *24–105mm lens at 65mm, f/14 for 0.4 sec.*

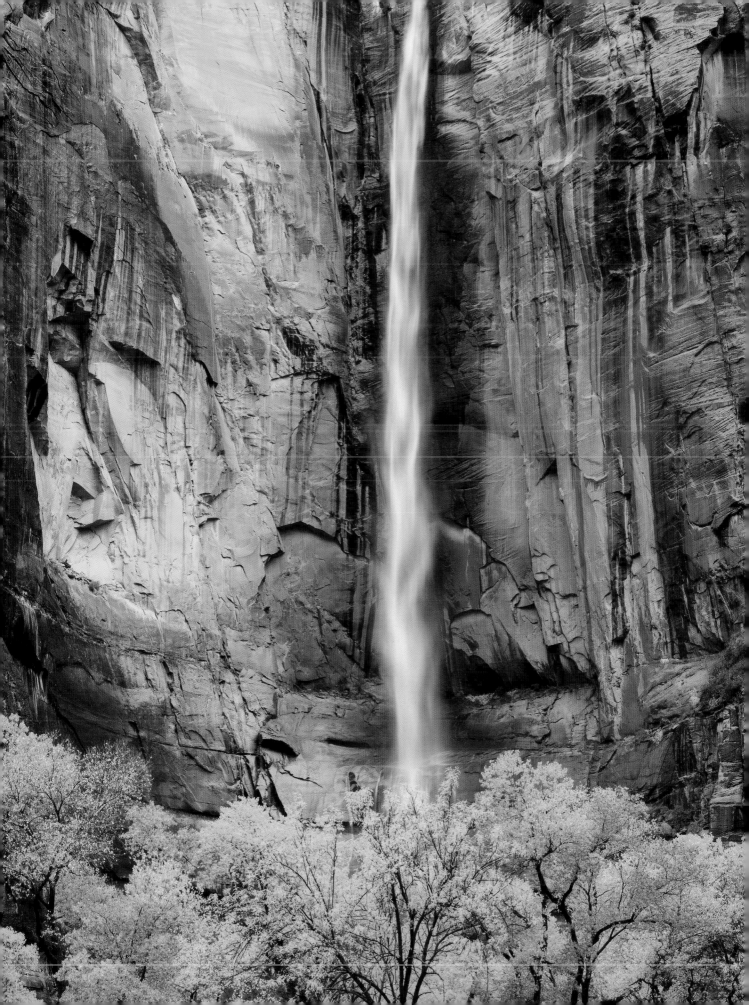

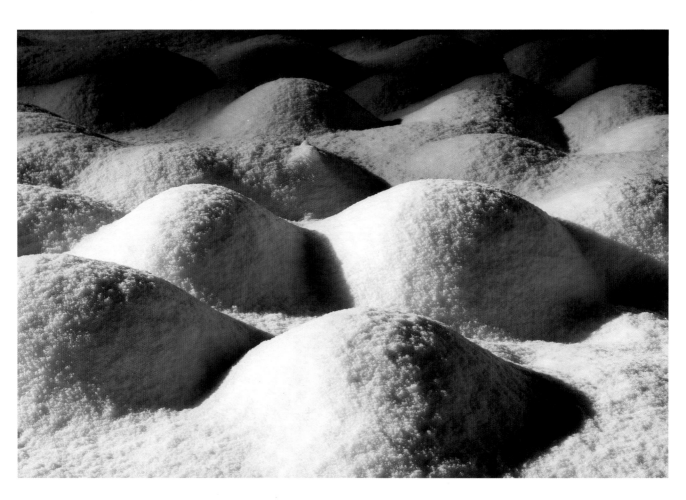

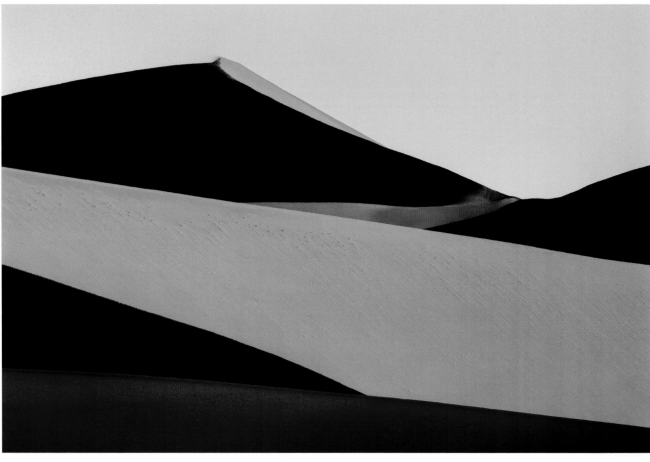

SHAPE AND FORM

As you compose a photograph, you will learn to move beyond seeing trees, sky, rocks, and ponds as literal objects and see them instead as shapes. For example, a boulder is a circle, essentially, and a tree is a line. A bald blue sky is negative space, as is an expanse of water. All these shapes need to be considered as visual elements when composing a picture. Once you can do this, you'll find you can control the balance and proportion of your composition more effectively, creating a stronger picture. A repetition of shapes can create visual interest, and that's when pattern and rhythm can develop. Shapes carry strong symbolism, too, and the shapes that dominate your composition will play a role in defining the tone or feeling of the picture. Square shapes, such as the blocky rocks along a coast, can express solidarity and structure. Triangular shapes, such as mountain peaks, represent strength and endurance. The triangle, in fact, is one of the strongest structures. Mountains are triangles, tapering from a wide base and becoming narrow as they poke up into the sky space, expressing a focused energy and often an imposing nature. Overlapping steep hills or dunes can create triangular shapes if light and shadow are strong, and those shapes express a powerful emotional energy. Circles, when unbroken, represent wholeness, and are quite common in nature, from the eyes of birds and animals to water bubbles and raindrops to pebbles.

Form is the three-dimensional representation of an object, and it's defined by the light and shadow on it. We know a boulder is round by the gradation of light to shadow as it wraps around the rock, if the subject is side lit. If the subject is front lit, our objects may not have any dimension, and they will appear flat in the scene, more like a shape than form. Lighting defines the curve or roundness of a tree trunk or an apple hanging on a branch, and light and shadow define a blossom and the form of an animal if the light is even slightly at an angle to the object.

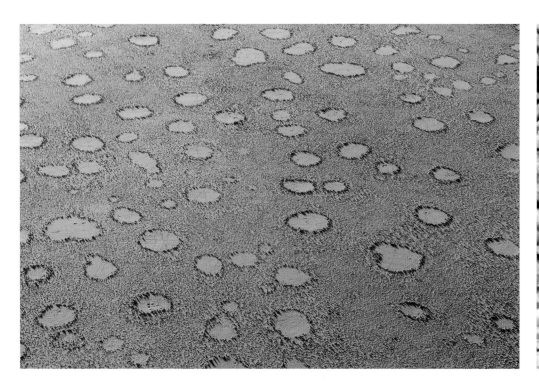

PATTERN AND RHYTHM

Pattern forms whenever you have repeating lines, shapes, or forms. Pattern is probably the most common design element present in nature. Take a walk and notice how many patterns you see in the flowers, leaves, bark, and clouds in the sky. While technically a pattern is defined as the repetition of three or more similar objects or shapes, the strongest patterns emerge when there are many more repetitions within the frame. It's best when there is one singular element, such as shape, that repeats; the more similar the shape, the stronger the pattern. Yet there are no rules here; it's simply fun to find and photograph pattern.

When pattern develops enough measured repetition, it can begin to express a visual rhythm. This only occurs when the repetitions of the pattern are an equal, measured distance, or beat, apart. The pulses of waves on the ocean, mud ripples on the beach, wind ripples on dunes, even altocumulus clouds can create rhythm.

ABOVE, LEFT:
Aerials offer an incredible view of nature's designs on the surface of the earth. While flying over the Namibia desert, numerous "fairy circles" created an unusual pattern that I wasn't expecting to see. The scale of the scene is hard to imagine because of my altitude. However, this makes the pattern stronger as I could include more repetition of the circles. Scientists are still debating what causes these areas devoid of vegetation, but all I know is they make for great photographs of the desert from the air.

📷 *24–70mm lens at 76mm, effective, f/8 for 1/800 sec.*

ABOVE, RIGHT:
These tiny mosses were in bloom and created a great pattern study in miniature. Using my macro lens, I was able to focus in very close to fill the frame with the tiny plants. Composing like this so the pattern appears to continue creates a stronger visual impact, especially in a close-up or intimate landscape. With the pattern extending beyond the edge of the frame in all directions, we imagine that it's larger than it may be in reality, and that suggestion of there being more gives the picture greater impact.

📷 *100mm macro lens f/16 for 1/10 sec.*

RIGHT:

The cones of a white pine tree, overlaid by fallen needles, create both pattern and texture in this scene. It can be great to have something to disrupt the pattern, as the piece of lichen does. The lichen strengthens the impact of the pattern of cones and gives the eye a place to rest in the composition. Sometimes a pattern is too strong graphically to view for very long, and the eye needs a break like this. Plus, the anomaly creates interesting contrast. An additional element of line in the pine needles also created a little pattern of its own in this many-layered picture.

📷 *24–105mm lens at 105mm, f/16 for 1 sec.*

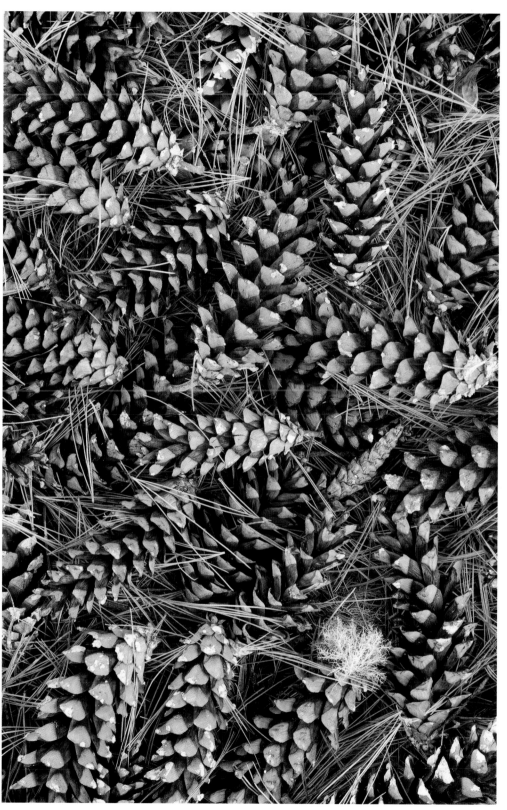

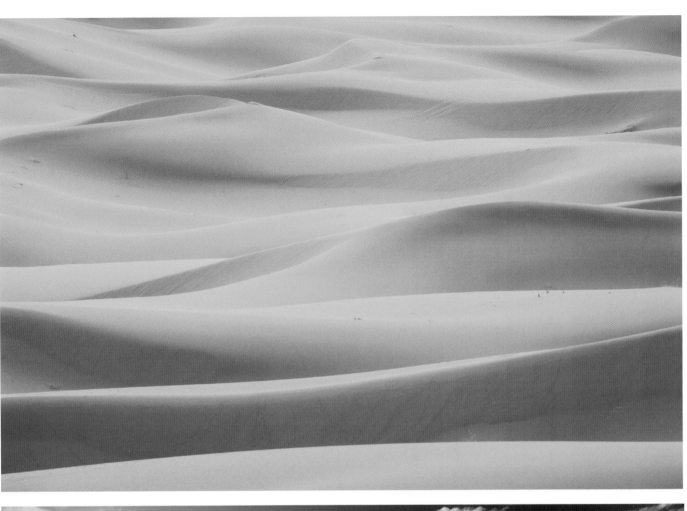
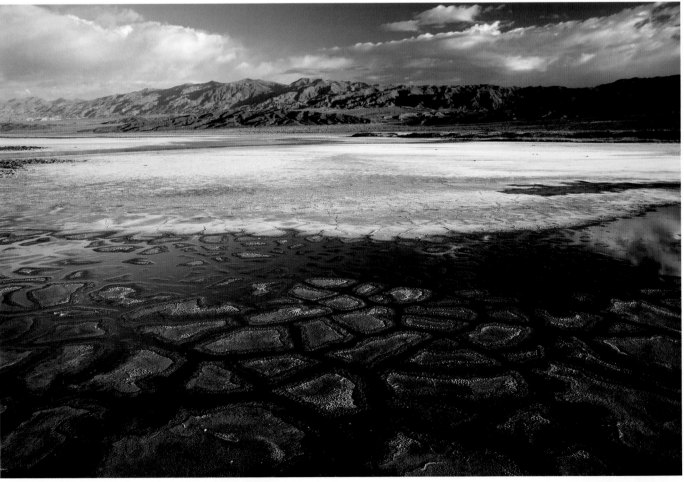

OPPOSITE, TOP:

Although photographers often think of pattern for a detail or intermediate landscape, pattern can also add impact to a landscape. The dunes in the Sahara desert within Morocco were a soft apricot hue on this hazy morning. We had climbed a tall dune hoping for a great sunrise, but the dust was just too thick for dramatic light, so we sat and enjoyed the view until it got light enough to see what else we could photograph. I loved how the dunes, slightly below me now, rolled out sensually into the distance. I composed so that this pattern of undulating dunes filled the frame. With all the repetition of the dunes, a rhythm had begun developing within this picture.

55–200mm lens at 300mm (effective focal length), f/13 for 1/20 sec.

OPPOSITE, BOTTOM:

The salt marsh in Death Valley National Park was just beginning to dry up when I was visiting, and the salt was emerging from the ground and creating these unusual and interesting shapes in the mud in front of me. I wanted to emphasize this pattern within the larger landscape I was creating, so I angled the camera downward to emphasize my foreground.

24–105mm lens at 28mm, f/16 for 1/15 sec.

ABOVE:

Duckweed and water lettuce covered the surface of the water in a wetland near Delray Beach, Florida, and made such a great pattern. I liked both plants, but the bigger one is what created the strong pattern. If the pattern is the main subject of the landscape, then allowing it to spread out past at least two edges of the frame will create a more compelling photograph.

24–105mm lens at 105mm, f/14 for 1/13 sec.

 TIP

Use a viewing loupe. I can't live without mine! On sunny days, the loupe allows me to block the extraneous light and view the LCD so I can check focus as well as the composition for distracting elements.

TEXTURE

The texture of objects and scenes in nature add to a photograph because they evoke memories and often a strong emotional response. We know what the fur of a rabbit or favorite dog feels like, or blades of grass and beach sand. We know which textures feel smooth, rough, wet, and dry. To show texture and elicit these responses, it's necessary to show the contrast of light and shadow. Texture is accentuated when a low angle of light skims across the surface of the scene or object, defining all the grooves, ridges, such as the rocky surface of the desert or grasses in a meadow. The more direct the light, the more pronounced the texture might be—direct sunlight can express the roughness of dried mud or sandstone. Not all textures require full sunlight and high contrast. Some work just as well in diffused light, as long as there is still enough contrast to produce shadows.

OPPOSITE:
The repetition of the curling bark on this madrone tree in the hills near my home in California created a wonderful pattern *and* texture to photograph. The opposing colors of red and green, though they're not pure, create a color contrast that is pleasing, and the random nature of the curling creates a loosely structured pattern. Even with diffused light, there was enough shadow to give the bark dimension, lifting it visually off the smoother background bark, which created the effect of texture. This was just one small branch on this tree—you can imagine what the rest of it looked like!

📷 *55–200mm lens at 234mm (effective focal length), f/6.4 for 1/45 sec.*

ABOVE:
Texture is not all about intimate or close-up views. It can be suggested on a grand scale, too. Here, backlight made all the colorful leaves pop against the darker fir trees on this hillside, and that creates an implied texture in the image.

📷 *70–200mm lens at 200mm, f/8 for 1/80 sec.*

POINT OF VIEW

How do you "arrange" things in nature photography, when Mother Nature seems to have already done that? By choosing a strong point of view. Your position, or point of view, is essential in conveying the story or feeling you are trying to express in the picture. This is where you get your physical exercise! By moving in (*not zooming*, but moving, with your two feet) you can effect great changes in the composition. This might mean finding a higher or lower position by climbing on a rock or a small hill. I like to carry a short stepladder with me to get an elevated viewpoint (provided I'm not too far away from the car). If you come across a field of tall sunflowers, for example, all you'll be able to capture from standing height is the first row. But if you can get higher, you can capture the field of flowers as they spread toward the background, a much different picture.

ABOVE:
A low point of view adds to the feeling that the owl is just peeking over the berm to check me out, and it was. I deliberately kept the foreground out of focus to enhance the visual effect of being at ground level, and positioned the owl just left of center. It doesn't make sense to put the owl way off in the perfect rule of thirds position, as that leaves too much empty space on the right.

📷 *150–600mm lens at 600mm, f/9 for 1/800 sec.*

OPPOSITE:
Getting on the ground and looking up at tall things such as trees is a great way to express height, even if you are stretching the truth! This exaggeration is what makes the picture more expressive. Using a wide angle, I got low and close to this aloe, known as a quiver tree, to show it stretching for the sky against the beautiful clouds that morning. The sidelight brought out the texture and the form of the tree. Point of view like this creates an expressive photograph.

📷 *16–35mm lens at 16mm, f/16 for 1/40 sec.*

Position your tripod higher or lower, to present a different point of view. It always amazes me how many people use a tripod at standing height, as if it were made for only that position! Get low, and look up, to exaggerate the tallness of a tree, or even an animal, if you can get that close. Or get up above, and look down on bear tracks in the woods or patterns on the beach.

Elevated positions allow you to minimize the background and present a viewpoint that is often clean and simple. A higher point of view can also make a subject appear smaller, foreshortened in the lens, if you point the camera downward at an angle. Getting in close to an object will emphasize its size and significance within the frame, changing the effect of the arrangement. Positioning above an object while close to it, and angling the camera downward, presents a much different effect than a low-angle view across the object. As you hop around the location, your point of view can transform a scene, and you might find several compositions that you like in one spot.

SPACE IN COMPOSITION

Negative space is more important in a photograph than many photographers realize. Too much negative space and the subject gets lost; too little, and your subject can feel crowded in the frame. When a bird or animal is looking right, leaving space in the direction they are looking or facing feels more balanced. Crowding them would create too much tension. But when objects are "pointing" in a direction, such as a saguaro cactus reaching for the sky, leaving just a little space at the top can create visual tension that makes the cactus seem even taller. When birds are flying, or animals are running, it makes sense to give them space to move into.

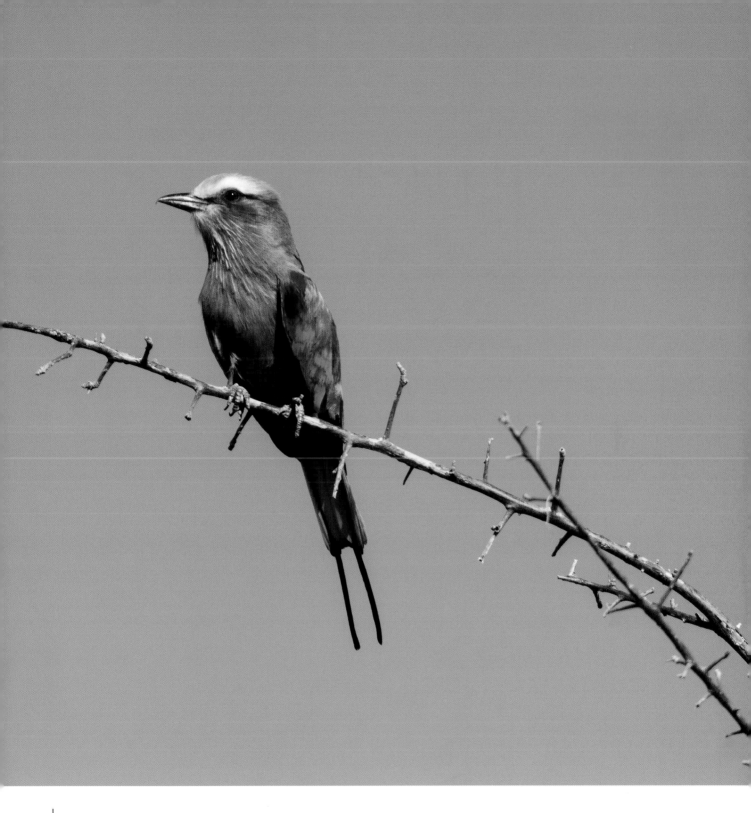

ABOVE:

"Just a bird on a branch," as we like to say in the bird photography world. However, it wasn't just any old bird, but one of my favorites, and having lilac breasted rollers stay perched when you pull up next to them in a safari vehicle is not always guaranteed! It's also not easy to get a clear view, as they perch amongst the branches, so I was pretty excited to have this opportunity to photograph one without a lot of clutter around it. Since the branch leads into the space on the left half of the frame, I positioned the bird just right of center on the right half, to keep the picture more dynamic. There wasn't any sense in positioning the bird in the rule of thirds position on the right, as that would have given too much empty space on the left. And certainly placing the subject in the middle would not have been a good option—too static! Since the bird is facing left the space on that side makes sense and a balance is achieved.

📷 *150–600mm lens at 828mm (effective focal length), f/10 for 1/1250 sec.*

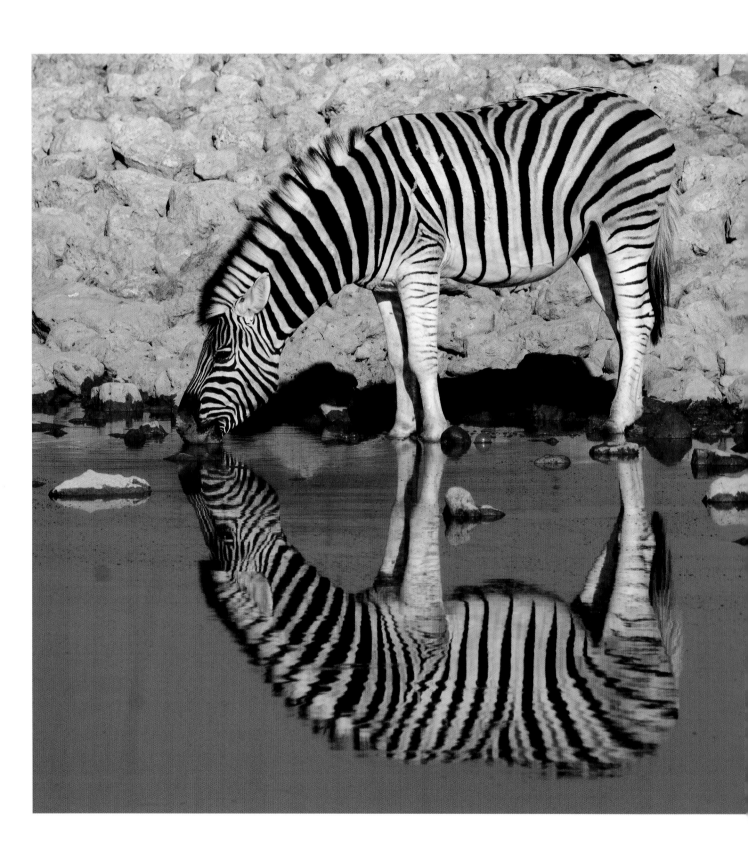

CHOOSING THE FRAME

When composing a picture, consider the shape of the frame. Plants that have a strong radial structure, such as sunflowers, or yuccas, do very well in a square frame, in which the eye is encouraged to move around in a circle. But put the same subjects in a rectangular frame, and they can feel squeezed, unless you've backed off enough to give them room around the edges. Other subjects do very well in the asymmetry of a rectangular frame, and it's what most of us are used to working with in photography. A horizontal framing works well if you are trying to express the breadth of something, or the calm, pastoral feeling of the scene. In a horizontal image, the eye is encouraged to move through the scene from side to side. A vertical, meanwhile, is typically a great orientation for emphasizing tall subjects, such as trees or waterfalls, and landscapes that need room to spread from foreground to background. But remember that rules are made to be broken! Putting a vertical subject in a horizontal framing can create dynamic tension and impact.

For most of us, achieving the right subject and frame balance may mean cropping the image to fit the frame, yet careless composition can make it difficult to get the right cropping later. If you don't think about the positions of your subjects within the frame and give them enough room, you might find that you clipped the top of the tree or the animal's ears. I was taught to crop in-camera, not later, as editors didn't like to see the tape or a mask that cropped the image. I walked away from many a good picture, simply because it didn't fit the 3:2 ratio of a 35mm slide, no matter how hard I tried. With digital, I can finally crop before anyone sees the final image. I still work to get it right in the camera, but when my composition won't fit the 3:2 ratio, I imagine how it will work when I later crop the space of the frame. Getting your subject in the right spot in-camera for later cropping takes some thoughtful practice.

Exercise: Try Different Cropping

Although cropping to save the picture as an afterthought isn't a great idea, cropping as a *tool* to learn composition can be. While you are trying to crop later, be mindful of why it works better with that crop. If you can't get it to crop well, think about why that is. As an exercise, use pictures that you feel you got right and see if a crop might improve them. Or try different cropping on pictures to see the impact is has on the subject and the space around them.

OPPOSITE:
Nothing beats a great reflection, and this zebra drinking at the waterhole in Namibia was the perfect way to start off the morning. We enter the frame on the left, and the eye is taken from the left side of the zebra to the right, and down into the water and back left, completing a circular motion. This continues the more we look at it. With the zebra and its reflection being the focal point of the picture, and since there was nothing of interest on either side of the animals, it just made sense to consider a square crop to emphasize the symmetry of the scene. The stripes add visual tension, because of the pattern of lines creating a feeling of movement, making the picture eye-catching.

📷 *150–600mm lens at 675mm (effective focal length), f/11 for 1/640 sec.*

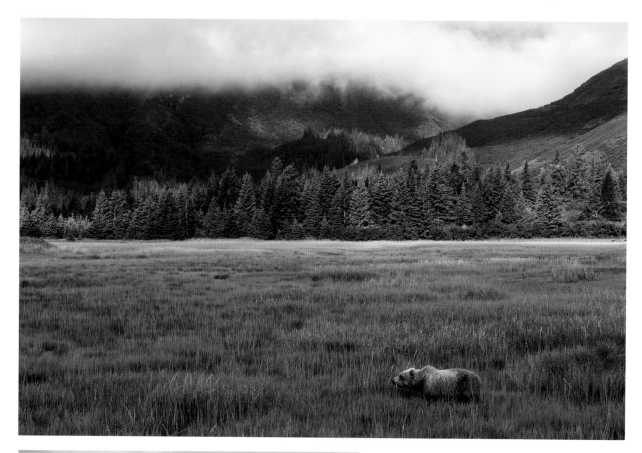

When nature cooperates, it's always great to make a vertical *and* a horizontal image of the landscape. You just never know how an image will be used, if you are selling your work. I recall countless times, when I was first starting out, that an editor would love an image and ask if I had the alternate orientation to the one they were viewing. Darn! When I think of the sales I lost . . . another lesson learned. Even if you are not selling your work, the two compositions are worth exploring. Each gives a different feeling to the landscape.

📷 *Top: 24–105mm lens at 58mm, f/11 for 1/320 sec.; Bottom: 24–105mm lens at 65mm, f/11 for 1/400 sec.*

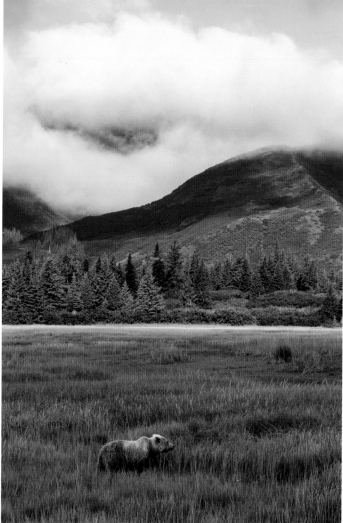

I encountered a field of giant sunflowers outside of Zurich while taking a walk near my hotel. The diffused light was perfect for photographing them. Fortunately I found some that were my height, as many were just above me and pointing toward the diffused sky and so were not an option for this situation. Then I tried to fit the round flower into the rectangular frame of my viewfinder. No matter what I did, centering the flower just didn't work—it was too tight in the frame for my liking, with more petals on the left and right, and not enough top and bottom. When I moved back a little, to give more petal room at top and bottom, the petals left and right started to show gaps in between them other

flowers. Even when the bee came, I didn't have a working photo. I then tried the vertical composition, thinking I'd cut into the center with the frame edge; but this felt like I had cut off the flower by mistake. When I turned the camera back to horizontal and tried that same idea of cutting into the center of the flower with the frame, that worked! It's because now the visual weight of the very light-colored petals falling below the center lead the eye downward and balance the heavy weight of the center of the flower. Even though this one is very similar to the proportions of the vertical, it feels entirely different.

📷 *Various focal lengths, f/8 for 1/80 sec.*

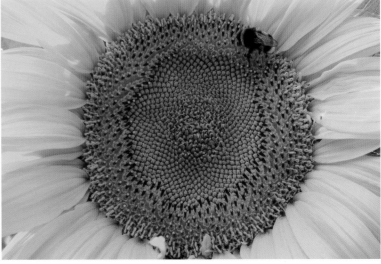

Once you explore and really see your subject or scene, you may find that there are better pictures to be made. By the time I spotted this great piece of ice in Glacier Bay, Alaska, we didn't have much time left on shore. It was hard to figure out how to frame the detail, as there was so much going on. As I looked through the camera, I moved all around the ice, and suddenly saw this fun image of a sci-fi bug. I quickly took a wider shot and switched to my macro lens and moved in close on my tripod to capture the second photograph, which was much more interesting.

📷 *Top: 24–105m lens at 105mm, f/8 for 1/125 sec., handheld. Bottom: 100mm lens at f/13 for 1/50 sec.*

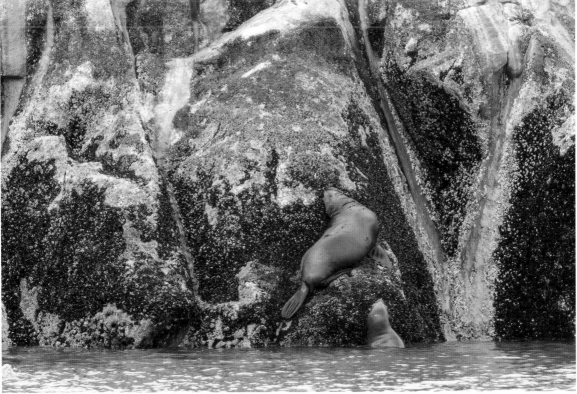

Getting in tighter and simplifying the scene can tell a different story. The story at top is about these sea lions hauled out high up on the rocks. In the bottom image, the story is also about them being hauled out on the rocks, too, but in this case the images shows how the sea lions found the smallest space on which to haul out. The graphic aspect of the tighter composition makes it more compelling, but it's always a good idea to take a wider view when you can, as they can express different ideas.

📷 *Top: 150–600mm lens at 250mm, f/7.2 for 1/1250 sec. Bottom: 150–600mm lens at 600mm, f/6.3 for 1/1250 sec.*

FILLING THE FRAME

You can create impact with wildlife and bird portraits by filling the frame with the subject. The larger the subject is in the frame, the more viewers feel as if they are right there. This makes a picture more exciting, and we can see details, such as the structure of a bird's beak or the whiskers on a large cat, that we otherwise would never get to see in the wild.

ABOVE:
Using a low angle of view, and a telephoto lens to fill the frame with this humpback whale's tail, I created the feeling of being in very close to this giant mammal, adding impact to the composition and moment. We actually weren't that far away, as the whale had surfaced close to our boat. Timing is everything with whale photography, and at first it was a guess as to what might happen. I was worried I might be too tight on my framing when the tail began to come up in the classic position, but thankfully it fit. Over the many years of trips I've made, I can now better predict what might happen next, and give enough room for these giant creatures to fill my frames, and my keeper rate has improved a great deal.

📷 *100–400mm lens at 310mm, f/5.6 for 1/500 sec.*

OPPOSITE:
Filling the frame with your subject creates more impact in the picture. This cheetah was basking in the hot sun of morning in Namibia, and I loved the expression on its face. The sun was so strong and low that it was actually being blinded by light, no doubt, but I took advantage of that squint to capture a cute moment, almost like it was saying "Ah, that sun feel *so* good." Filling the frame with the cheetah was achieved with a crop afterward, as the lens wasn't long enough to do it in the field safely. Are they *ever* long enough for wildlife?

📷 *70–200mm lens at 300mm (effective focal length), f/10 for 1/1000 sec.*

CREATING IMPACT WITH CONTRAST

For many photographers, contrast is just something to manage in terms of light and exposure. Yet contrast is also a vital component in composition. Think of contrast in many ways: the contrast of dark to light or black to white, the contrast of textures, the contrast of colors, the contrast of size. We can use contrast to create more interest and increase visual strength. Sometimes, contrast becomes the dominant element in the photograph. Consider the color contrast of holly berries against the green leaves, or orange-red sandstone against a stormy blue-gray sky. Consider that, by keeping an animal small in the frame, you can express the vastness of a place with the contrast of scale. All of these situations introduce contrast into the picture, quite aside from the contrast of light and exposure, and can create increased visual strength in your picture. Contrast is probably the reason you saw something worthy of photographing in the first place!

OPPOSITE:
The tree in this scene is about 60 feet high, and while you can't tell that per se, you can tell it's a mature tree by the shape of it and the fact that it towers above the other vegetation on the slope. But juxtaposed against the sunlit wall of El Capitan in Yosemite, you have a contrast of scale. Each element strengthens the other: The large tree is diminished in size by the large wall of rock, which in turn makes the wall feel really large and imposing if you think about the relative size of the tree. Optical compression is at work here: I used a telephoto lens to stack the two elements closer together visually than they truly are.

📷 *100–400mm lens at 400mm, f/16 for 1/10 sec.*

ABOVE:
This cliff of columnar basalt was illuminated by morning sun, which brought out the texture of the formation. The yellow rabbitbrush plant growing on the rocks served as a point of color contrast and gave scale to the image.

📷 *24–105mm lens at 75mm, f/11 for 1/80 sec.*

OVERLEAF:
When the morning light finally broke through the clouds, it lit up Monte Cristallo in Italy's Dolomites with beautiful warm light, in contrast to the cloudy sky behind it. But another contrast was at play here that I liked more: that of the mountain feeling enormous when you spot the small refuge hut in the lower left. The contrast of scale was amazing in this scene. The mountain really is pretty massive, but in order to express that I had to find something with which I could compare its size, and the hut was perfect. By including something small in the frame, you can express the vastness of a place with the contrast of scale.

📷 *70–200m lens at 194mm, f/16 for 1/4 sec.*

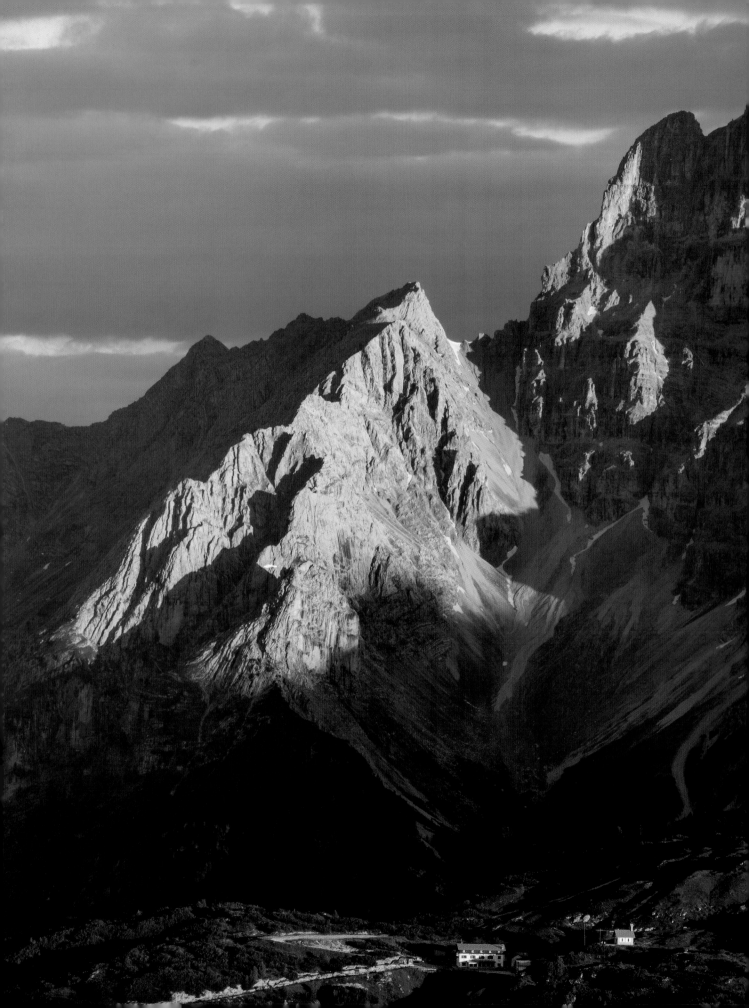

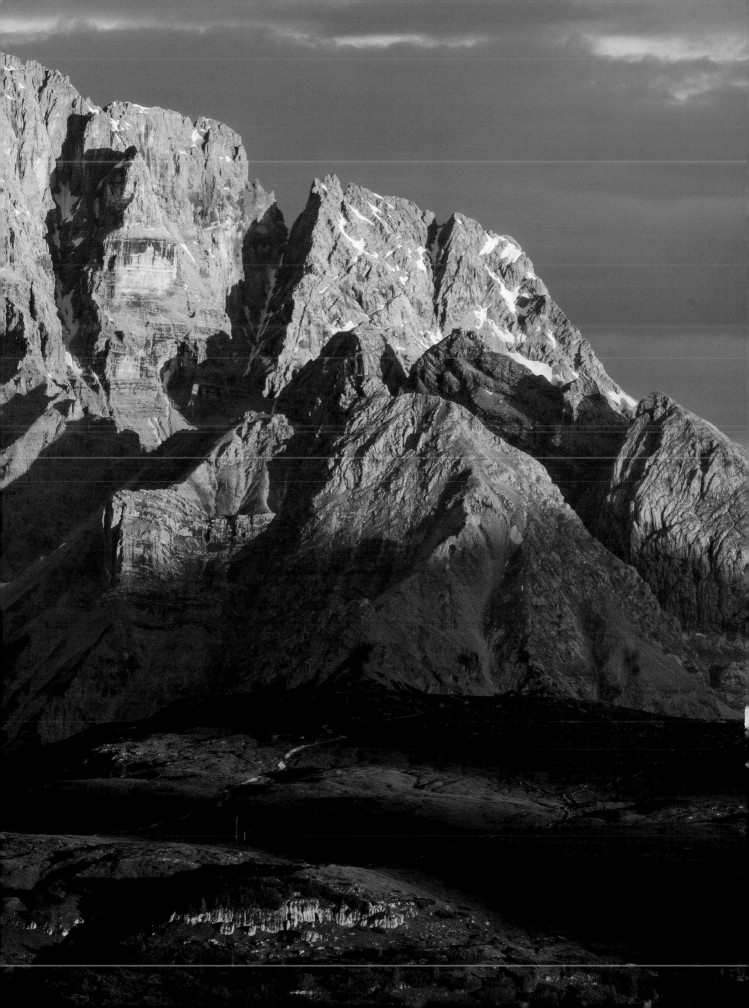

THE ART OF EXCLUSION

Learning the art of exclusion—that is, how to simplify your compositions—will help you strengthen your pictures. In fact, photography is really about distilling the scene in front of us down to just the elements that work together to make a compelling composition. Large bright areas can dominate, dark areas without detail can be like the great void, strong lines can be a major distraction, and out-of-focus foregrounds can create a visual block. Often you can greatly affect the arrangement of objects and what you are including in the frame just by changing position slightly. But it's possible to oversimplify, too. Learning the fine balance between exclusion and inclusion takes practice and mindfulness of what you are trying to say with the composition. Remember, less is often more.

Pay attention to distractions. In my workshops, students often make images that show some distracting elements they never noticed when making the photograph.

ABOVE:
This interpretive view of an elephant walking by a watering hole in Africa at sunset was a fun way to capture a story without showing anything of the real elephant. By excluding the elephant and the resultant clutter around it, I was able to create more significance to the silhouetted shape. I waited for the shape to be identifiable before pressing the shutter.

📷 *70–200mm lens at 300mm (effective focal length), f/9 for 1/400 sec.*

OPPOSITE:
Snow provides the opportunity to simplify scenes, and in this image, a feeling of minimalism occurred, due to the simplicity of this composition. By eliminating anything else in the scene except the main subject, you can create minimalism with many subjects. Here, the snow did the work for me! The snow covered the branches yet also revealed them, and I liked the feeling of gesture in the way the stalks spread out. This is a simple story about snow blanketing the landscape.

📷 *70–200mm lens at 200mm, f/13 for 1/50 sec.*

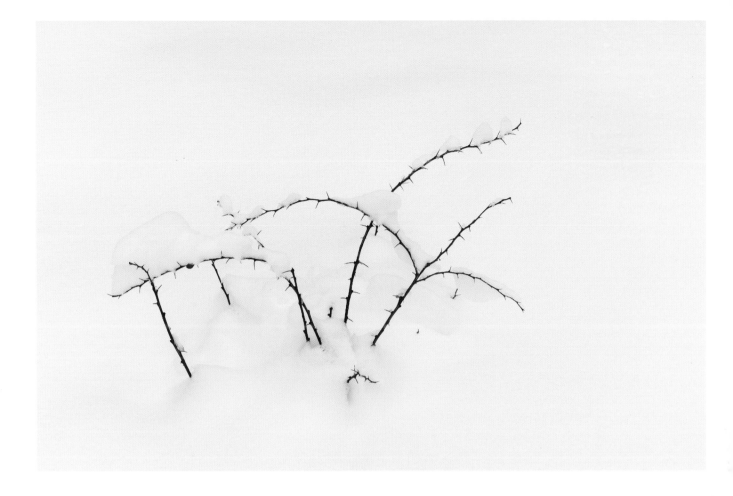

Those distractions are like a whistling teakettle for me. I can't concentrate on anything until I turn the kettle off, and in a photograph, I can't get past that teakettle! How do those distractions end up in our pictures? Why didn't we notice them when we were making the picture? It simply has to do with how the brain works. When we end up with unwanted elements in our photographs, it's usually because we were planted in the right brain, reacting emotionally to what we're seeing, all excited about the subject, the light, the texture, whatever, and did not let the analytical side, our left brain, take over and do its job by arranging and cleaning things up. The best way to prevent yourself from including unwanted elements at the edges of your frame or creating a poor composition is to take a step back before you press the shutter and ask, *"Is there anything I don't want in this picture? Anything that I find distracting (that I have control over)?"* That act of stepping back usually helps the left brain kick into action so you can catch the culprits—like the tree sticking

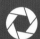 **Exercise: Take a Minimalist Approach**

I love minimalism, and when photographing nature I am delighted when I find a scene that can be distilled down to the simple essence. Creating minimalist compositions is not as easy as you think. The key lies in including only that which is necessary to express the subject, and not a leaf or stick more! Try it yourself: go out and see if you can simplify a scene to the point that it becomes minimalist, the essence of the subject. That might be grasses in a pond, one flower stalk covered in frost, a single leaf dangling off one branch, one blade of grass with water drops.

out of the elk's head, or the rock out of focus in the lower left edge. The great news is that if you get into the habit of taking a step back, you'll soon develop the ability to spot your own whistling teakettles before they end up permanently in your picture.

VISUAL DEPTH

Have you ever made photographs of a beautiful land-scape, only to be disappointed to see that the feeling of being there is somehow lost in the final image? I call pictures like that "passerby images," as if someone passing by just pointed the camera at the scene and quickly snapped a shot. The image feels remote, not engaging.

To bring the experience of being there to your viewer, you have to create a way to invite viewer participation in your photograph. Putting something of interest in the foreground that commands attention—a rock, a tree, or a wave rolling toward the beach—engages the viewer's interest. Getting in close to the foreground objects when you make the picture will draw viewers in and make them feel they could reach out and touch the subject, or get their feet wet. It's a visual stepping stone that helps viewers participate in your scene. The image becomes participatory, and it is all based on the principle of per-spective.

Here's how perspective works in a nutshell: The closer you get to an object, the larger it appears in comparison to other objects and elements in the scene, while those in the middle and background appear to stay relatively the same size. The apparent space between the close object and any other object also seems to expand, and this is what gives the photograph the illusion of depth. This near–far relationship creates a tension between fore-ground and background, and strong visual interest. This is a classic technique for photographing large landscapes, yet it works for many other compositions, because of the perspective that is inherent in any situation. Whether you realize it or not, you are already creating visual depth as you move around to separate a rock from a bush, to keep the tree from breaking the horizon line, or from poking out of an animal's head.

Changing focal lengths only changes framing. Only you can change perspective with your choice of position, or point of view. Find the best position you can when arriving at a location, by walking around and scouting the area. As you do this, you'll naturally find something that grabs your attention. The elements in the scene will combine in a way that just grabs you.

The same principles of perspective apply in any type of photograph. If you are photographing a flower, with other flowers in the background, depth will be suggested by your closeness to that flower, which will make it appear larger.

You can also suggest depth by selectively focusing on your subject or foreground and choosing an aper-ture to keep the background out of focus. This keeps the viewer's eye on the subject, yet by including the softly out-of-focus background you hint at the environment. If the subject is a flower, you hint at the meadow where the flower might grow, while keeping the background soft creates depth.

OPPOSITE:
This creek below the Tre Cime di Lavaredo peaks in the Dolomite range of Italy had lovely yellow flowers growing all along the marshy edges. I chose a clump that I could get close to, and framed the scene vertically with a wide angle to include the towering peaks. Using the vertical orientation of the frame accentuates the height of the peaks and enhances the range of depth in the image. By getting slightly above the foreground group of flowers, I was able to include the middle ground of flowers that stretched deep into the background. The stormy light added drama and mood to the final scene, but soon after I had to run for cover!

📷 *16–35mm lens at 16mm, f/16 for 1/8 sec.*

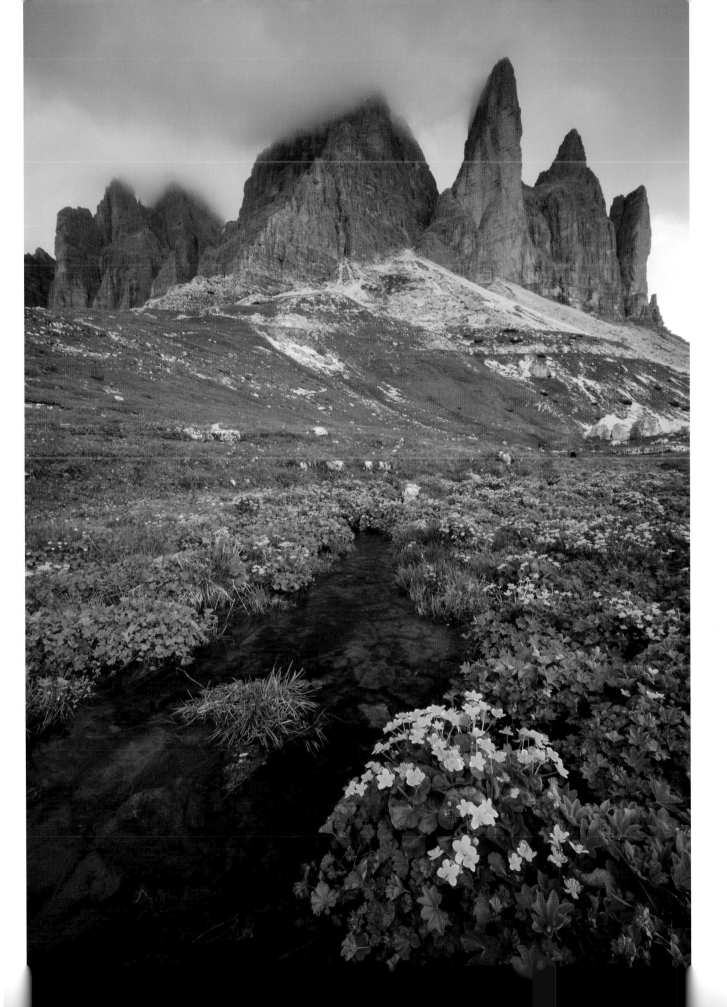

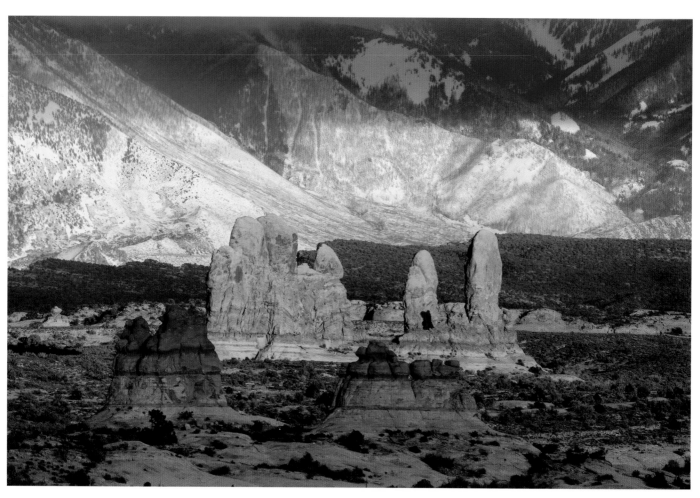
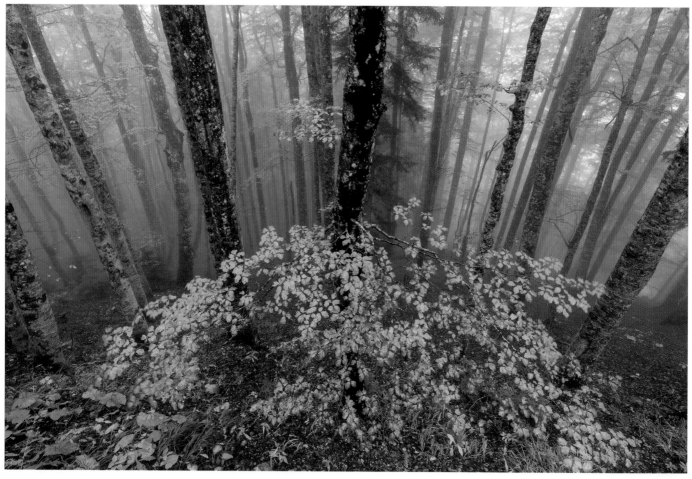

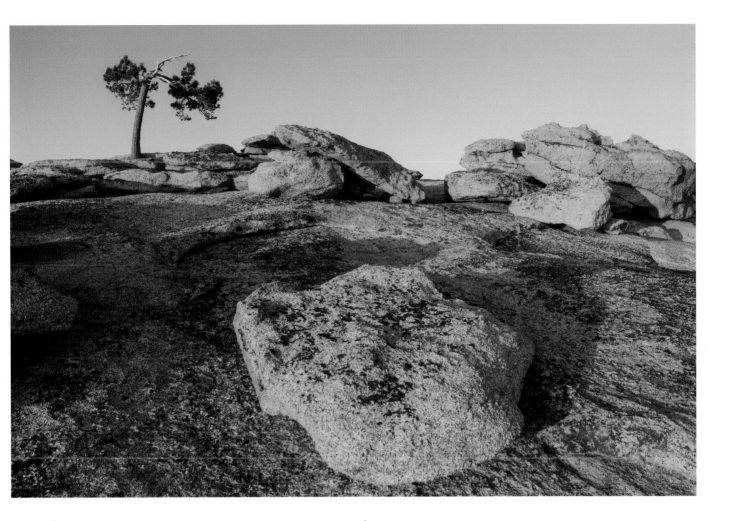

OPPOSITE, TOP:
Although still a near–far relationship, I used the optical compression of a long focal length to visually stack these formations within Arches National Park, Utah, against the La Sal mountains to the south of the park. This enhanced the visual strength of the mountains, as they now appear very large and close to the hoodoo formations, which makes this picture more unusual than the typical wide-angle landscape. It had been a cloudy afternoon, but the sun broke through enough to light the snow-covered slopes and illuminate the hoodoos in the middle ground. Soft light also illuminated the foreground hoodoos to give them definition but the middle ones remain the main subject.

📷 *150–600mm lens at 483mm, f/9 for 1/200 sec.*

OPPOSITE, BOTTOM:
The beech forests in Triglav National Park in Slovenia are beautiful. When the fog rolled in we were all excited to photograph the forest, but the hillsides were so steep in this one area we could only photograph from the roadside. This gave us a unique point of view, however, and I loved this one branch that stood out against the other trees in the background. Fog had created a sense of depth by isolating this branch a bit from the rest of the forest. By using my wide angle, and pointing down, I was able to distort the trees to make an unusual composition.

📷 *16–35mm lens at 21mm, f/16 for 1.6 sec.*

ABOVE:
The sweet light of sunset, enhanced by forest-fire smoke in the distance, created a peachy light on the rocks and weathered tree atop this granite dome in California's high sierra. Getting low and close to this one piece of granite allowed me to create a relationship with it and the rocks and tree beyond, and expressed depth with the near–far technique. Getting closer meant getting wider with my angle of view to include everything I wanted in the frame and not clip the top of the tree. The sidelight brought out the wonderful rough texture of this weathered granite, and created dimension in the whole scene.

📷 *24–105mm lens at 28mm, f/16 for 1/4 sec.*

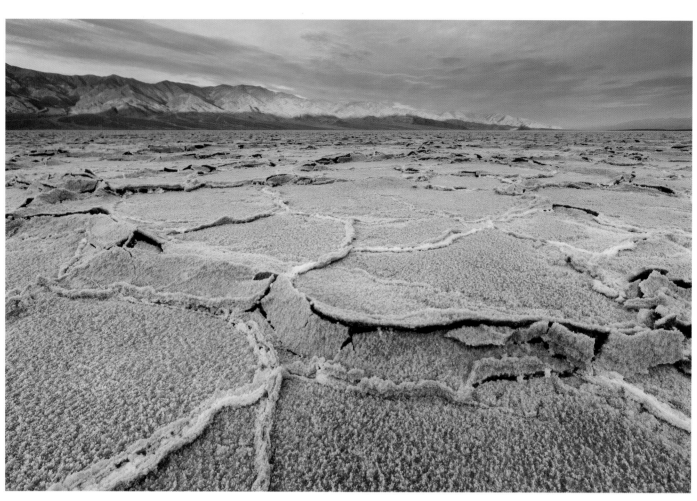

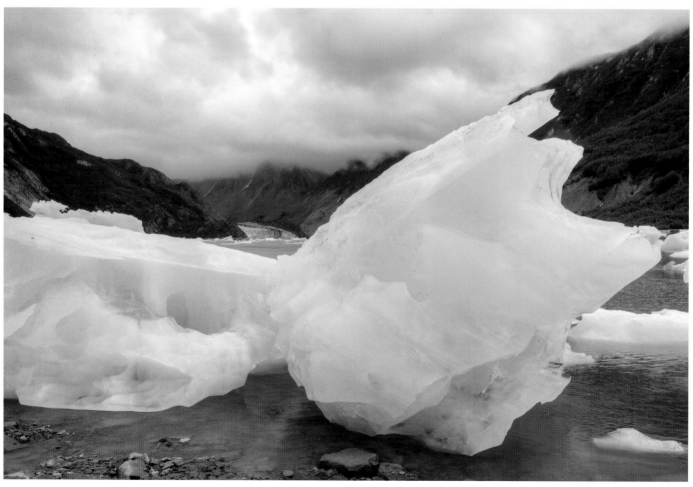

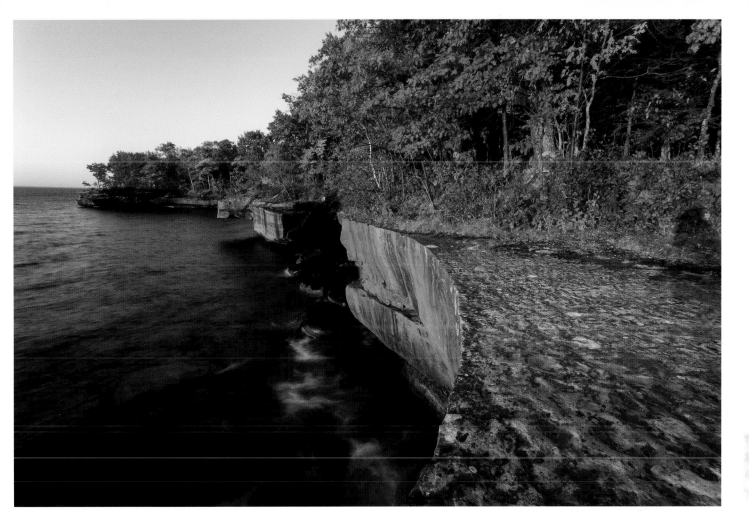

OPPOSITE, TOP:
Dawn was a soft blue on this morning at the salt flats in Death Valley. Clouds were rolling in, and I wondered whether there would be any good light. I wanted to draw attention to the wonderful pressure ridges that are formed as the salt pushes up to the surface. They create polygonal shapes that add visual interest and story to the picture. I positioned my tripod about a foot above the ground and, using a wide-angle lens, angled the camera downward to emphasize the salt formations nearest to the camera. This created the expansive depth I wanted to express how the salt flats reach back toward the mountains. I had to be high enough to show details in the middle ground for this to work. Had I gotten too low, the details behind this ridge would have been lost in the flattening of the perspective. In the diffused light of predawn, there was just enough brightness to create directional light on the foreground, which brought out the texture of the salt formations, when suddenly the sun broke through the clouds briefly to light up the back mountains.

📷 *16–35mm lens at 19mm, f/13 for 1/5 sec.*

OPPOSITE, BOTTOM:
Getting in close to this iceberg, but at eye level, provided the opportunity to put viewers in the scene without using the angled-down method to include a strong distorted foreground. I had seen the glacier in the background and wanted to relate it to the pieces of ice that had broken off and floated forward. The slightly wide-angle view still stretched the ice a little visually, just enough to make the shape expressive. This near–far approach gives you a feeling of being there, walking around the icebergs.

📷 *24–105mm lens at 32mm, f/16 for 1/15 sec.*

ABOVE:
The sweep of this cliff along the shoreline of Lake Superior provided a great leading line, which guides the eye into the scene during this beautiful sunrise. I used the foreground rock and that sweeping line to create a near–far relationship that expresses depth. By positioning my tripod very close to the edge, and sitting with one leg dangling off the edge, I was able to find just the right viewpoint. Sometimes you take risks to get the point of view! The sweep of the cliff edge and the sharp cut of the face of the cliff express the story of how they are sculpted by the water below.

📷 *17–40mm lens at 17mm, f/16 for 1 sec.*

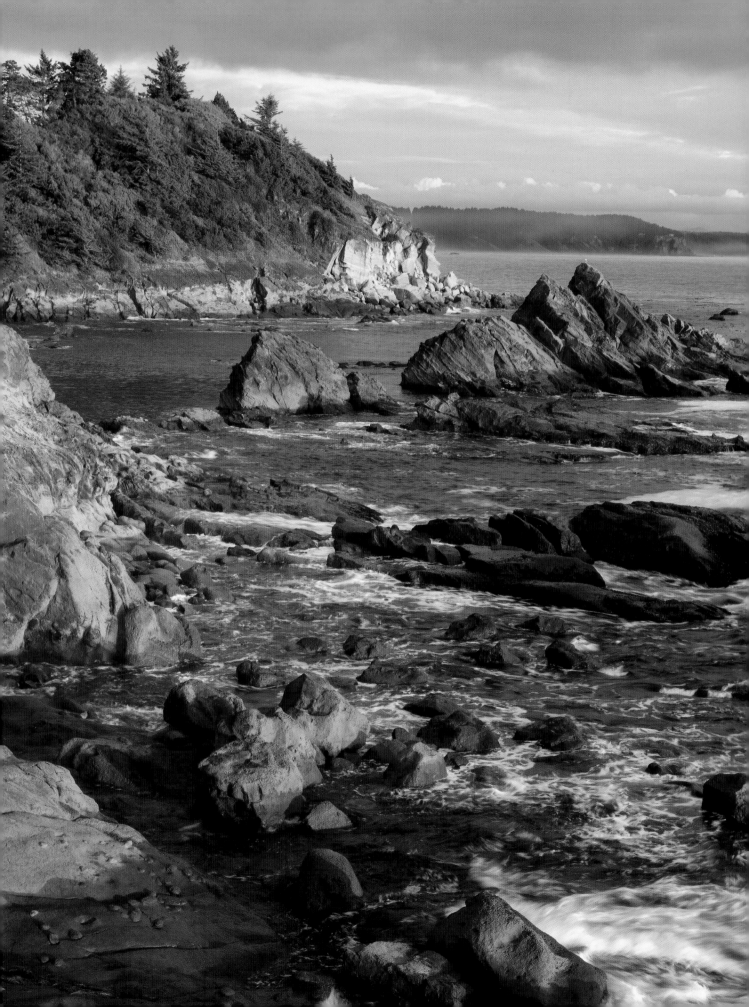

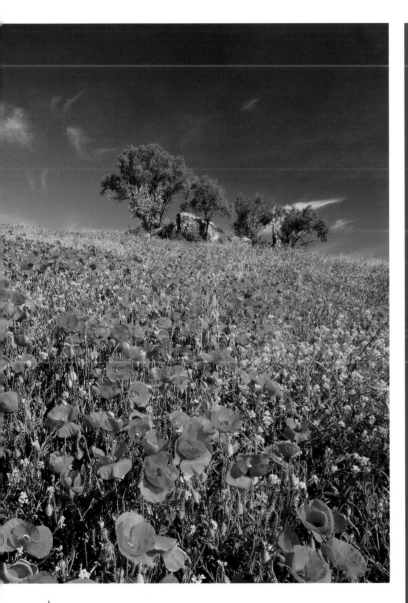

Exercise: Practice Perspective

Try this simple exercise: Arrange two or three flower pots on a table, 2 feet apart, with a slight offset of each pot so you can see them. Move in very close to the first pot, and you'll see how large it becomes, making the one behind it appear much smaller. If you leave the camera in that position, and you move the second and third pots closer or farther away, you can see how the relationship and the appearance of depth changes. Get higher, too, and see how the space opens up between the first and second pots, while the space between the second and third doesn't change as much. This simple exercise proves the concept of perspective, and how effective having something close to the camera is for impact in the photograph. Think about the old dinosaur movies: They used regular lizards placed very close to the camera with the human characters placed back some distance, to make the characters appear small and the "dinosaurs" very large.

OPPOSITE:

It's not always possible to get in low and close to create a more extreme angle of view and emphasize the foreground dramatically, but you can still create depth in any picture if you think about perspective. On the rugged coast of Oregon, I was standing on a small promontory above the water to get this view. By including rocks coming into the frame from the lower left and right, and having some boulders fairly close to the bottom of the frame, the story of depth begins, and each group of rocks becomes a layer as you move into the background. The layers of objects and the resulting planes of focus were a good way to express depth. The warm sidelight added texture and the breaking waves added movement to the landscape.

📷 *24–105mm lens at 58mm, f/16 for 1/5 sec.*

ABOVE, LEFT:

This field of poppies in southern Spain was just a small patch on a hillside, out back of a small village, but there was no missing this cheerful color when driving by! I asked our driver to pull over and we all jumped out, eager to go to work, as it was the first field of flowers we had seen. I chose to capture a vertical composition of the field, using a wide-angle lens to get in close to the foreground flowers. This point of view showed the flowers spreading up the hillside to the trees, and that gave me the strong depth I was looking for in the picture.

📷 *10–24mm lens at 22mm (effective focal length), f/13 for 1/50 sec.*

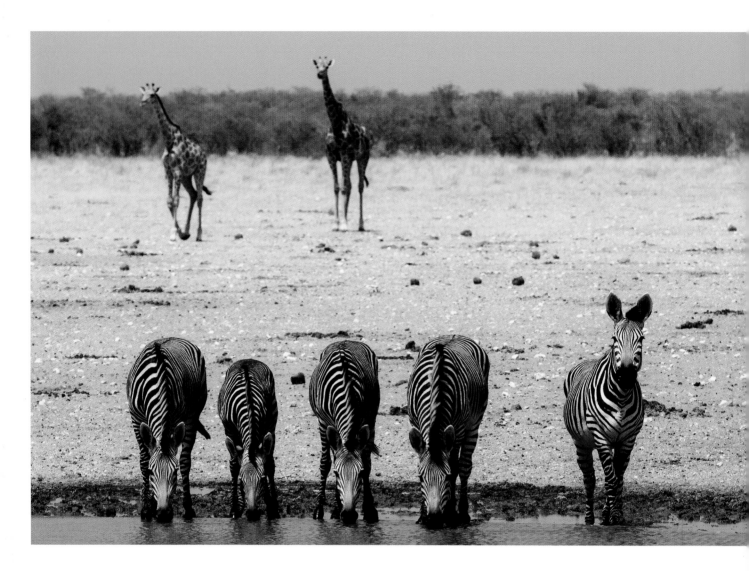

ABOVE:
Even with wildlife, you can create the suggestion of depth, if you pay attention to the background activity. Here, at a waterhole in Etosha National Park in Namibia, one zebra stood guard while the others drank. The giraffe ambling in behind them created a layer of interest, as well as size difference, adding depth and a more interesting background than if it had not been present.

📷 *150–600mm lens at 309mm, f/11 for 1/1250 sec.*

OPPOSITE:
Selective focus is an effective way to suggest depth. By isolating the subject from the background, selective focus increases the feeling of separation, or distance, which implies depth. This one sable antelope was more curious than the other, and it approached our safari vehicle fairly closely on this private reserve. But the other one was not as sure, and I liked that it stayed in the background. When it turned so the two heads aligned as they looked at us, I pressed the shutter. The shallower depth of field that you get with a telephoto lens created the appearance of depth in this scene.

📷 *70–200mm lens with a 1.4x teleconverter, at 266mm, f/8 for 1/1600 sec.*

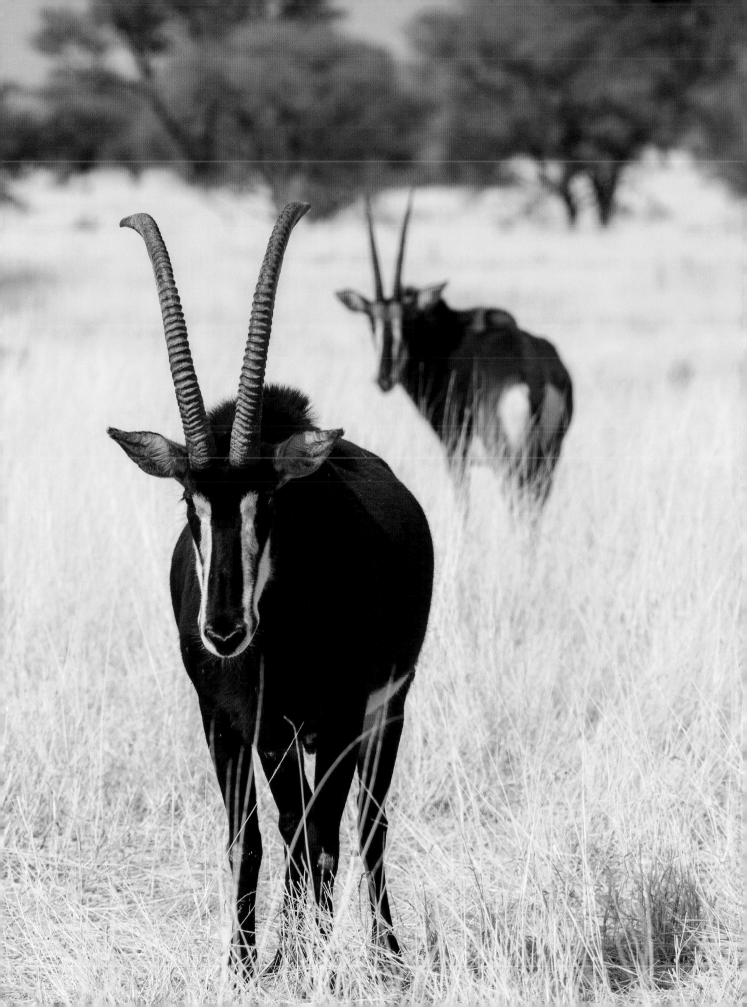

CHAPTER 4

SEEING IN COLOR

"The whole world, as we experience it visually, comes to us through the mystic realm of color."

— HANS HOFMANN

Color can evoke strong emotional responses in us. Each color has its own attributes, in terms of how we interpret or relate to it, and each has a specific visual weight. Cool colors recede into the middle or background, and rarely call out for attention. Warm hues advance, assertively, and in fact compete with one another for attention. Of the three primary colors —that is, colors that cannot be creating by mixing other colors—blue is light, red is heavy, and yellow is in a class all its own.

OPPOSITE:
Quiver trees are actually large aloes. They are amazing to photograph, and on this day in central Namibia the sunset left a beautiful warm glow on the trees, against the blue sky. The contrast of the warm hue of the trunk and the cooler blue sky creates a pleasing and harmonious color palette.

📷 *24–105mm lens at 24mm, f/16 for 0.8 sec.*

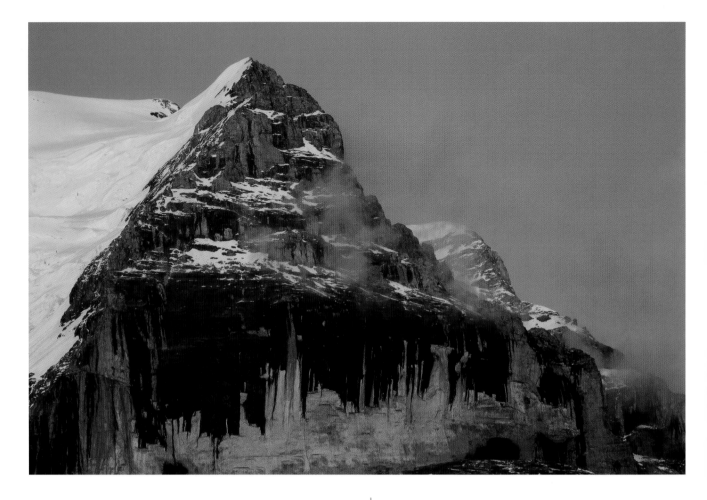

Think of how we respond to color in nature. The bright, strong colors of the reds, yellows, and oranges of a summer's flower meadow change to darker yellows, burnt oranges, and browns in autumn. By the time winter comes, most everything is a shade of muted brown and beige, tones that represent a return to the earth. Come spring, the landscape erupts bright green, and with that hope, growth, and renewal are expressed again.

Knowing more about the characteristics of color can help you make creative decisions in composing your pictures. Color is an element, just like shape or line is, and should be thought of as another tool to use in making pictures. While we can't control the color in nature and must use the colors provided in any given scene or situation, we can consider the significance of the colors present and make creative decisions that employ the power of color. It's important to remember, too, that the attributes we assign to colors often come from our experiences, such as those with fire, water, sky, or sun.

ABOVE:
This massive rock wall is part of the base of the Jungfrau, in the Swiss Alps. The spectacle hovered above my hotel room balcony, and I love it when I don't have to climb the mountains to see a view like this! Sweet sunset light was bathing the rock and lighting up some clouds in wonderful peach and pink hues, which were a perfect color contrast to the clear blue sky.

📷 *70–200mm lens at 159mm (effective focal length), f/10 for 1/20 sec.*

BELOW:
This color wheel represents complementary pairs in the primary, secondary, and tertiary level of colors. In photography, colors even close to these pairs can create an image with more impact due to color contrast.

COMPLEMENTARY COLORS

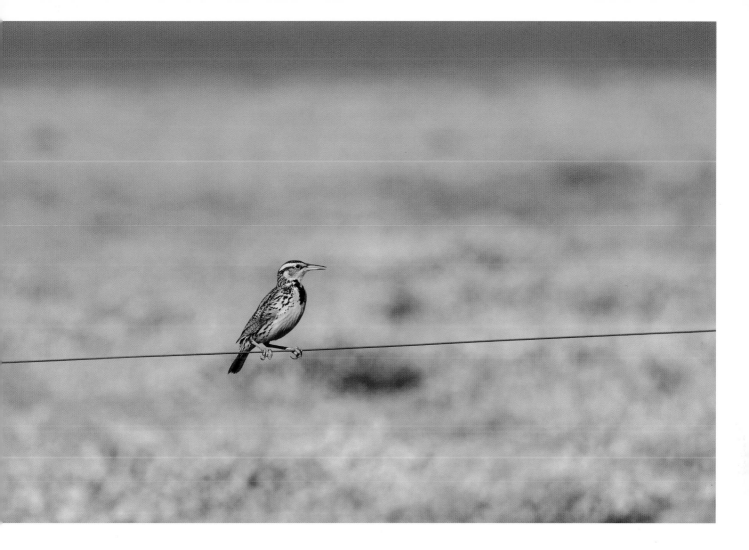

YELLOW

Like a high-speed train blowing its whistle, yellow comes screaming out from the background to grab our attention in a photograph. Even when surrounded by other colors, yellow will advance visually and, radiating light, command our attention. Yellow is so aggressive that we have to consider carefully how we utilize it in our nature compositions. One small yellow flower can become the focus of the image, whether we intend it to be or not. Emotionally, yellow is full of energy and vitality; it's hot, cheerful, sunny, and oh-so-pretty to see. Another color may try to stand out in contrast to yellow, but it won't win, unless perhaps the yellow is dulled.

ABOVE:
This Western meadowlark was made for its environment, certainly during spring, when the yellow breast is a perfect match for the yellow flowers blooming on the Carrizo Plain in southern California. Same-color images such as this only really work if there is a good match of the hues or tones of the colors. The bird's brown, white, and black markings help separate it from the background. This image is cheerful and bright, because of the color, and flowers always make us smile.

📷 *150–600mm lens at 600mm, f/11 for 1/1000 sec.*

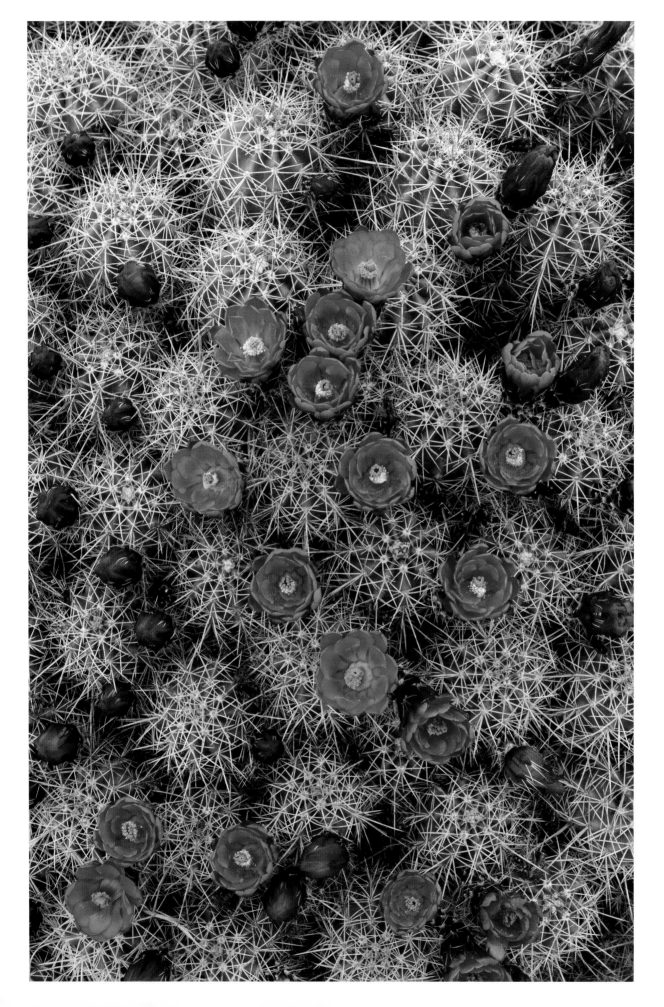

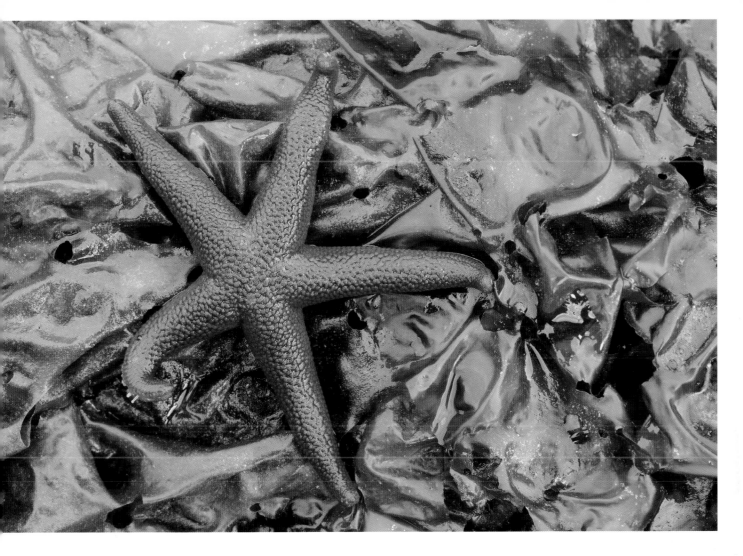

RED

Like an old comfy chair in the living room, red sits boldly in our picture space and expresses energy, power, and passion. Red can also express danger, even death, and, ironically, ripeness, vitality, and life. Red advances when next to blue, green, or orange, and like yellow, can dominate a scene, but that all depends on its proportion in the frame. Photographers love red, and it's often the focal point in pictures. Red and its complement, green, are the color pair most commonly seen in nature.

OPPOSITE:
This claret cup cactus was nearing peak bloom in Utah's Canyonlands National Park. I yelled "STOP!" to my friend who was driving, because when I see brilliant red in the Canyonlands, in April or May, I just *know* it's claret cup in bloom, and I love these cacti. I chose to frame this image vertically because of the way the blossoms spread out. The red just about pops off the page, it's so brilliant.

📷 *24–105mm lens at 85mm, f/16 for 1/20 sec.*

ABOVE:
This blood star is a beautiful shade of red. I picked it up and placed it on the green kelp to create a fun photograph of color contrast. Once you put these creatures down, they begin to move, and I like the expression of its arms in this frame.

📷 *100mm lens, f/11 for 1/25 sec.*

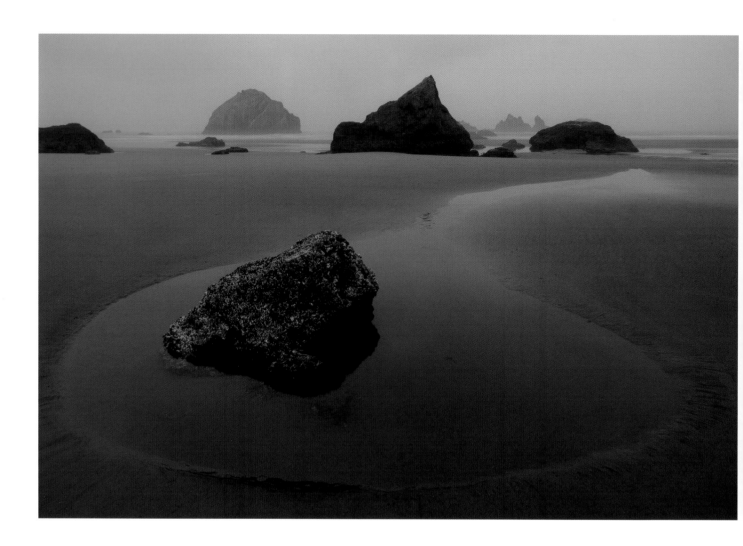

BLUE

The third primary color feels a bit more laid back. Blue implies chillin' on the surface of a lake or looking into the sky above our heads. Blue is calming and expresses tranquility, purity, and peace. Some hues of blue, like the blue of shade, or the bluish cast of daylight, can feel cold and uninspiring. But go out at twilight, and the deep blue is spiritual and mysterious. Deep blue recedes in a photograph, and middle-tone blues just sort of sit on the fence, neither aggressive nor recessive. Against other cool colors, blue may dominate, but it hangs in the background when the warmer colors are around.

BALANCING COLOR

Like the primary colors, the secondary colors of orange, purple, and green also have emotional characteristics. Orange, derived from yellow and red, expresses a similar heat, and is associated with warmth, fire, and energy. Violet, a cooler color, expresses mystery and is considered healing. Green is the symbol of nature and represents growth, life, renewal, and hope.

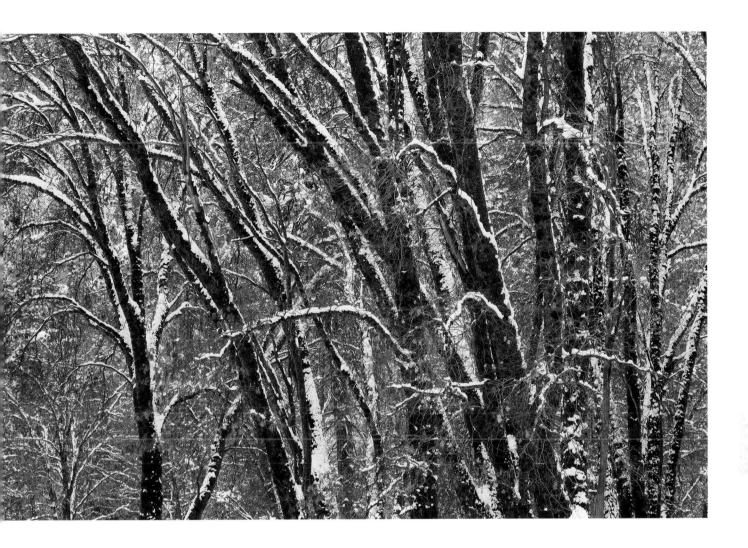

When composing nature photographs, we're often presented with many colors simultaneously. We can't alter the colors, but we can manage them by arranging them in our compositions, and by the proportion we give them in the frame. If you understand how dominating yellow or red are, you may choose a point of view to minimize those colors so you can control the balance in the composition. Colors also have different visual weights. Red is heavier than blue, and pink is lighter than green. This knowledge can help you when looking at the elements in your picture and deciding how to work with colors. If you have green and orange in the frame, for example, the orange hue will stand out strongly, as all warm colors tend to advance visually.

The list of considerations goes on: Too much yellow will weaken the rest of the colors in a picture. Colors that

OPPOSITE:
The blue light of early twilight on the beach in Bandon, Oregon, expresses a mood of mystery, as well as tranquility. Blue is a calm, quiet color, and it reflects the mood of this beach scene. You can almost feel the silence on this empty beach.

📷 *24–105mm lens at 24mm, f/16 for 30 sec.*

ABOVE:
A dusting of fresh snow stuck to these oak trees in Yosemite Valley, California. I loved how the burnt orange hue of the leaves still clinging to the trees were essentially the only color, other than a hint of green moss here and there. I guess those little leaves just didn't want to let go yet! This scene expresses the concept of fall changing into winter.

📷 *24–105mm lens at 105mm, f/13 for 1/6 sec.*

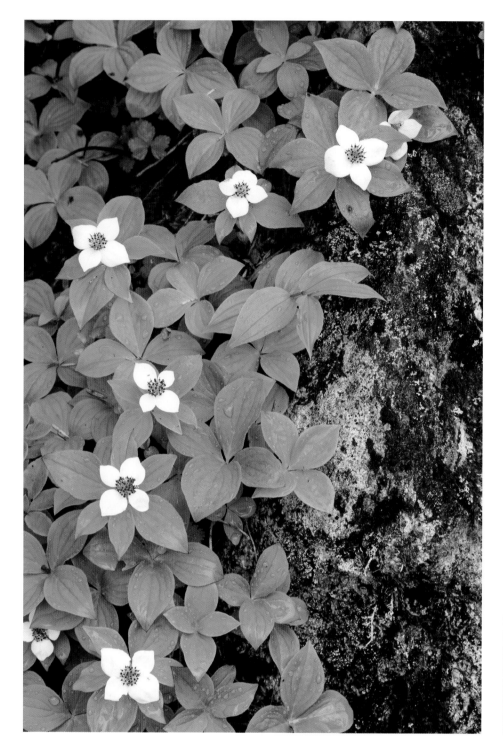

are in harmony will vibrate when juxtaposed. Just look at something pure red against the same proportion of pure green and you'll see what I mean. Against similar hues, blue is calm; against orange, it expresses a stronger energy. Using all of the properties and emotional attributes of color, we can take advantage of these colors in nature to make our images more compelling.

ABOVE, LEFT:
The fresh green leaves of these bunchberry plants, with their cheerful white bracts, provide a nature detail that feels pure. Green represents growth, and the blossoms also represent the growth cycle, making the picture express the energy of life.

📷 *24–105mm lens at 105mm, f/16 for 1/8 sec.*

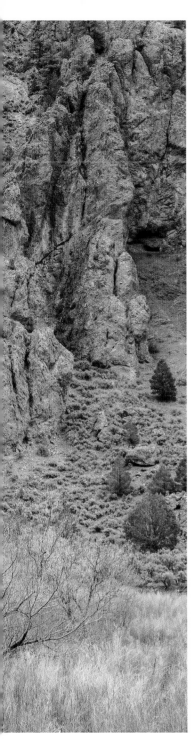

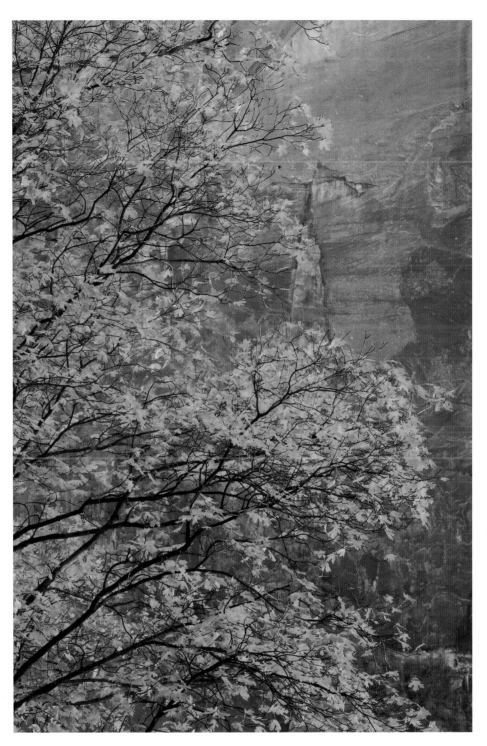

ABOVE, CENTER:

Driving along the back road in Utah from Highway 70 to Salt Lake City, I came upon a scene that simply caught my eye for the subtle colors it displayed. Soft greens, grays, reds, and beige made for a very earthy palette, brought out by the diffused light of the cloudy day. Though it was early May, the higher elevation had not yet warmed up enough for the trees to have leaves, which was fortunate, as the bare tree and the willows around it added a complementary hue for the rest of the picture. Bright, fresh green leaves would have become too dominant in this scene.

📷 *24–105mm lens at 84mm, f/14 for 1/20 sec.*

ABOVE, RIGHT:

Haze cast a purplish hue on the cliff behind this maple tree, and the warmer hues of the autumn leaves against the purple created a pleasing contrast. The backlight coming through the leaves adds a glow to the tree, which helps it stand out sharply from the background.

📷 *55–200mm lens at 111mm (effective focal length), f/16 for 0.5 sec.*

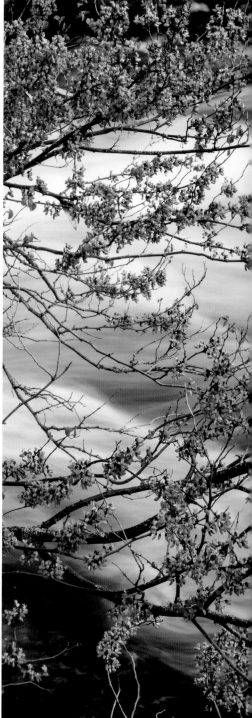

TOP:

I love cardinals, and here, in the morning light outside of Tucson, Arizona, this one stands out strongly against the pale green of the foliage, a great complementary background. The bird advances off the page because of the dominance of red and the contrast with the green.

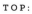 *150–600mm at 500mm, f/8 for 1/2000 sec., handheld.*

BOTTOM:

Pink and green are close enough to red and green to be a harmonious pair. This ice plant was perfectly situated as it spilled up and over the green cactus in a riot of pink blossoms. I had to wait for the sun to come out to open the flowers, and then wait some more for a cloud to diffuse the light. Added to that was the need to shoot slices of varying focus points, to render the entire image sharp when I was finished processing in the computer.

70–200mm lens at 135mm, f/22 for 1/15 sec.

ABOVE:
Shade created a cool color cast in this image from California's Sierra foothills. I later adjusted the image to remove some of the blue but left enough to add a feeling of freshness to the scene. If you warm up the color cast too much on water like this, it doesn't look as appealing. I chose a slow shutter speed to allow for the motion of the water to show and create a flowing background to the redbud branches.

📷 *70–200mm lens at 78mm, f/18 for 0.8 sec.*

OVERLEAF:
You can see in this picture how yellow can dominate. In a scene of many warm hues, the stand of aspen trees becomes the focal point of the scene, due to the dominant nature of the color yellow. Aspens propagate by a cloning method, so the trees in this stand are likely descended from one parent, which is why they will all tend to turn color at the same time.

📷 *70–200mm lens at 165mm, f/16 for 1/13 sec.*

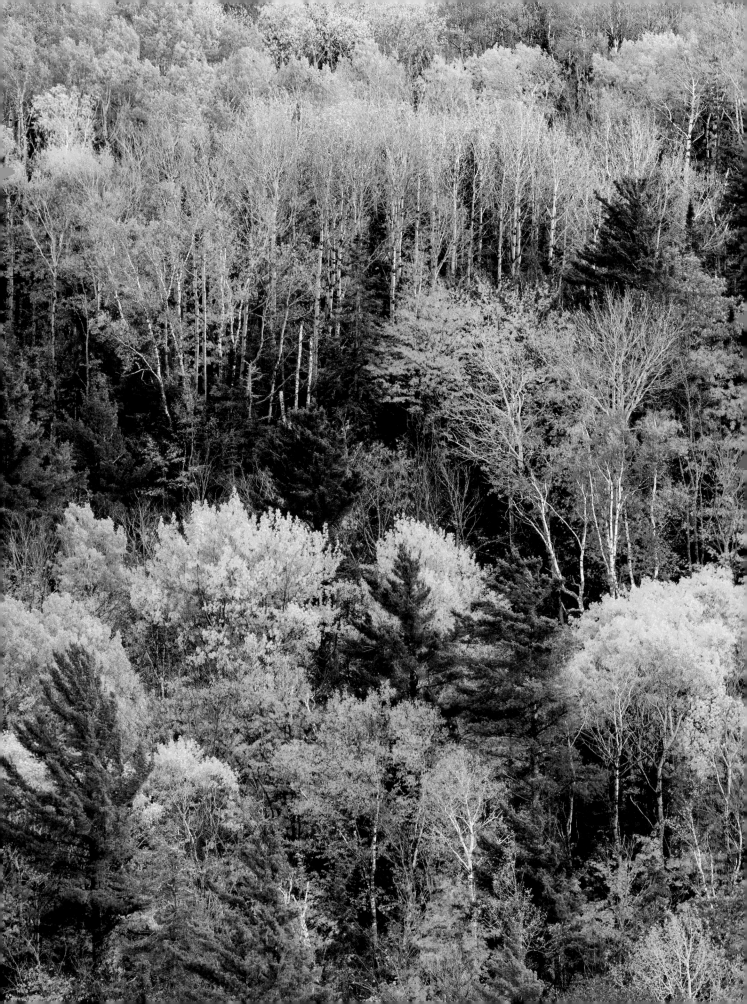

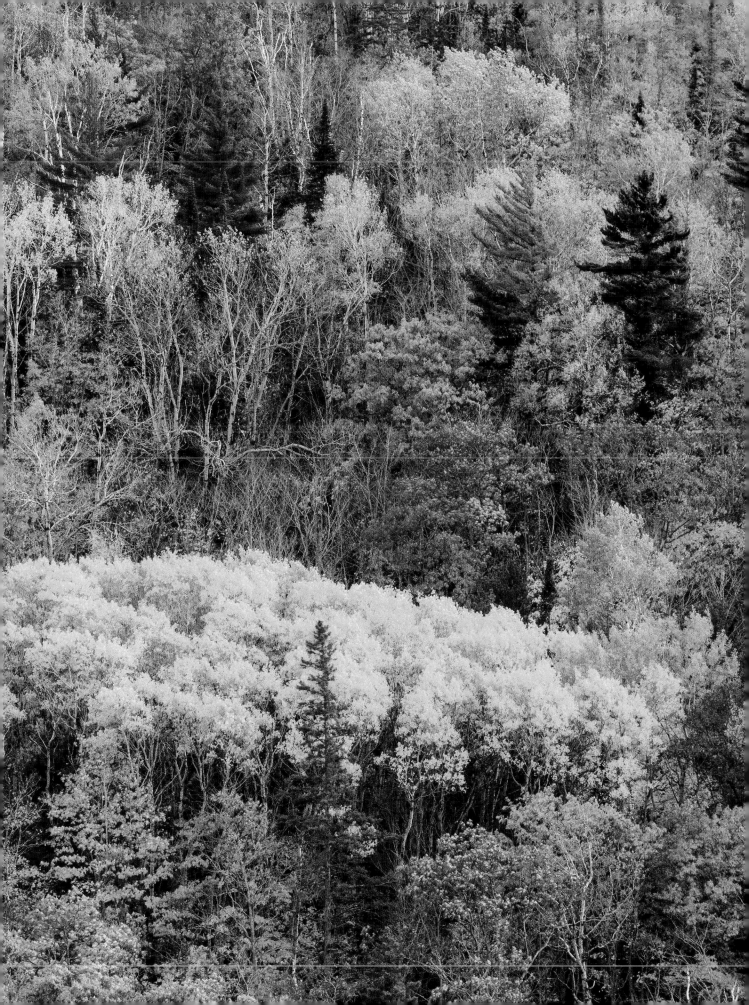

A CASE FOR BLACK AND WHITE

Until color film became reliable, many great photographers brought to light the beauty they saw in nature using black-and-white imagery. Some of them stayed with black and white their entire lives. While Ansel Adams used color in his early commercial work, he chose black and white to express the natural world that he loved. Black-and-white work has long been considered to be art photography.

Working in black and white will actually strengthen your ability to compose pictures, and to see and use light. In the absence of color, we can see the shapes, lines, forms, and textures that light reveals in the landscape. Color can seduce us away from those things, if we let it. I maintain that you can work in both color and black and white and do well, if you are looking at the elements for their graphic representation and paying attention to tonal values. I still think in color, and I understand the language of color, after so many more years devoted to it. I love color. But the digital darkroom has allowed me to explore black and white more easily again, and now, when I create a black-and-white image, it's because the color isn't doing it for me, while light and contrast are.

RIGHT:
Channeling my inner Ansel Adams, I photographed this classic view from atop Sentinel Dome in Yosemite National Park. The day was beautiful, but the color image left me sort of cold, as it wasn't close enough to sunset to bring out the warmth of late light. I decided this could be a good black and white because the tonal contrast was great.

📷 *24–70mm lens at 52mm, f/16 for 1/50 sec.*

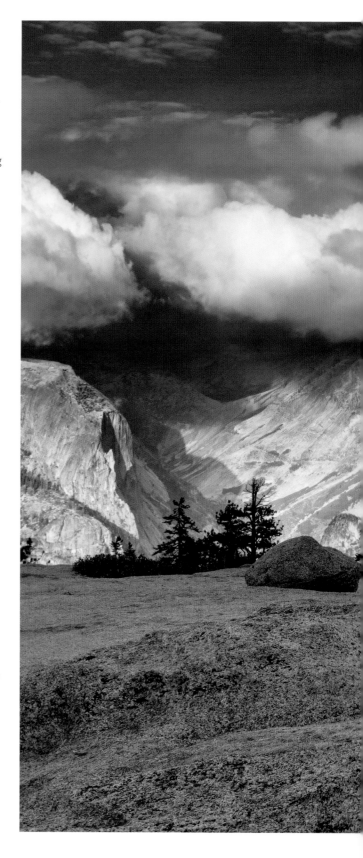

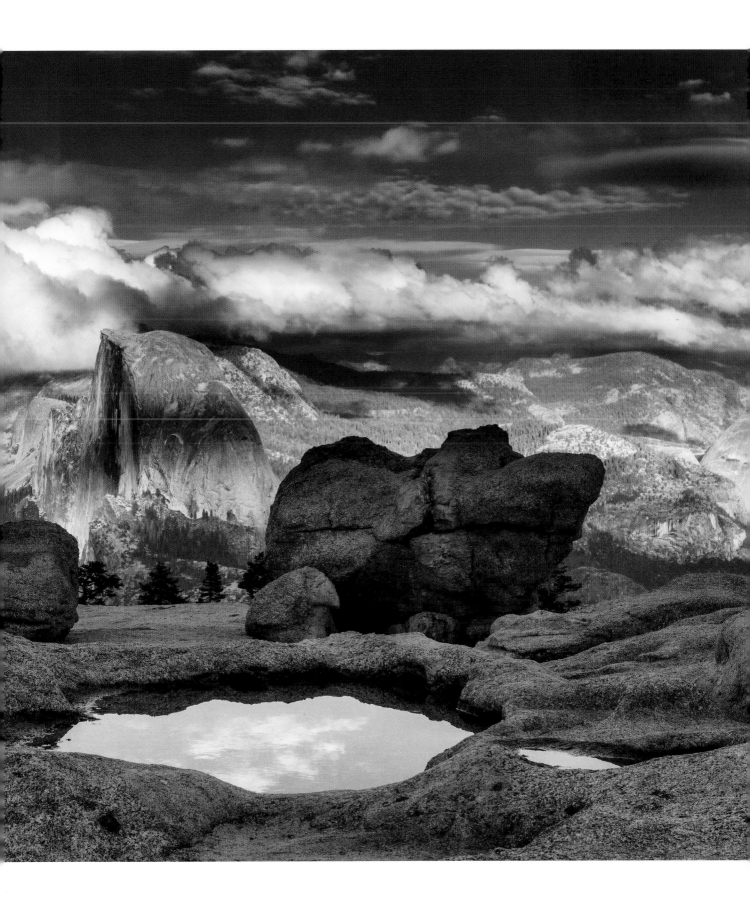

ABOVE:

The rocks at the Racetrack, a dry lakebed in Death Valley National Park, are a great playground for photography. Late afternoon light brought out the texture of the dried hard mud of the playa and the tracks of rocks that had moved. Shade on the mountain in the background puts the attention on the rocks and their tracks.

📷 *24–105mm lens at 50mm, f/16 for 1/20 sec.*

OPPOSITE, TOP:

The fallen oak leaves along the trail to Calf Creek Falls in the Escalante area of Utah were a pretty mix of earth tones. I felt the image would be stronger as a black and white, so I converted it and brought out the highlights of the older, drier leaves that were gray in the color image. I also liked the "crunchy" texture of this image.

📷 *24–105mm lens at 105mm, f/16 for 1/6 sec.*

OPPOSITE, BOTTOM:

The Zabriskie formation in Death Valley unfolds in a series of cream, beige, soft brown, and soft brick-color hues but needs the rich colors of dawn to be enhanced. After sunrise on this morning, the color of the light was gone, but the angle of the light was still nice for the mud formations. As the light on the back mountains crept down the slope, I was able to capture strong light, shadow, form, depth, and texture.

📷 *70–200mm lens at 135mm, f/16 for 1/15 sec.*

OVERLEAF:

It was a blustery, stormy day as I left Moab and headed north in Utah. Traveling on back roads through high desert valleys, buttes, and washes, I was having a great time playing with the storm light on the land. The color of the land was not exciting, being beige, brown, and gray, but dramatic light ensured a successful black-and-white image.

📷 *70–200mm lens at 150mm, f/14 for 1/200 sec.*

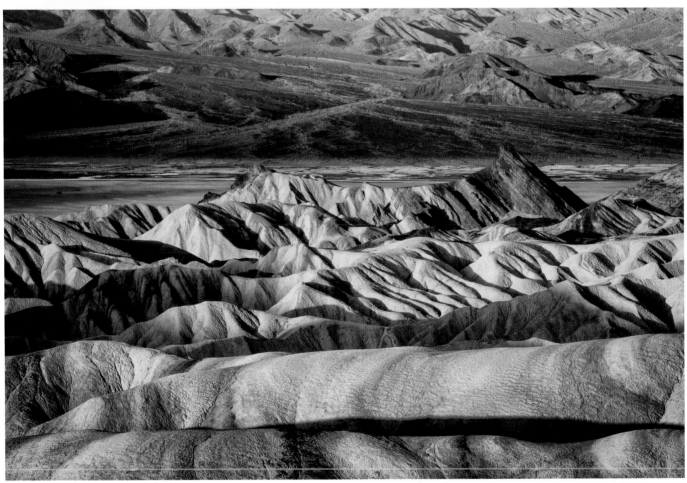

CHAPTER 5

INTERPRETING THE LANDSCAPE

"A great photograph is one that fully expresses what one feels, in the deepest sense, about what is being photographed."

— ANSEL ADAMS

Nothing better expresses the vastness of wilderness, the majestic beauty of mountains, or the ruggedness of a coast than the image of a grand landscape spread out before our eyes. It's in this large-scale image that we can capture the depth and breadth of a scene, and include many elements that combine to express natural beauty. Apart from the grand landscape, though, we can be similarly moved by the intimate landscape, as well as by close-up and telephoto images.

OPPOSITE:
The wind was whipping up the surface of the water on Lake Superior, in Wisconsin, and the late afternoon light bathed the water, rocks, and trees in a wonderful warm glow. I positioned my camera and tripod about three feet above the beach and angled the camera down, to create strong visual depth and put the viewer there on the beach with me. I composed with room for the water to rush in over the stones and waited for the moment. When it happened, I got my feet wet—but it was worth it! For images like this, you need to make many pictures, because you will get varied results in the waves. But you'll find a favorite image where everything comes together perfectly.

📷 *24–105mm lens at 24mm, f/16 for 1/40 sec.*

These interpret the natural world differently, and the intimate landscape is a favorite of mine. Nothing excites me more than to find an intimate scene that puts me in closer touch with nature, a scene that celebrates nature's design. Perhaps it has to do with my own desire to make that deeper connection with nature. The experience of finding magical details delights me; that I can share these little details through my photographs with others fulfills me.

THE GRAND LANDSCAPE

The grand landscape can grab hold of us and inspire and amaze us. The power of nature, the awesome (yes, I'll use that term) beauty of nature, *is* overwhelming. Locations such as the Grand Tetons, the Swiss Alps, or Iceland serve up dramatic scenes to photograph, but beauty isn't found only in remote, wild places. The large pond in your woods, the view along a frozen stream in a mountain meadow, the waves rolling in to a beach that spreads for miles are landscapes that most of us will encounter more often, and they are just as beautiful. They might be slightly smaller in scale, but they can be just as grand in the superlative sense.

Of all the subjects of outdoor and nature photography, the grand landscape may well be the most challenging, because so many things need to come together: an interesting location, great (or at least very good) light, interesting elements in the foreground as well as in the middle and background, a balance of the tonal contrast, and focus throughout.

With so much information in the big scene, it's critical that you find a way to provide structure and a visual flow. You want to create a way to guide the eye through the scene, showing details and telling little stories along the way. You also want to build in the depth that you see, by using the concepts of perspective and near-to-far relationships.

FINDING A NEW ANGLE ON FAMILIAR SCENES

Some locations have been photographed so often that it's difficult to create anything fresh or new. Light and weather conditions can help you express a popular location differently, as every visit will be unique. Unless the composition is really different, though, it's hard to get people excited about the same old view. That being said, I am guilty of photographing from the well-worn tripod holes of certain locations. I visit my favorite haunts fairly regularly, because weather and light change, and in some cases because I am still looking for the perfect photo conditions. It's hard not to do that in some places, yet we should all push ourselves to go beyond those tripod holes and look at ways we might be able to interpret the scene just a little differently with a unique perspective.

OPPOSITE:
The afternoon was stormy, but my friend drove me to a secret location to photograph these petroglyphs. Though I wasn't blindfolded, I wouldn't have been able to find my way on my own, after too many turns and intersections in dirt roads. I just know we were somewhere in eastern California. The sun was getting close to setting, but since it was behind clouds I figured I didn't have a good shot at getting a picture, but I composed a photo anyway just in case. Suddenly, sunlight broke through enough to light up the clouds without shining toward us, and it was such a beautiful sky! It was great to have that hint of light on this image. It added such mood and expressed the spiritual feeling this ancient site imparted.

📷 *17–40mm lens at 20mm, f/16 for a bracketed series.*

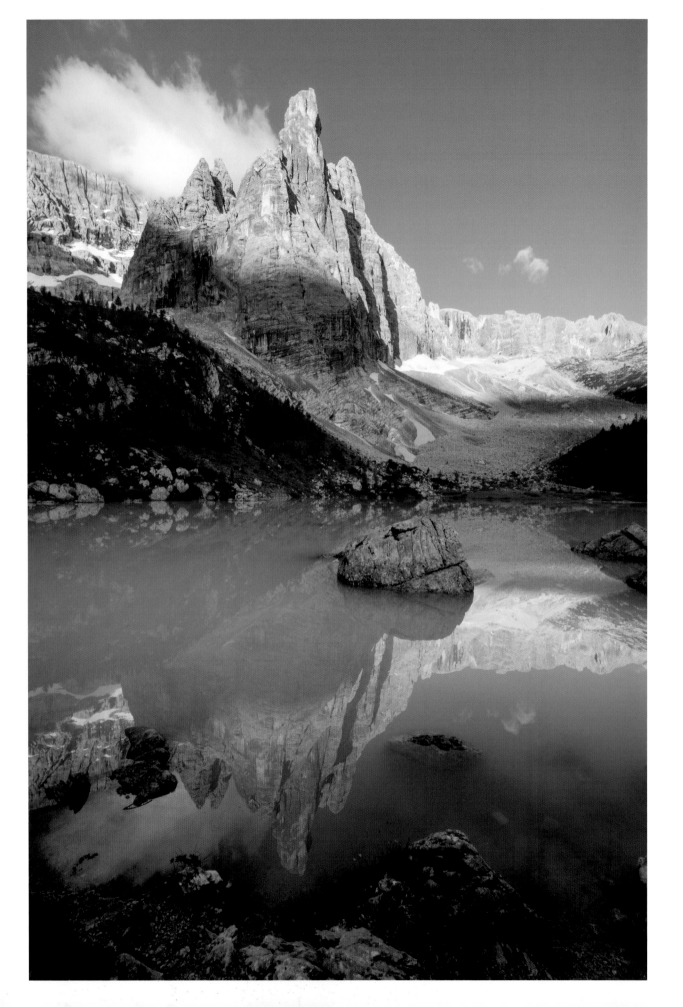

Go down the path away from the overlooks, and down the road to less-explored locations, and find your own grand landscapes. There are infinite scenes waiting to be discovered through your eyes.

APERTURE AND GRAND LANDSCAPES

With landscapes, it just *feels* right to have everything sharp. That's because when we look at the foreground, it's sharp; we shift our eyes to the meadow in the middle of the picture, it's sharp; and when we look at the grove of trees against the mountain in the background, it's sharp, too. Our brain naturally combines these areas of sharpness into one complete image, and so we want to choose an aperture that will render that sharpness in our photograph. Often $f/11$ or $f/16$ will do it, but to ensure maximum sharpness throughout, we need to focus using the concept of hyper-focal distance. When focusing on any point in the scene, you have a range of focus that includes an area in

OPPOSITE:
Afternoon light struck the rock formations high above this glacial tarn in the Dolomite mountains of Italy, and the contrast of the warm light against the cooler hue of the lake made this a dramatic moment to capture. I included the edge of the lake as the first step into the scene, and used the rock as a further stepping-stone in the middle ground. I carefully composed so that the mountain reflection didn't merge with the rocks near shore. It was a tight fit but it worked.

📷 *16–35mm lens at 16mm, f/11 for 1/40 sec.*

ABOVE:
I had stopped in for lunch at the cafeteria during this rainy day in Monument Valley, Utah, and was enjoying a nice bowl of soup when suddenly the weather broke slightly and the sun lit the valley floor below the rim. I ran outside, leaving my soup and jacket behind, to get a photograph before it all disappeared. Light like this is fleeting but it's what every landscape photographer searches and hopes for! I made several exposures before the clouds closed up and the show was over.

📷 *24–105mm lens at 40mm, f/9 for 1/200 sec.*

front of and behind that selected point that will be sharp. This is called your depth of field. Using smaller apertures, this depth of field will be pretty deep, but to ensure your foreground and background are sharp, you'll want to focus at a distance within your scene that will render the best depth of field. Charts or apps help you know the zone of focus that you have to work with at a given aperture, and you can use this knowledge to place your focus so that your foreground and background are sharp.

If you can't get all of your landscape in focus for some reason, it's pretty essential that the foreground at least be sharp, as that is the way we'll be visually invited into the scene. Since most of us can't really see infinity sharply, the far background can be slightly soft, but the larger the print, the more pronounced that softness can be. A background that is noticeably out of focus can be distracting. If a small aperture is not providing you complete focus, you have three options:

- Raise your camera position a bit higher, and angle the camera downward slightly to reframe the same composition. This puts the camera's sensor plane a bit more parallel to the plane of focus across your scene, and you'll get more depth of field.

- Use a focus-stacking method of taking several pictures, shifting your focus plane in the frame each time, from the foreground all the way to the farthest background, while still keeping your aperture small. You generally won't need too many focus "slices" when using a wide-angle lens at a small aperture. And, in fact, this allows you to use an aperture of $f/8$ or $f/11$, the "sweet-spot" settings for best resolution on most lenses, which takes care of any resolution that might be lost at $f/16$ or $f/22$. Once you have the exposures, combine them in focus-stacking software. This won't work if your scene has movement, since you'll end up with ghosted edges and things out of alignment. For more on focus stacking, see page 162.

- Consider using tilt-shift lenses. These are great tools for landscape photographers. A 17mm or a 24mm tilt-shift gives you a lot of control over depth of field in landscape photography.

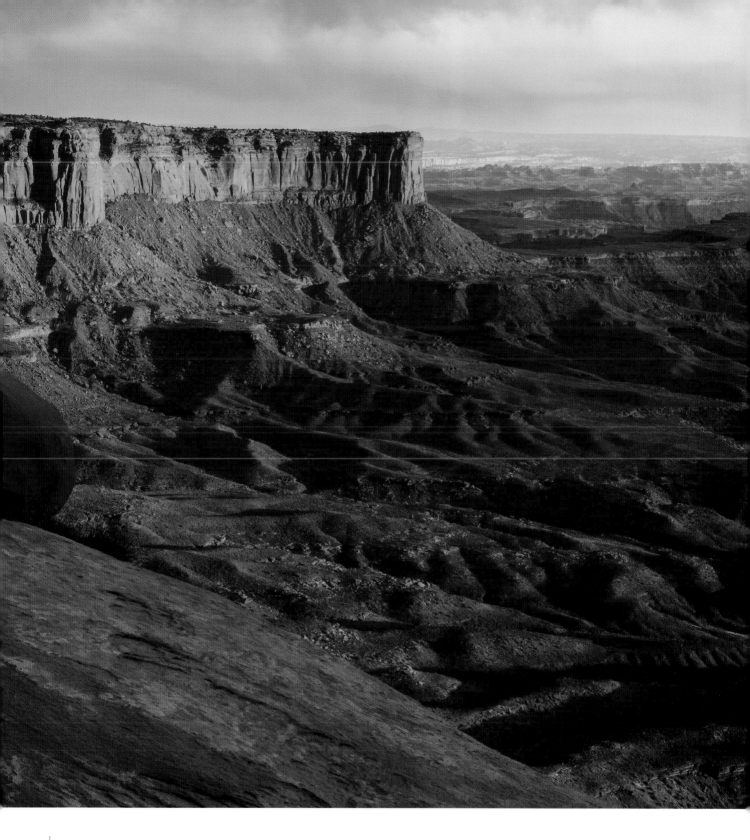

ABOVE:
Late afternoon illuminated the cliffs opposite my position in the Island in the Sky district of Canyonlands National Park. The clouds above reflected just enough warm light to fill in the foreground details, thankfully, as I wanted to create some feeling of depth in this landscape. It needed to all be sharp, however, or the rocks I was standing on would be distracting and hard to get past visually. To get it all in focus, I chose a small aperture and set my focus point according to the depth-of-field app on my phone.

📷 *24–105mm lens at 55mm, f/16 for 0.4 sec.*

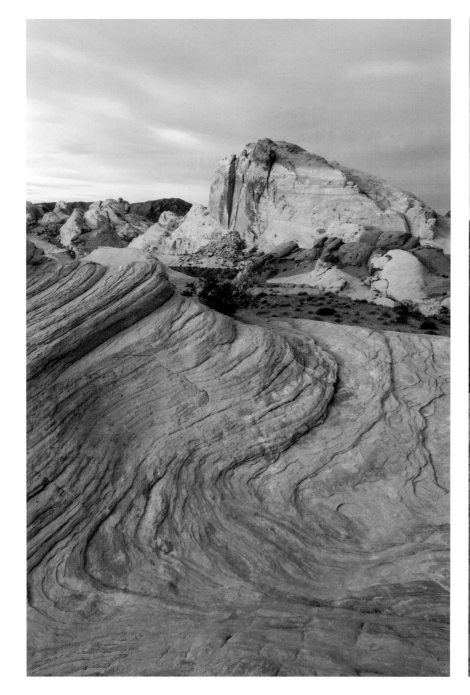

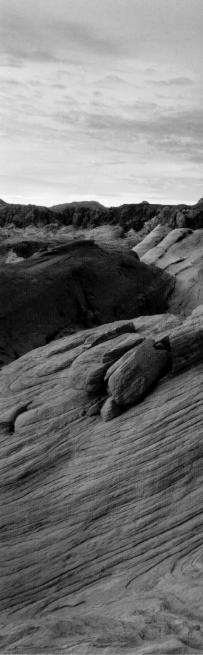

WIDE ANGLE AND GRAND LANDSCAPES

Photographing large sweeping vistas is best with a wide-angle lens, typically in the range of 11mm to 24mm. While you can certainly photograph the grand landscape with 28mm to 35mm, too, longer focal lengths beyond 35mm won't express the scale of the scene in the same way. A 50mm is like the view of our human vision, so if we are seeing the vista as "grand" with normal eyes, why doesn't it look that way in the photograph? Because the depth in a 50mm view is not expressed as strongly. You need the exaggeration of wide-angle lenses to create a stronger perspective. The stronger the perspective, the more we feel the largeness of the scene. Using a wide angle, then, is great, but you can't just point at a landscape and expect great results. Wide angles optically push everything away

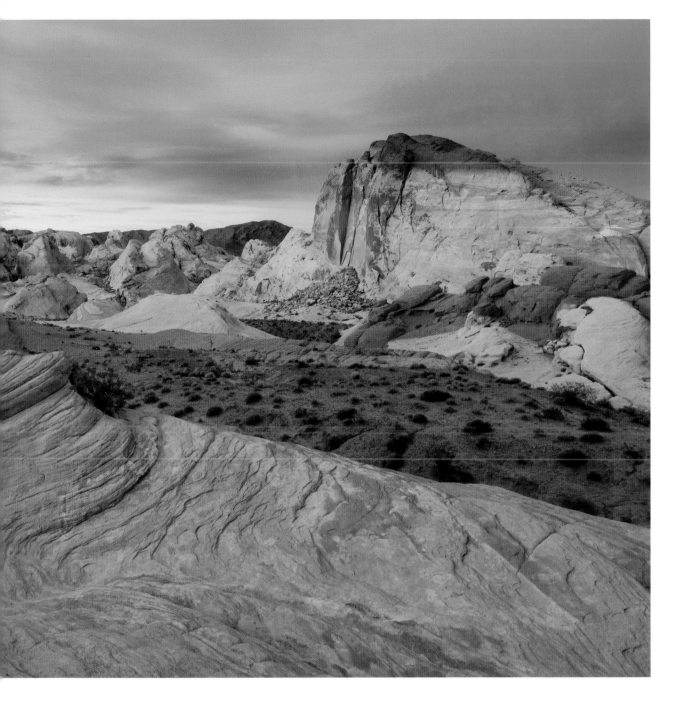

from where you are standing. The result is that the image feels remote, like a distant view from the side of the road. To counter that problem, you need to find and get close to something to use as the foreground, interesting enough to engage the viewer and tie the foreground to the background visually.

OPPOSITE AND ABOVE:
Dawn was stunning this morning in Valley of Fire State Park, Nevada, where my friend and I were camping. Using the strong lines of the foreground sandstone, I couldn't decide which orientation I liked best. The light was changing as the clouds moved in on us, so I quickly but carefully took both compositions. The vertical image was made first, because I love the strength of the curving S-lines in the rock. Then I switched to a horizontal format, and that switch caused me to rethink my position and change my point of view. The horizontal includes more of the beautiful sky, and it also includes the middle area of land and offers a broader feeling to the landscape, although it's a little less dynamic in terms of foreground. In the process of interpreting the landscape you have to think of all the elements to determine what will look best in any orientation of the frame.

Both: 24–105mm lens at 24mm, f/14 for 5 sec.

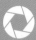

Pointers for Landscape Photographers

- Look for interesting locations, and find a fresh perspective.
- Try to be there in great light.
- Get *physically* close to things in the foreground. This exaggerates their size in relationship to other objects and elements in the frame behind them.
- You may need to be at a slightly higher position to show background elements, and keep them separated from the foreground.
- Find a way to create a flow for the eye by using leading lines, or a repetition of rocks, or tufts of grass, to bring the viewer from foreground to background.
- Pay attention to the middle ground and background. In landscape images, as in a good book, you must have a flow from start to finish. You don't want to lose someone in the middle of the landscape!
- Watch for mergers or distractions: trees or rocks breaking the horizon line; branches poking in from left or right; out-of-focus grasses or objects in extreme foreground.
- Check the range of light, from brightest area to darkest, and check exposure. Bracket for blending later or HDR if needed; use graduated neutral-density filters if feasible to balance the light.
- Always work on a tripod for careful compositions, and accurate focus and depth of field.
- Make sure you have sharpness throughout the scene. You'll typically be using f/11 to f/22 for an aperture, but you'll need to set a hyper-focal focus. Use a hyper-focal app on your smartphone or printed charts to calculate and set the hyper-focal focus to get foreground to background in focus. Make an exposure to check the focus. Preview the picture at magnification, to verify focus on both the foreground and background, if you are worried about the focus.

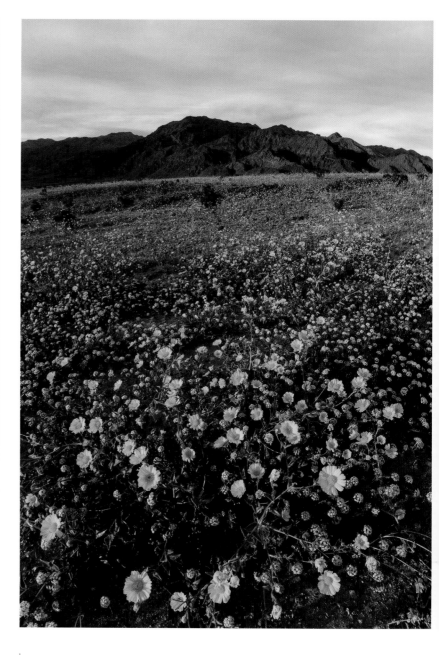

ABOVE:
Unlike the dense wildflower meadows in the Rockies or other mountain environments, desert flowers in Death Valley National Park, California, need their space, as the scarcity of water means only a limited amount of plants can survive in a given area. This is where using a close-in approach for landscape helped. I positioned my tripod above the flowers in the foreground about 2½ feet, and angled the camera down, which optically distorts, but this distortion helped to emphasize the flowers. Being slightly above them allowed for the rest of the landscape of blooms to spread out toward the mountains in the background.

📷 *16–35mm lens at 16mm, f/18 for 1/10 sec.*

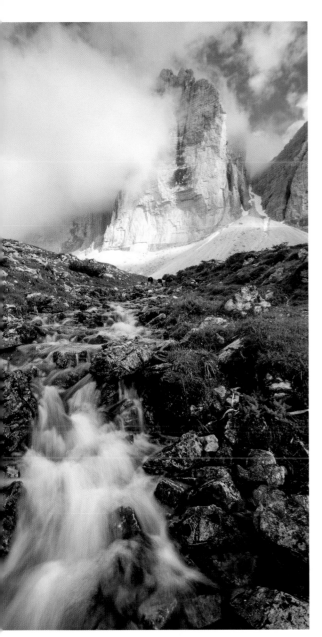

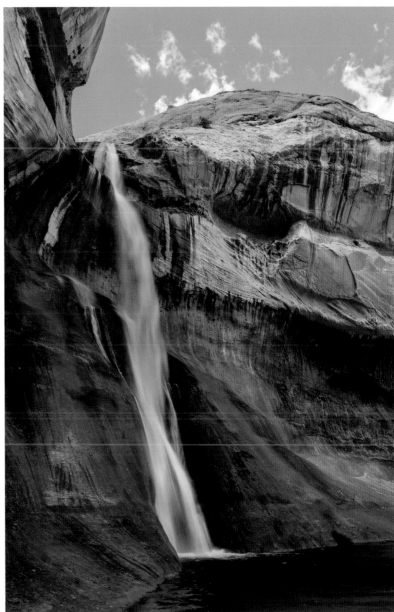

ABOVE, LEFT:

Trekking in the Dolomite Mountains of Italy, I came to this beautiful scene with the stream flowing with the famous Tre Cimi formations in the background. The clouds were amazing as they swirled around the peaks. Getting in the middle of this small stream allowed me to use it as a strong foreground element. Sometimes you just have to get your feet wet! The stream expresses energy, and it creates a visual pathway leading from foreground to the mountains. I waited for the foreground to fall into softer light from a passing cloud, to minimize contrast, hoping to get dappled light on the background at the same time.

📷 *16–35mm lens at 17mm, f/16 for 1/5 sec.*

ABOVE, RIGHT:

Sometimes, in order to capture the full tonal range in a landscape, you just have to make several exposures and blend them. There's no way to use a graduated neutral-density filter on a scene like this, because the line between rock and sky is not even. And when you get the exposure just right for the falls and the rock walls, so your shadows aren't too dark, you've blown out (over-exposed) the sky. If you expose for the sky, the rest of the scene will be too dark and can present quality issues when lightening it up later. HDR won't work easily, either, because the moving water can look odd, unless you blended back in the water from one of the brackets after the HDR was finished. For this image, in Utah's Escalante Grand Staircase National Monument, I chose to expose one image for the sky, and then when the sun went behind a light cloud, I exposed for the falls and rock (as that evened out the light, thereby reducing the contrast), and later in the computer blended the two together for a natural look.

📷 *24–105mm lens at 24mm, f/14 for 1/8 sec.*

ABOVE:

Not every landscape image works with a super-close foreground. Imagine these scraggly bushes up close in your face! The closer you get, details that may not be photogenic are likely to appear. The view was still great in soft afternoon light, and the three bushes in the foreground are still integral to the composition, as they create a stepping-stone into the landscape and add texture.

📷 *24–105mm lens at 32mm, f/16 for 1/6 sec.*

BELOW:

I was drawn to the layers of pattern and the light and color on a friend's pond in Minnesota. It exemplified the riot of color that autumn is for me. The soft angle of sun creates a textured surface across the lily pads, while the sunlit trees reflected in the water add color between them. The cooler hues of the lily pads in shade versus those in the soft sidelight of morning add a nice color contrast to the scene.

📷 *70–200mm lens at 183mm, f/16 for 0.6 sec.*

Choosing an Aperture

As one of the three controls in the exposure triangle, aperture controls the amount of light coming in to the sensor, and it controls depth of field, that is, how sharp the image will be in front of and behind the focused subject. However, many photographers don't use aperture as creatively as they could to make their pictures more expressive. Landscape photographers using 35mm typically use *f*/16 or *f*/22 to get everything sharp, and conversely, most photographers know to use a wider aperture to reduce clutter in the background on close-up images.

You can make choices with aperture, though, that will ensure that certain types of images are stronger or more expressive. It's not as simple as just using *f*/16 for maximum depth of field or the opposite extreme of *f*/2.8 to get blurred backgrounds. How then do you decide what the correct aperture *should* be for your picture? Simply put, you need to think about what the subject is, and how much story or information you want or need in the background to express your interpretation of the scene. Each type of picture, a landscape, an intimate landscape, or a macro image, will benefit from a carefully chosen aperture, and no two situations will be identical. There are technical reasons for choosing the right aperture, but there is also the creative outcome to be considered. We'll discuss the choices throughout this chapter.

ABOVE:
These great standing stones in western Ireland hold a mystery to their origins. Choosing a wider aperture than I might typically use for a landscape allowed me to isolate them from the background, yet still put them in their environment. It also allowed me to soften the visual strength of the waterfall in the background.

📷 *70–200mm lens at 200mm, f/11 for 1/50 sec.*

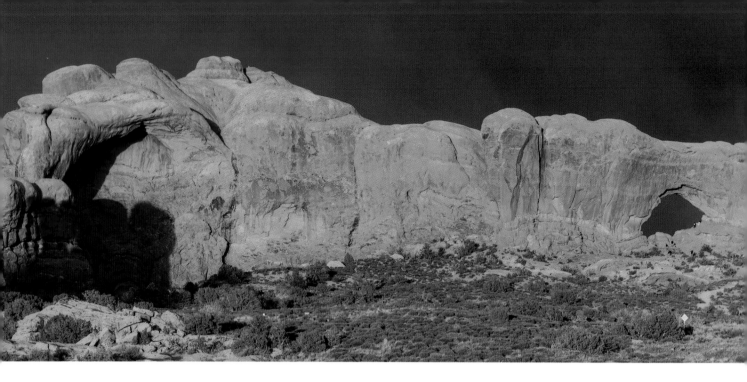

THE PANORAMA

Along with wide-angle compositions, panoramas can express the breadth of the landscape, and offer a dynamic and expansive interpretation. This broadened view is impressive and stimulating, as it's wider than we can see normally. So much beauty, all spread out in front of you; it's exciting! With a panorama format you can express the vastness of a place and bring a fresh view to landscapes.

By common standards, a panorama format is a 3:1 ratio, that is, three times as wide as it is tall. In the days of film, when Kodak introduced the APS (Advanced Photographic System), you could choose normal or wider formats when making your pictures on the same roll, and markers defined the actual image dimensions. The wide view, a 3:1 ratio, became popular as a new way to present scenes. But for purely creative purposes, any time you stitch together three or more images so that the width is wider than the height by at least two or three times, it's a panorama! It doesn't take a lot of technical knowledge to create a simple single-row horizontal panorama. There are some basic things to consider, however, such as using manual exposure, not getting too close to foreground objects, and not using a polarizer. Refer to the photo tips here for more on the technique. Once you make a few, you may find yourself hooked—there are so many scenes that make interesting panoramas.

Think about vertical panoramas, too. These are really different views. It may be one tall sequoia or other tree that you compose, or a tall waterfall. You'll photograph it the same general way as any panorama only this time you'll be moving the camera vertically. That presents some challenges with distortion, but these issues can be easily corrected in the computer.

ABOVE:
The amazing storm light on a spring afternoon in Arches National Park, Utah, lasted long enough for me to make a quick panoramic composition. These ten vertical images combined provide a very wide view of the entire Windows area with various arches. With an image this wide, several shorter panoramas can be cropped from it, but I just had to celebrate the incredible light by including as much as I could manage. At original size this image would be 72 feet wide!

📷 *150–600mm lens at 309mm, f/13 for 1/8 sec.*

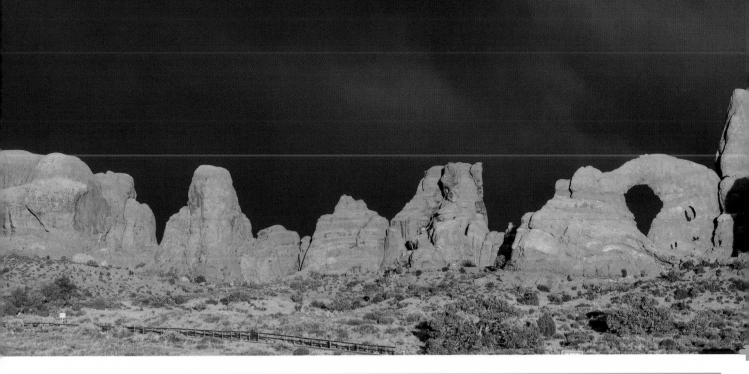

 ## Creating Panoramas

- Look for scenes that have visual interest from side to side, and light that is interesting yet not too extreme in range from one side of the scene to the other.
- Try to position yourself so that a main point of focus (say an arch or tree) will not end up dead center in the pano when you're all done stitching it together, or allow room on one side or the other to crop and reposition. This can be hard to pre-visualize in the field, but if you have a smartphone, you can take a panorama with it to see how things will pan out.
- Turn the camera vertically. This way the file of your panorama, when all stitched together, will be a large file, so cropping off the excess on top or bottom still leaves you with a large image file for big prints.
- Use a tripod and a leveling head for accuracy when rotating from side to side for the individual images. Whether on tripod or handheld, compose with more space at top and bottom of the frame than you think you'll need, because an upward or downward tilt always seems to occur. This will hopefully keep you from clipping off the tip of a mountain or a group of trees, or the animal's head, when the alignment of images happens in the stitching process. When making vertical frames, you have a large end-file to work with.
- Use manual exposure mode, and take a meter reading for the brightest area to be sure you hold the highlights. Check your darks, too: If the range of light is too great, you may need to do bracketing for HDR, which adds to the complexity of creating a panorama. Otherwise, set an exposure for the balance of the scene, protecting foremost the highlights and whites.
- Do a practice run from side to side, overlapping about 30 to 50 percent, while noting how many images you'll be making to cover the area you want to include (if you want to achieve a true pano ratio). After a practice run or two, noting where you need to begin and end, take a picture with your hand in the frame, to mark the beginning of the series, and then start making the actual pictures, still overlapping by 30 to 50 percent so the computer has more data to work with in aligning the pictures. When done, take another picture of your hand, with fist closed. Believe me, a system like that really helps later when you are wondering why you have twelve images that don't seem, on their own, to be a great composition!
- Watch out for objects closer to the camera, as you can have parallax issues, especially with wide-angle lenses. If you are including foreground elements, you may need to align the nodal point of your lens (the center of your lens in terms of overall length) directly over the center of the tripod. It's easy when you use a slider bracket to do this. Or, just stay away from having objects close to the camera. There are dynamic panorama images to make using the near-far relationship to create depth, but they require a bit more planning and involve more refined technique.

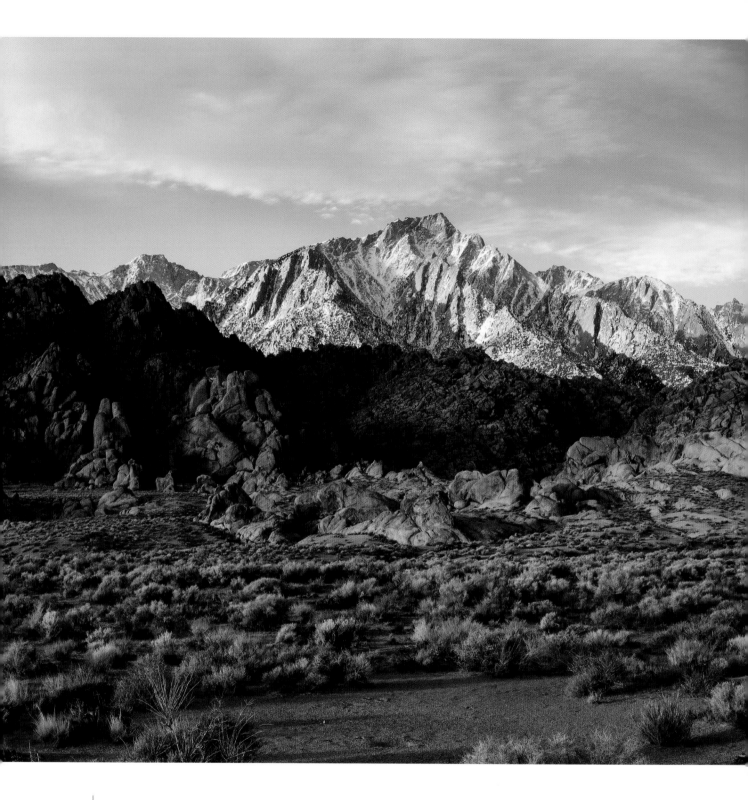

ABOVE:
The soft morning light of an autumn day brought the Sierra to life against the Alabama Hills, an area of rounded granite boulders that have appeared in many a Western movie. The layers of the grasses and bushes with the hills of rocks created great layers. The angle of the light created shadows across the land and brought out texture and form. I manually set the exposure to be sure I held the bright areas of snowy mountains and clouds. I must have been asleep that morning, though, as I made this panorama using horizontals. When I realized that and switched to vertical orientation, the light had changed and I never got it back. Another lesson learned: Get caffeine first!

📷 *24–105mm lens at 40mm, f/16 for 1/13 sec. across the range of images.*

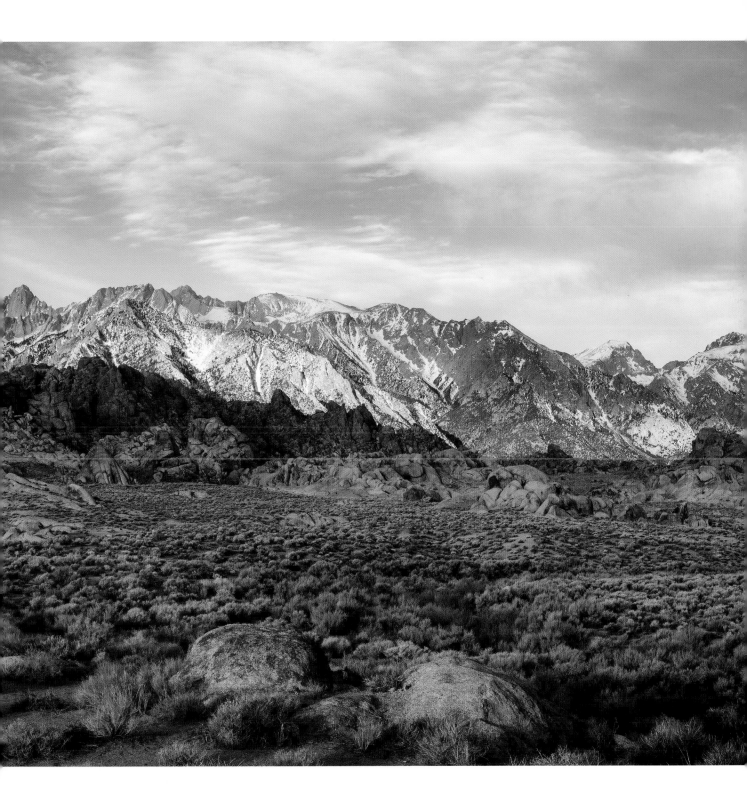

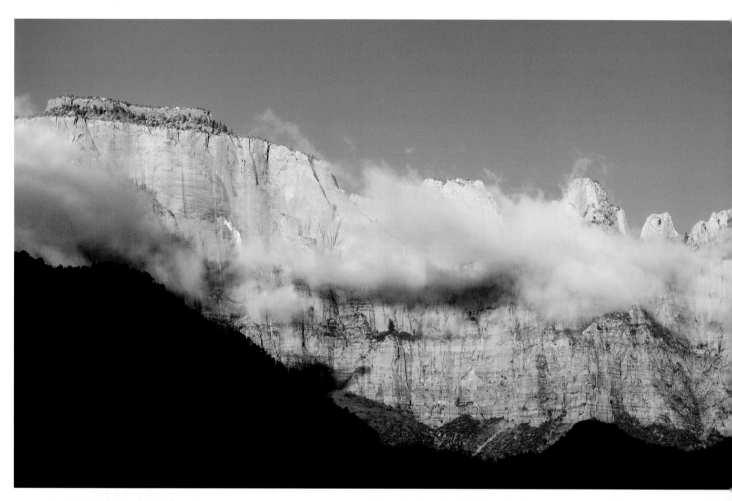

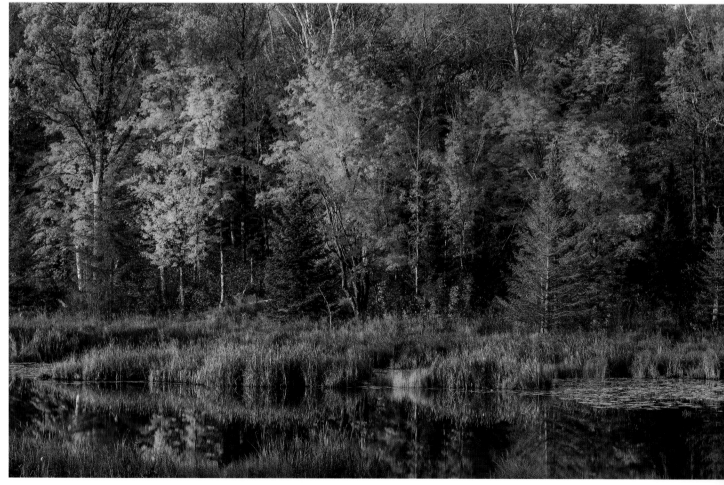

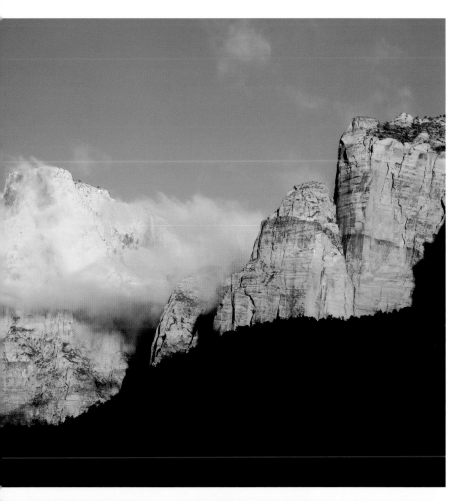

TOP LEFT:
I have photographed this view countless times on photo tours and workshops I've lead to Zion National Park in Utah, but this time, the added atmosphere of low clouds added magic to the scene. After making a few standard 35mm compositions, I set up to make this six-image stitch. I made sure I was level, and made a few practice swings left to right to be sure, and to see how the spacing would look on top and bottom. I ended up being close to that dark edge of the shadows at the bottom of the frame. Thankfully, I made it with space to spare, yet it's a reminder to always give yourself more room than you really want when making the vertical frames. That way the picture file will be tall enough when stitched to give you leeway to crop off what you don't want; it's a real disappointment if you clip the mountaintop or cut off a tree that was essential to the panorama.

📷 *55–200mm lens at 101mm effectively, f/13 for 1/60 sec.*

BOTTOM LEFT:
I was visiting a friend who had this pond on his property, and we took off early one morning in the hopes of photographing mist rising off the pond. But by the time we arrived at the edge, the little bit of mist had evaporated, so instead we photographed the quiet beauty of a diffused sunrise as it lit up the trees around the pond. I quickly set to work making a panorama, as I wanted to capture a wider view than my lens would provide. I calculated the number of images I needed to make, in this case nine, and set my exposure manually.

📷 *70–200mm lens at 160mm, f/16 for 0.5 sec.*

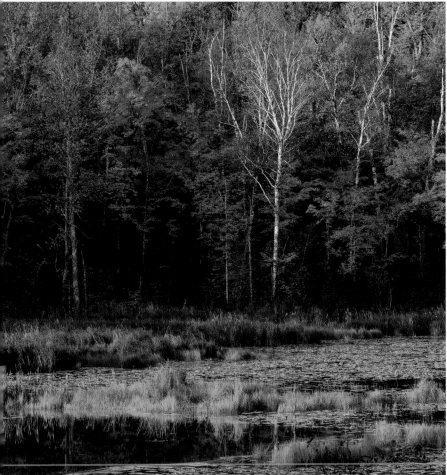

THE INTIMATE LANDSCAPE

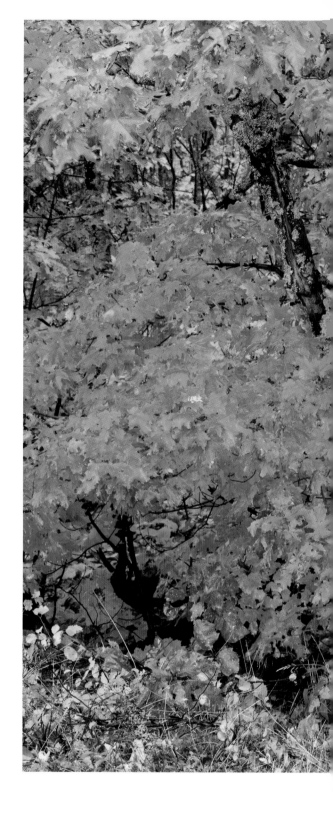

What is an intimate landscape? To me, an intimate landscape lies somewhere between the very close-up, or macro, image and the grand landscape. It's a point of view that, when successfully expressed, puts the viewer in your footprints, to experience what you found so compelling. Intimate photographs are usually simplified, distilled down to a few elements, or at the very least reduce the visual information of a large-scale image into something more focused, more directly interacting with the photographer at the time of creation, and later, the viewer. Eliot Porter, a master landscape photographer, defined this in his book *Intimate Landscapes*, and he was a strong influence in my visual growth as a photographer.

By sharing your discoveries through your images, you are trying to invite your viewer to have a deeper connection as well. Whether they've experienced the touch of dried mud or not, they will still have a visceral reaction when viewing it. I have had people tell me that the intimate photograph they were viewing spoke volumes to them, proving to me that somehow intimate pictures reach in and touch something deeper in all of us.

Great details can be lost in the larger scene, just by the sheer amount of visual information that is contained in that larger view. Intimate landscapes can capture those details. Within a large landscape with a stream flowing through it, the flowing stream has a story to share. It may be in the colors reflecting off it, or the way it pours over the rocks. Beyond the overview picture of a canyon, your personal discoveries can tell the story of what happens in that canyon. The grand view and the intimate scene feel very different when viewed.

Typically, an intimate scene won't have sky included in the frame, but that's another rule you may choose to break. Visually, sky creates an expansion of the view, a reason to look up and away from the details, whereas the photographer's intent with an intimate landscape is to keep you immersed in experiencing the scene that is close at hand.

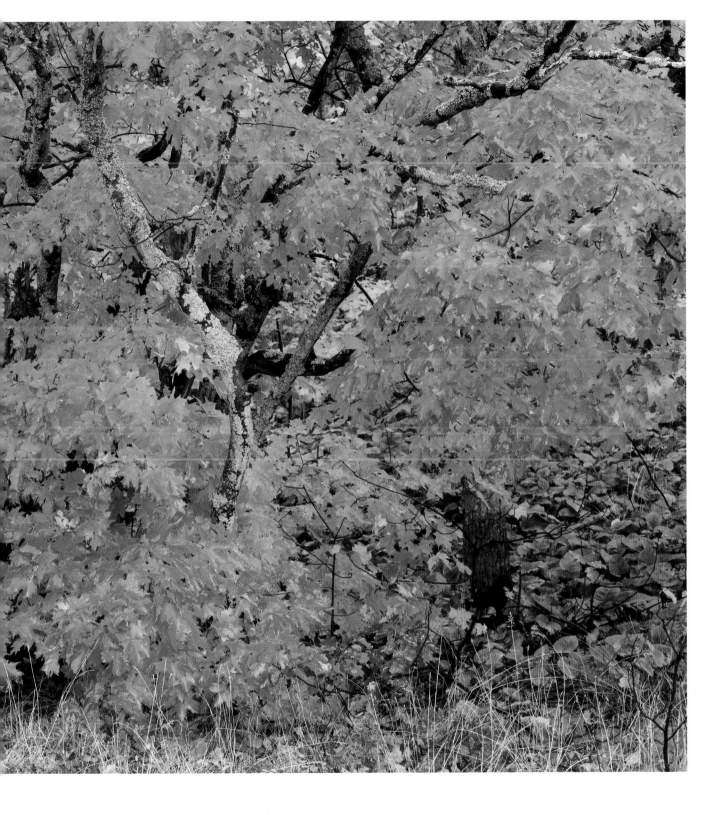

ABOVE:

It doesn't get much redder than wet maple trees at their peak in autumn! The rain had saturated everything in the upper peninsula of Michigan, but it brought out the colors of the deciduous trees beautifully. As we drove along the road, this maple screamed "photograph me." The lichen-covered tree trunk on the right became a focal point and the other trunks added supporting structure to the composition. Because an image like this requires diffused light, a benefit is that you can make many photographs like this in cloudy or rainy situations, as you don't need or want dramatic sunlight. Remember to use a polarizer on wet subjects. It cuts through the glaring highlights and brings out the truer color of things.

📷 *70–200mm lens at 70mm, f/13 for 1/3 sec.*

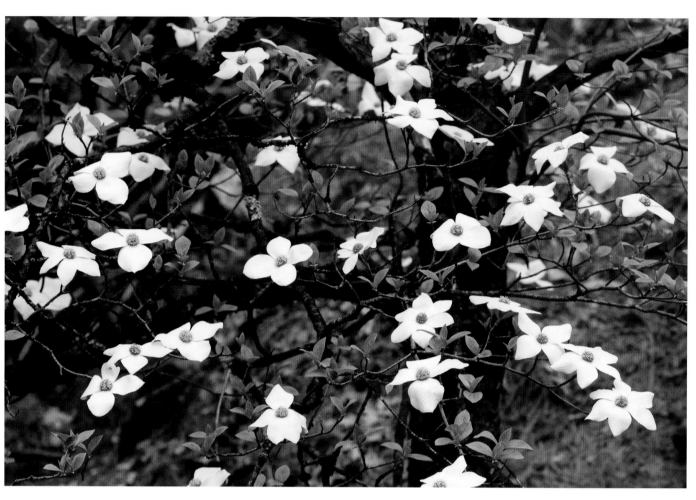

OPPOSITE, TOP:
Not all intimate landscapes work with total sharpness throughout the scene. In this image of dogwood bracts, I wanted the pattern of them to dominate, and so those needed to be sharp, but the background of ground, branches, and understory clutter wasn't desired. The aperture I chose was the best compromise for this scene. Anything less and the dogwood blossoms were going out of focus too much at the edges, anything more rendered the background too sharp. Nature doesn't always hand it to us as perfectly as we'd like.

📷 *100–400mm lens at 220mm, f/13 for 1/13 sec.*

OPPOSITE, BOTTOM:
What a wonderful find this was on a cold morning in Utah. I was looking for water pockets that might still have water in them for reflections, and I discovered instead a shallow one where the water had frozen over, creating a most interesting design. I positioned myself directly overhead to frame the part I liked best. I used the rock as a focal point, and let the shape of the frozen blue area unfold around it. I could have used my shorter lens, but I needed to stay high enough and far enough away to keep from getting any shadow or reflection from my tripod or me.

📷 *55–200mm lens at 300mm (effective focal length), f/14 for 1/4 sec.*

ABOVE:
Ice! I can't get enough of it when cruising the Inside Passage in Alaska. This piece had a very cool tunnel in it, so I composed quickly (as we were on a slow but moving boat) to put the end of the tunnel in the upper left, and let the eye be drawn in from the bottom toward that. You can feel the ice in this picture, it's so intimate, and it reminds me a little of a Fresnel lens construction!

📷 *100–400mm lens at 285mm, f/5.6 at 1/200 sec.*

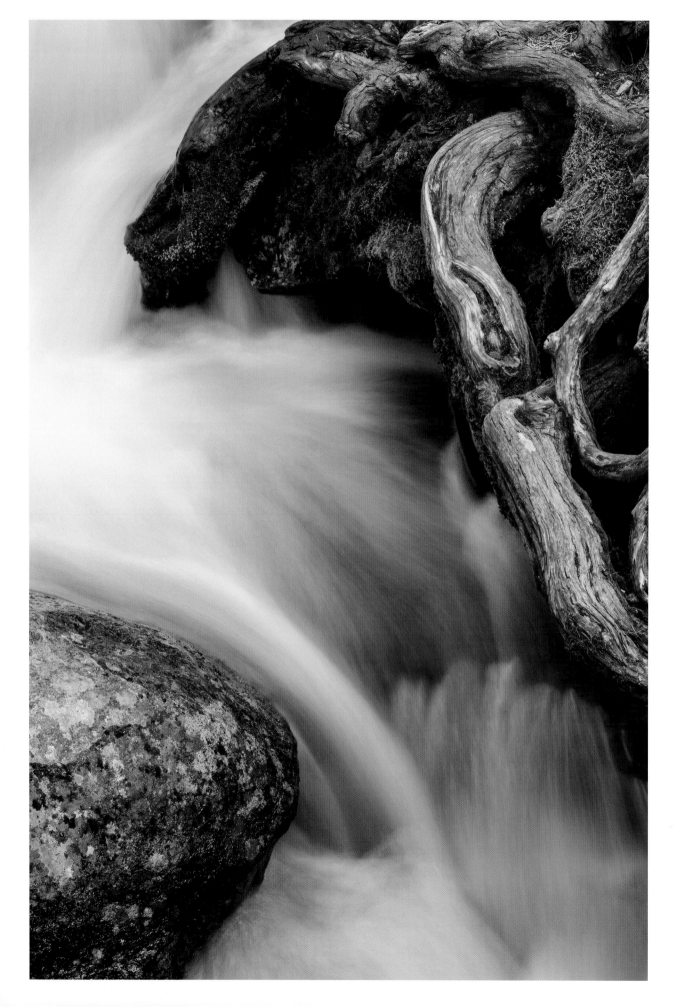

 ## Creating Intimate Landscapes

Actually *looking* for intimate scenes is like looking for the perfect mate: They will just find you! For me, if I am walking around in nature and absorbed in the moment, experiencing whatever it is, or wherever I am to the fullest, then I'm more open to seeing intimate landscapes. They just sort of present themselves to me. I believe that if you are open and mentally focused on what's right around you, they will be visible to you, too. But while you're waiting for that to happen, here are a few things you can do to help you make a good intimate landscape:

• Ask yourself what it is about the place where you are standing in this moment that is special. Look for scenes that tell a story in their own way, without needing the big picture.

• Look for patterns, textures, and strong shapes in the landscape that can help create graphically pleasing images that express the beauty and wonder of something.

• Keep the sky out of the picture to retain the "close-in" feeling and keep the eye from wandering off.

• Most intimate scenes are best when photographed with a mid-range focal length. Although any lens could be used, the distortion of a wide angle can push the view away, or create a strong pull that can take the feeling of intimacy away. It just feels different, and may not give you the intimate feeling that you want. I personally prefer to use about 40mm to 300mm for my intimate views, but on the longer end of that range, I would typically use the 300mm at the closest focus to make the scene intimate.

• Pay attention to aperture and choose what best fits the photograph you are making.

OPPOSITE:
The spring melt of the high Sierra meant the waterfalls and creeks were flowing in Yosemite Valley. As I explored Bridalveil creek, I looked for intimate scenes that told the story how the water rushes through rocks and roots on its way downhill.

📷 *100–400mm lens at 160mm, f/18 for .6 sec.*

ABOVE:
Nature astounds me at times. Madrona trees shed their bark, like an animal sheds its skin. In this close-up, the rough outer bark had split open to reveal the under layer of burgundy bark that was peeling away to reveal the newer layer of yellow-green, virgin bark. This image works as a strong visual representation of shedding the old to make way for the new.

📷 *70–200mm lens at 173mm, f/18 for 0.3 sec.*

RIGHT:

As part of interpreting the intimate landscape, consider minimalist compositions that still tell a story. The dead trees of Dead Vlei in Namibia stand in a parched lakebed, and their shadows, falling across the pattern of dried earth, express the harshness of life and death in the desert. You don't need the tree to tell this story: The bare, branchless tree shadow stretching across the hard playa says it all.

📷 *16–35mm lens at 24mm effectively, f/16 for 1/80 sec.*

BELOW:

These rocks on the shore of Lake Superior in Wisconsin created lovely round shapes and forms, and the beach was covered in them. A seagull flying overhead, or while preening, had lost a feather, and when I spotted it lying on the rocks, I knew I had a good intimate landscape opportunity. I used my 90mm tilt-shift lens to put the plane of focus as parallel as possible to the camera, as this was on a slight slope. I still used a small aperture to ensure sharpness. An image like this needs sharpness to be effective.

📷 *90mm tilt-shift lens f/16 for 1/20 sec.*

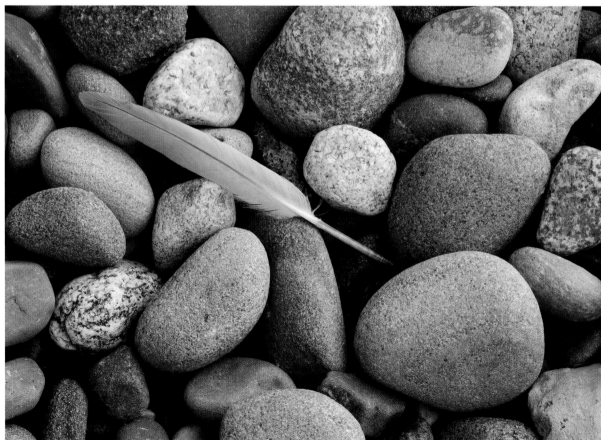

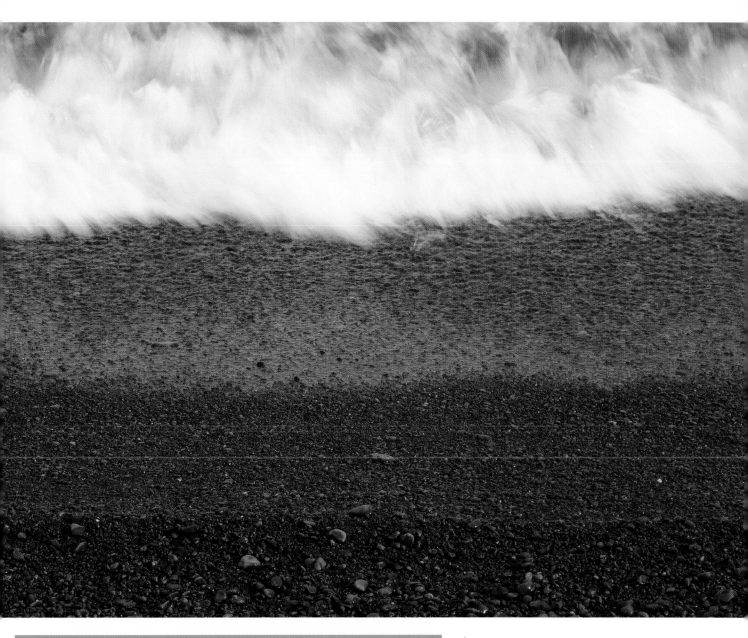

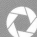 ### Exercise: Look More Deeply

Start learning to see details by taking a closer look at elements within the big picture. Narrow your field of view, and start taking visual inventories of the smaller details that you may have missed while you were focused on the grand landscape. If there are rocks in the scene, take a closer look at them. Or a stand of trees—are those worthy of a picture, too? Does the little group of rocks and trees together make a nice, intimate forest scene? Would the pattern of flowers around that one rock be a picture? The more you ask that question, while looking at any landscape, the more you'll narrow your focus to see the parts. I like to refer to it as "binoc-u-vision," like using a pair of binoculars to extract a piece of the big scene. Most locations will offer many intimate photo opportunities within the big picture, if you open your mind up to looking more deeply.

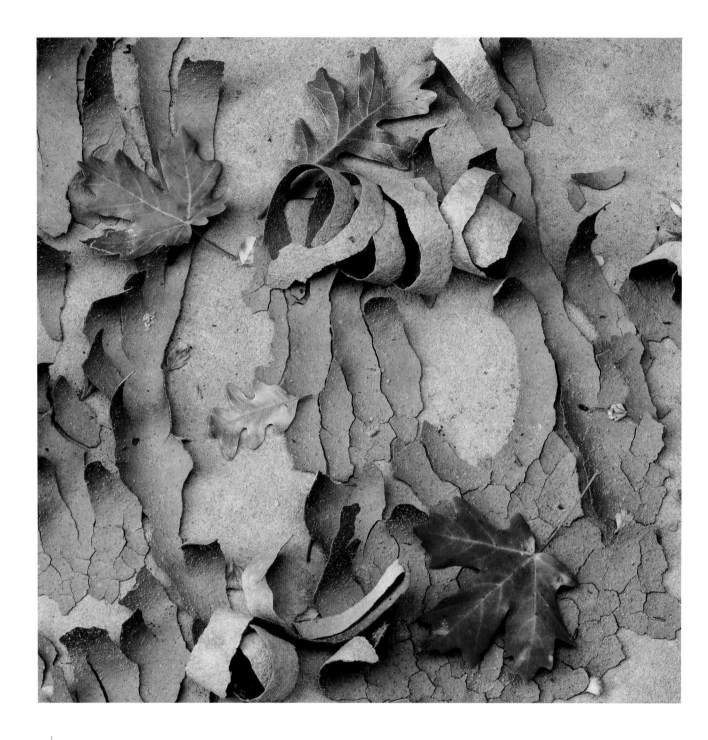

ABOVE:
This scene of curling mud reminded me of how paper curls when you run scissors down it with your thumb pressed against the blade. I am addicted to photographing dried mud, because each situation is so different! The autumn maple leaves that fell on top of this scene are softer hues, expressing the end of autumn's brilliance, and they also create a counterpoint to each other, with the other oak leaves filling in the story. I composed with a square format in mind, as the rectangular frame would have included too many distracting bits, and cropped afterward. After many years of photography, I am so used to the rectangle ratio of 35mm cameras that I rarely crop to a square. However, this wonderful scene needed a square crop to have impact.

📷 *55–200mm lens at 157mm (effective focal length), f/16 for 0.8 sec.*

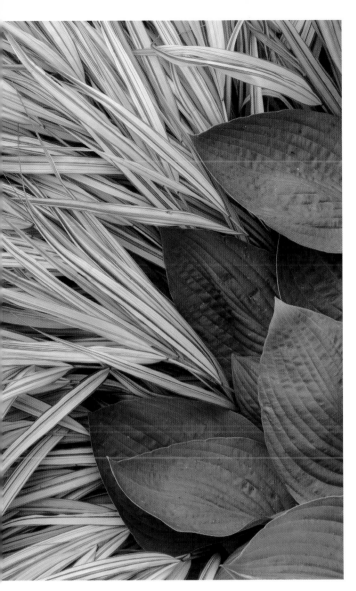

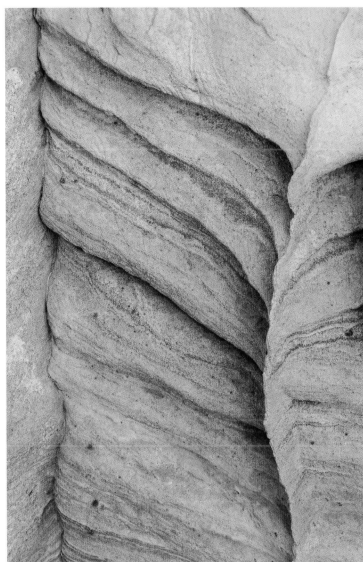

ABOVE, LEFT:

The contrast of the colors and the shapes of the hosta leaves and flag grass grabbed my eye in Central Park's Conservatory Garden in New York City. Master gardeners have a great eye for design, and they can design a garden plan that will delight the visitors' senses and guarantee there will be compositions for the photographer, too! The grass, with its yellow hue and lines, was visually assertive, so to express that and create a little tension, I gave it just a little more space in the frame.

 24–105mm at 70mm, f/11 at 1/60 sec.

ABOVE, RIGHT:

The folds in the rock resembled ice cream as it is being churned. This was causing me to get hungry after walking around in the midst of these sherbet-hued rocks in Nevada's Valley of Fire State Park. What's amazing is that this geologic process that developed over a long time almost appears to be soft and still flowing. Getting in close on this scene abstracted it, which brought attention to the repeating curving lines as they folded together. This is pretty intimate; you could stick you fingers in there and lick them off—well, almost.

24–105mm lens at 92mm, f/11 for 1/60 sec.

TIP

What if you can't get the sharpness you want in the background, even at small apertures? If using a zoom, consider zooming your lens to a slightly wider focal length, as this will give you better depth of field. This method is great if you have a high-megapixel camera, of at least 18–20 megapixels. Stepping back a few feet or yards will also help, but your entire perspective and composition may change too much if you physically move. Once you have the depth of field you want, you can crop to the composition you originally had intended.

CONSIDERING DEPTH OF FIELD

When creating intimate landscapes, depth of field is still important. Consider photographing a pretty pile of autumn leaves on the ground in the woods while standing directly over them. The background behind the top layer of leaves is really just more layers of leaves showing through here and there, along with the shadowy crevices in the gaps between the leaves. It doesn't have to be sharp all the way through in the dark decaying areas, but it should feel sharp overall. This has to do with the shapes, pattern, and/or texture of the leaves, which are the real subject, and therefore we need sharpness to see it all. For this type of intimate landscape, I prefer to use a small aperture of *f*/11 or *f*/16 to get everything sharp, or I will use a focus-stacking technique (see page 162). Imagine if half the plane of focus was blurry! Images with a flat surface to them are more pleasing when everything is in focus, thus a creative choice in aperture in this situation is more limited.

Yet what about intimate scenes where you are not positioned overhead and looking down? For example, what if you were lying on your belly and looking *across* that pile of leaves to one that is sticking up. That leaf sticking up is your subject, and it's perpendicular to the layer of leaves in the pile. To get everything sharp would be very challenging because of the opposing planes of focus, but ask yourself: Why would you want them both sharp anyway? The eye sees the leaf standing out from the pile, so the aperture you choose should express what the eye is seeing. You control the viewer's interest by the selective focus. In this example, a wider aperture, something in the range of *f*/2.8 to *f*/6.3, perhaps, would yield a shallower focus and isolate

the leaf to make the point. Shallow depth of field in a scene like this creates an emotional impact, as we somehow feel intimately involved with the subject. There are many creative choices to make with aperture in intimate landscapes of this type, and it will depend on what you want to emphasize, and how you want the overall image to look.

ABOVE:
I loved the reflection created by the wet sand along the shore of Lake Superior. These two rocks created a wonderfully intimate scene with the reflection, but to get both the rocks and the reflection in focus was not possible, even at f/16, due to my low angle of view across the plane of the beach, rocks, and water. Focus stacking works well with images that don't have any movement, but this had water moving. I figured it was worth a try to make two images, one sharp of the rocks and whatever was around them within the depth-of-field range, and one focused on the wet reflection, and blend the two layers later in the computer. This turned out to be very effective in creating the results I wanted.

📷 *70–200mm lens at 144mm, f/16 for 1/8 sec.*

OPPOSITE:
To make a different image of walking in the woods, I got on my belly and photographed the leaves along the path in front of me. I set my aperture to render the background out of focus but still keep it identifiable so that it completed the scene. This viewpoint is that of a dog while walking along the path, and it gives us an intimate view of the forest floor.

📷 *16–35mm lens at 23mm, f/11 for 0.6 sec.*

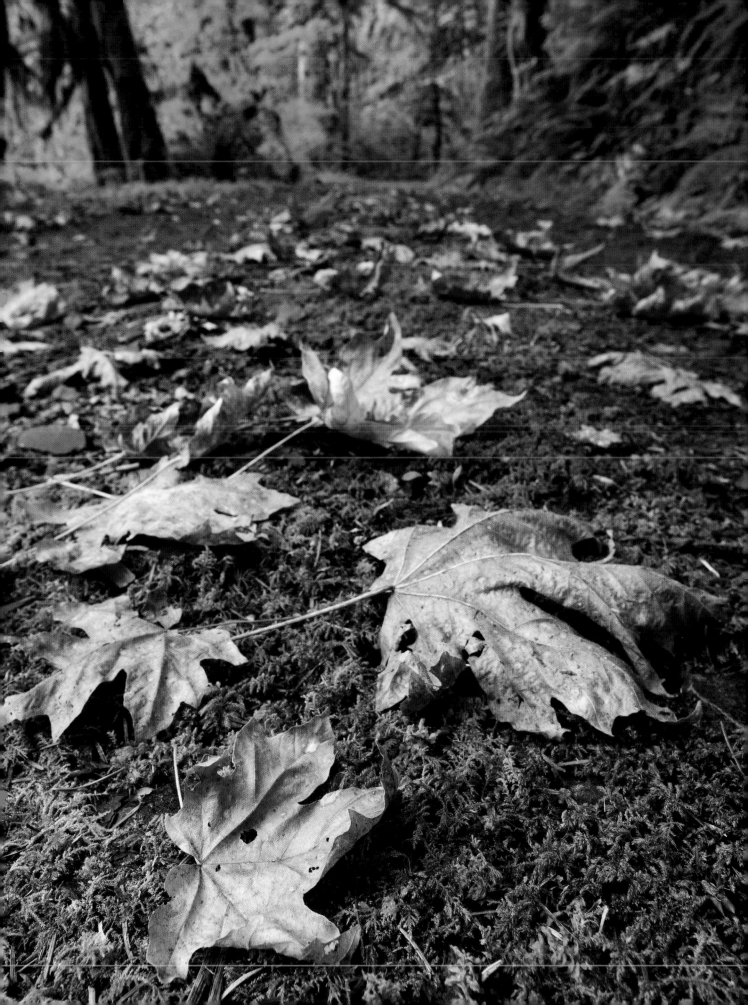

CLOSE-UP
IMAGES

Close-up photography brings us even closer to the subject, to fill the frame with the beauty of the small world around us.

In a close-up image, you have gone in closer, to magnify a detail within the intimate image, and are visually closing off the rest of the world by focusing the attention narrowly in a way no other style of photography does as well. When we get in this close, we really feel the bumps and slippery texture of kelp and see the pattern of a sea urchin shell.

Close-up images of flowers, tree bark, ice details, and plants give photographers a way to continue the dialogue with nature on a deeper level. The excitement of finding a dew-covered blossom, or a dragonfly, or a dew-covered dragonfly is magic for a close-up photographer. While that could be said for how a landscape photographer

feels about cracked ice on the edge of a high-country lake at sunrise, or how an intimate landscape photographer feels about dried, curled mud, close-up photography is like beachcombing. You search the meadows, gardens, beaches, and forests for small treasures. These details each express their own story, and can be metaphors for life. Peeling bark suggests unfolding, or change. A tiny leaf sprouting on a tree suggests emergence, life, and growth. When you photograph close-up details, try to see what stories you can find being expressed.

OPPOSITE:
I had long heard from friends about the Himalayan blue poppies that bloom at Longwood Gardens in Pennsylvania and I finally had the opportunity to see them. I imagined a small field, and was full of anticipation. When I got there and asked where the poppies were, I was lead to two oak half barrels, and in each of those there were about four plants! Turns out they are so delicate and rare it's too hard to grow a field of them. So, close-up photographs became the plan. But the background behind the barrels was distracting. Fortunately, because we were planning on doing close-ups of other flowers, my friend had suggested we bring some large prints of out-of-focus foliage to use as backgrounds. What a great idea that turned out to be! We placed the 16x20 print behind this poppy, far enough away to be sure the paper's surface was out of focus. Because the print images were made in totally diffused light, they worked really well. I could then use a small aperture to render the whole flower sharp, as they had a lot of depth to them. The bright, diffused light from above came through the petals, backlighting them. Needless to say, with a little "reframing" of my vision, and the foresight of my friend to bring along the foliage prints, we were successful in getting pictures of these famous flowers.

📷 *70–200mm lens at 155mm, f/14 for 0.5 sec.*

ABOVE:
In the woods in Cuyahoga Valley National Park, Ohio, I spotted these three narcissus that, due to wind, had gotten stuck together, and I loved how they created an implied line from the top to the bottom flower. I worked to get as parallel as possible to them, and chose an aperture that would render them sharp but keep the busy background under control.

📷 *70–200mm lens at 85mm, f/5.6 for 1/200 sec.*

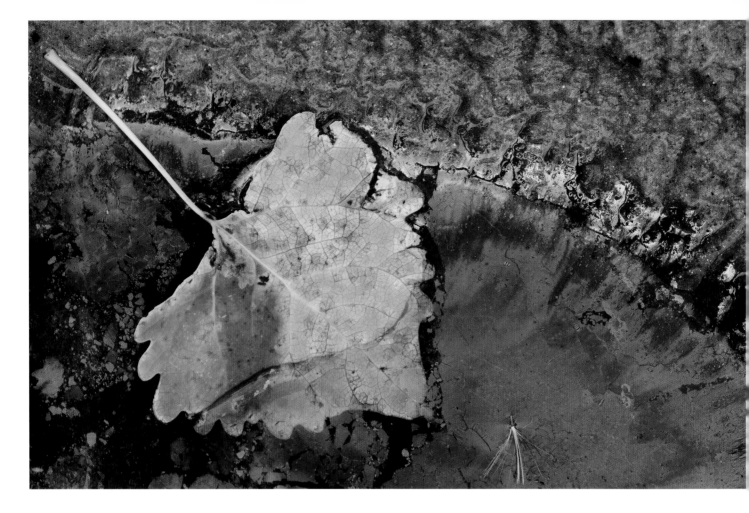

ABOVE:

A cottonwood leaf rests in a small puddle of water that is laced with oil from decaying leaves. The prismatic effect from the oil provided an unusual color contrast to the yellow leaf. I was drawn to this, and the half-submerged leaf that was changing from green to yellow and brown, all telling the story of the process of decay.

📷 *55–200mm at 246mm (effective focal length), f/14 for 1.5 sec.*

OPPOSITE, TOP:

This section of dried mud in a desert wash looked like some sort of a sectioned worm at first glance, and that is what attracted me to it. Soft light skimming the surface of the mud pieces brought out texture, but the shapes still dominate in this composition. I positioned the most noticeable worm-like section around the lower right rule of thirds intersection to emphasize it.

📷 *24–105mm lens at 105mm, f/16 for 1/15 sec.*

OPPOSITE, BOTTOM:

Walking through a muskeg bog on a cloudy afternoon, we arrived at a tiny pond covered with lily pads. We were past the season of the blossoms, but I found this seedpod beautiful. Half submerged, with only the yellow edge breaking the surface, it snuggled up against the big leaf visually. I loved the contrast of size and the colors. The curve of the surface tension around the edge of the leaf had a neat highlight that outlined the edge nicely. The drops of water from a light rain added interest, and I darkened the pond water by using a polarizing filter, which also made both leaf and seedpod stand out. I chose to include just a part of the big leaf to balance the visual strength of it against the bright yellow seedpod. In this case, there is just enough visual tension to be interesting.

📷 *70–200mm lens at 200mm, f/11 for 0.3 sec.*

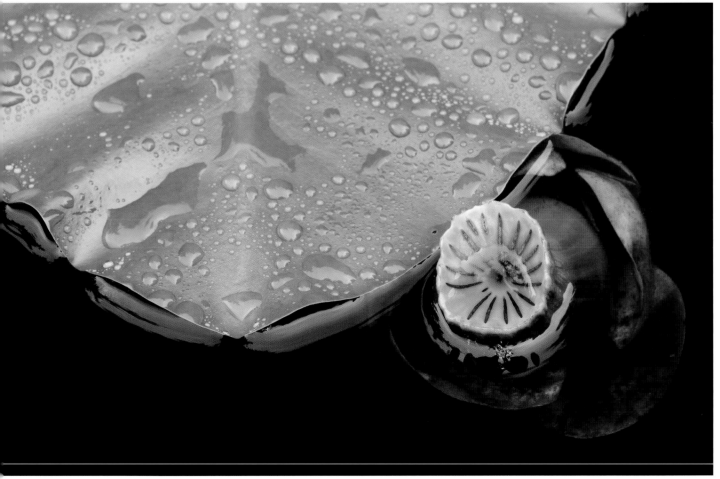

WORKING WITH BACK-GROUND IN CLOSE-UPS

The best way to create impact with a close-up is to keep attention on the subject, and not have the background distract. Expressive close-up images of wildflowers, for example, often have backgrounds that contribute to the image by appearing simply as washes of soft color, or that have just enough detail to suggest the flowers are in a meadow. When working in this close, your depth of field is very narrow, down to inches and fractions of inches, instead of feet or yards. However, you still have to think about that background and what it means to the whole composition. In close-up photography, a small change in position and aperture can make a huge difference in the background and its effect on the photograph.

APERTURE AND CLOSE-UPS

The challenge in close-up photography is to "squeeze" the most sharpness you can out of an aperture while maintaining a pleasing out-of-focus effect on the background. For this to work, you often need to get as parallel to your subject as possible, or at least to the plane of view running through the section that you want to make sharp. Simply put, though not always simply executed, the more parallel you are to that plane of focus, the more control you have over keeping the subject sharp while blurring the background. Consider this: If your flower stalk bends just slightly at the tip, in order to get it sharp you may have to increase the aperture, and that makes the background a little sharper, and that little amount may be too much. If you choose an aperture that gives you a flower stalk that is sharp, but in the process creates a busy background, then creatively that picture will fail.

But what if you switched to a telephoto lens to narrow your field of view and composed that same scene? You have eliminated some background, and it will be less in focus, because your depth of field narrowed with the longer focal length. By moving back a bit and putting on a telephoto lens, you have a little more creative control over which aperture will now be the best for your flower stalk and the background.

I prefer creating beautiful backgrounds that complement the subject by including a hint of the natural environment. For these types of photographs, I choose an aperture that will strike a balance between subject sharpness and the background. Since close-up photography isn't about getting life-size or greater than life-size, you don't need a dedicated macro lens. I use my 70–200mm lens a lot for close-ups of flowers. Depending on the size of a blossom, I can get close enough with that lens and fill the frame with the flower. When I need to get closer, I'll reach for my 500D close-up lens, which, when applied to the front of the 70–200mm, allows me to focus as close as 18 inches, giving me even more magnification, maybe even into the realm of macro. I like this combination because it allows me to keep my bag lighter when I'm backpacking or traveling. I can use extension tubes, too, to get even greater magnification.

 Tip

When lines go out of focus, they become larger bands of light and color, and they can become very distracting in the background. Highlights of shiny leaves and white blossoms "bloom," or expand, when put out of focus, too. When out of focus, glistening dew or raindrops can become distracting. However, those same highlights can become interesting when used creatively!

ABOVE:

I love it when you find flowers that are outstanding in the field! This cheerful blossom, a tidytip, caught my eye because it was surrounded mostly by blue lupine. To keep the eye focused on the tidytip, I chose f/8 for the image at left, because any wider of an aperture resulted in some of the petal edges going out of focus, even though the background looked even better. Photography is often a compromise. At f/16, the image at right added a bit too much depth of field, making the background distracting.

📷 *90mm tilt-shift lens at 90mm. Left: f/8 for 1/25 sec. Right: f/16 for 1/6 sec.*

RIGHT:

You never know what surprises are in store when photographing nature. I found this wonderful California poppy bud with the skin just covering the upper half of the blossom. I loved how the flower was beginning to unfurl like a dancer swirling her skirt. I worked quickly to get a simple, uncluttered background. I found a position that put grass lawn behind the flower, and the grass was far enough away that it would go softly green. I made a few exposures, trying to time them between light breezes that moved the flower slightly. I turned to get something from my camera bag, and when I turned back, the skin had popped off and the flower was unfolding in a different way! I used my close-up lens on my medium telephoto to allow me to focus closer, which in turn magnified my subject in the frame. A vertical composition helped narrow my field of view and accentuated the tall thin stalk of the flower.

📷 *70–200mm lens at 200mm with 500D close-up lens f/10 for 1/160 sec.*

CREATIVE APERTURE FOR EXPRESSIVE CLOSE-UPS

What about using aperture even more creatively to create expressive close-ups? Think about working with an aperture that gives you so little depth of field that the only thing that's sharp is what you've focused on, and even then maybe only a part of the subject will be sharp. With such selective focus, you can emphasize the one tiny element of a subject that interests you. It may be the edge of a leaf, or the stamen of the flower.

To achieve very selective focus, you either need to have your camera mounted on a focusing rail, so you can fine-tune the focus with geared precision, or to develop the ability to "rock in and out" with your body to get your focus. A common method for macro photographers doing handheld selective focus work is to focus using their toes, if lying down. You literally push forward by rolling up on your toes, or pull back by rolling back off them. High-tech, isn't it? But it gets the job done without fussing with your tripod, and it's an organic method that seems to fit the nature of the genre. You can rock in and out of focus while kneeling or standing, too, although precise control is harder in those positions.

OPPOSITE:
For most close-up photography, you want to keep your background as simple as possible. Using a telephoto lens as a close-up lens is a great way to narrow the field of view. To reduce the potential issues of a cluttered background in this image of a magnolia bud, I went to the extreme, and put on my super-telephoto zoom and racked it out to 500mm to fill the frame. I was far enough from the flower to render it sharp at the aperture. The focal length narrowed my field of view and also blurred the background, because my aperture at that focal length was producing a narrow depth of field.

📷 *150–600mm lens at 500mm, f/13 for 1/25 sec.*

ABOVE:
The month of May brings a lot of dew to the meadows in central Italy, so early one morning I went searching for flowers and discovered this delicate pink blossom on a stalk of wild gladiolus. The tiny droplets of water on the flower and the green sepals were simply beautiful, and the pink against the green was a lovely color harmony. I positioned myself to be as parallel as possible with the side of the blossom to keep most of the flower in the same focal plane. Had I known about focus stacking when I made this picture, I may have tried to use it. However, since the majority of this flower is sharp, the image still works.

📷 *100–400mm lens at 260mm with 500D close-up lens f/11 for 1/60 sec.*

ABOVE:
My favorite rose is like rainbow sherbet, and its colors are so lovely. One morning I discovered this one tiny drop of water resting on a petal. It was the last drop left from the morning dew. I'm glad I saw it when I did, and I immediately got out my macro lens to compose a photograph before it, too, disappeared. I placed the drop near the rule of thirds position in lower right, letting the petal layers fill up the other space with softly out-of-focus colors. My aperture was shallow to keep the drop and immediate petal edge sharp and let everything else go soft.

📷 *100mm macro lens f/5.6 for 1/250 sec.*

OPPOSITE:
Morning dew is so special for a nature photographer, and it built up on this lupine blossom in a way that bejeweled it. I like the view from the top, and because it had a slight angle to the top surface and faced left, I left a little more room on that side. Diffused light of the morning was perfect light for capturing this beautiful flower. I deliberately kept a shallow depth of field on this with a wide aperture, to keep the attention on the top of the flower stalk, letting the rest become soft shapes of color.

📷 *100mm lens f/6.3 for 1/1600 sec.*

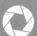 ## Photographing Close-Up

- Keep the background out of focus to create emphasis on your subject, isolating it from the background. The farther away your background is from your subject, the more it will be out of focus at any given aperture.
- Pay attention to your background. Look for complimentary colors to your subject, but keep it uncluttered and simple, as non-distracting as possible.
- Keep your subject from being too centered. Place flower stalks, flowers, leaves, and the like off-center and use their stalks and branches to lead us to the focal point of the picture, maybe the blossom or leaf. Remember that asymmetry often has more impact.
- The more parallel you are to the implied plane between all the areas you want sharp, the less aperture you need to make that all in focus.

- Diffused light is the most effective for most close-up subjects such as flowers, plants, and foliage patterns, but strong specular light often works well for photographing textures of wood, stone, and sand and for backlighting subjects.
- In close-up photography, the slightest movements are magnified, so you need a sturdy tripod, remote release, mirror-lockup at times, and high-enough shutter speeds to freeze any breeze motion. Exceptions are images made with very selective focus and wide-open apertures. Then you can usually hand hold the camera successfully.
- Use a tripod that gets all the way down to the ground or has another way to get low.

RIGHT:

California poppies and a lot of other close-up subjects have more depth than you might think! I was trying so hard to get all the flowers in focus, but the background became rather ugly with too much distraction. The solution was to use a wider aperture to control the background and make enough exposures with a shift of focus to stack later in the computer. It was the only way to get all those wonderful dewdrops in focus. The only risk here was motion from the slightest breeze. That can really mess up a focus stack. But the sun had not yet risen, and the air was still. I made six exposures for this image.

 70–200mm lens at 150mm, with 500D close-up lens f/6.3 for 1/160 sec.

OPPOSITE:

I made seven exposures here, changing the focus each time, to render as many of the blossoms as sharp as I could, while allowing the very back of the image to still be out of focus, since there wasn't much visual interest in those areas. When working in this close, even *f*/16 won't give you enough depth of field, so the focus-stacking method is a great solution to an age-old problem of how to get it all sharp if you aren't using a view camera.

 16–35mm lens at 31mm, f/16 for 1/8 sec.

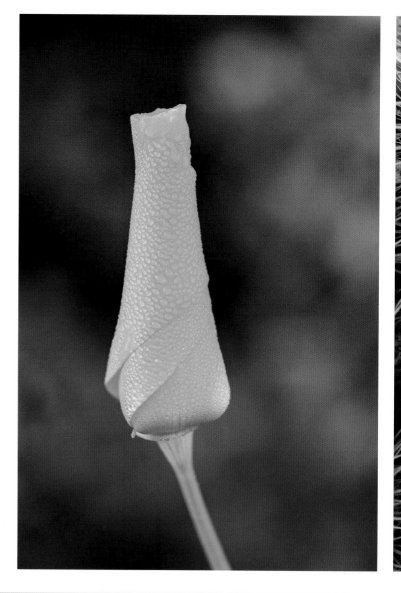

Focus Stacking

A technical approach called focus stacking can be used for getting your subject entirely sharp, while keeping the background out of focus (or completely in focus). This method works great when it works, but it's not for the faint of heart, as it takes methodical work to get perfect results. That said, I have used the focus-stacking method for many close-up images that were simply not possible without this technique. I'm glad it's available to use as a tool to craft better images.

Focus stacking requires that there be no movement within the frame. This means moving water, clouds that are shifting, or a breeze blowing branches can ruin your photograph—and your day! Still, it's a great technique to use for stationary objects, or ones where you can just wait to let a branch or a meadow of flowers settle back down after a slight breeze shifts it (and hope they settled in the same spot). Creating the images needed is tedious, because of these environmental challenges.

Working from a tripod, with a composition locked in, focus on the closest thing to the lens that you want sharp, then make an exposure. Then make each exposure thereafter with a small shift in focus toward the background, making sure you don't miss any slices, until you have included the entire area you want sharp. You can choose *f*/16, but even better would be to use

an aperture in the "sweet spot" of the lens; in other words, the aperture that will give you the best resolution. The wider the aperture, the more slices you may need to make to cover your area of intended focus. Since you are making many exposures that overlap the depth of field, when you are finished and combine the pictures, you should have a landscape photograph that is super-sharp from the first grain of sand on the beach to the horizon line in the distance.

For intimate details, the technique is the same, and you still have a choice of achieving complete sharpness in the image, or keeping the background out of focus. If you chose to keep the background out of focus, you can choose an aperture of say *f*/5.6, and do enough focus slices to render the subject area sharp, stopping your focus series just after you have captured the elements you want to be sharp. This will keep your background in softer focus and your entire subject sharp. To use the method this way, you want to determine what aperture would make the background just right, and not use anything smaller than that. For close-up images, the technique would be to use an aperture that will render the background as soft as you want, and make a lot of focus slices, moving ever so slightly each time, to get enough overlap to have your close-up subject sharp. Focus stacking is more difficult with close-ups due to the narrow depth of field, as well as breezes that can constantly alter the subject, but it's still possible.

THE TELEPHOTO IMAGE

Telephoto images of the landscape at 300mm or more are neither an intimate nor a close-up view, but they can extract surprise details from the grand scene and bring them closer for us to view. Telephoto lenses have a special place in my toolbox for interpreting the landscape. The magnified and compressed view is unique and can only be seen with the aid of a telephoto lens. I love scanning the landscape with my long lens to see what surprises I can find within it.

Telephoto lenses are also perfect for creating close-up portraits or action images of skittish birds and animals, and I simply couldn't survive as a nature photographer without a lens that covers at least the 300–400mm range. The inherent narrow depth of field with a telephoto lens is great for photographing portraits of animals and birds without a cluttered background. The closer you are to your subject, the less depth of field you'll have. This works really well for wildlife photographs. Yet in using your telephoto lens for an extracted landscape, you'll want to be sure that your depth of field is enough to cover the physical distance within your scene, so use a small aperture.

RIGHT:
The immense Margerie glacier in Glacier Bay National Park, Alaska, has beautiful striations of moraine (layers of rock and dirt) running through it, created as the ice marched down the valley and carried with it tons of debris. While the grand landscape view was a great image, I was drawn to the curved lines on the right side of the glacier. I switched to my telephoto zoom lens to fill the frame with that section. By doing that, I abstracted the scale. You no longer know just how large or small this area is, until you notice the tiny seagull flying against the wall of ice, and this gives the image impact.

📷 *150–600mm lens at 213mm, f/8 for 1/800 sec.*

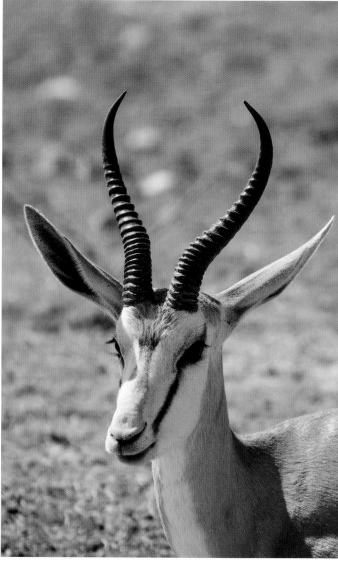

ABOVE:
It's amazing how, when using a super-telephoto lens, just a slight shift in the aperture setting can make a big difference. Your depth of field is very narrow when you are close to your subject like this, which can be a real challenge when trying to keep enough of the animal sharp. Photographing from the safari vehicle, I didn't have the option of moving just a few feet to prevent the twigs in the background from growing out of the springbok's head. I figured that I could remove them later in Photoshop, and I made the picture on the left using f/11, but I knew it also made sense to use a slightly wider aperture to try to blur out the twigs, while keeping the horns and nose sharp. It's not always possible to run through a series of aperture tests when photographing wildlife, but on this very warm afternoon, the springbok was resting, and ruminating, so I had the unique opportunity to change apertures, and settled on f/8. Even at f/8 for the image on the right, the twigs are there, but they're much less distracting.

📷 *150–600mm lens at 900mm effective, f/8 for 1/1250 sec.*

OPPOSITE:
This cute burrowing owl was a find near my friend's house in Arizona, but the trouble was, these birds make their burrows in the berms along the canals in an agricultural area. These are not pretty backgrounds, and behind them was a messy clutter of dried grasses and bushes. I took the first picture, at left, at an aperture of f/9 to minimize the background, while still keeping the owl in focus. After inspecting my results on the magnified view of my LCD, I knew I was okay and that the background looked a lot better. I took another picture at f/16, shown here at right. While it's not a huge difference, you will notice the background did start to become too busy, which causes the eye to wander away from the owl to inspect the setting. The first image holds the attention on the owl because of the smoother, less distracting background.

📷 *150–600mm lens at 600mm. Top: f/9 for 1/1600 sec. Bottom: f/16 for 1/500 sec.*

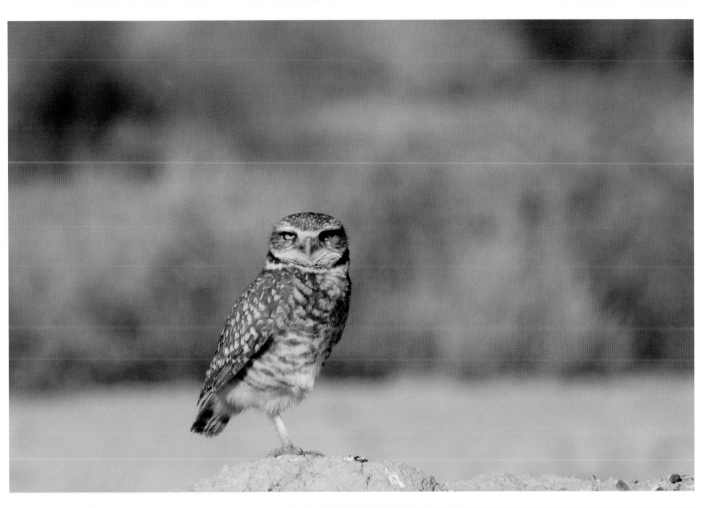

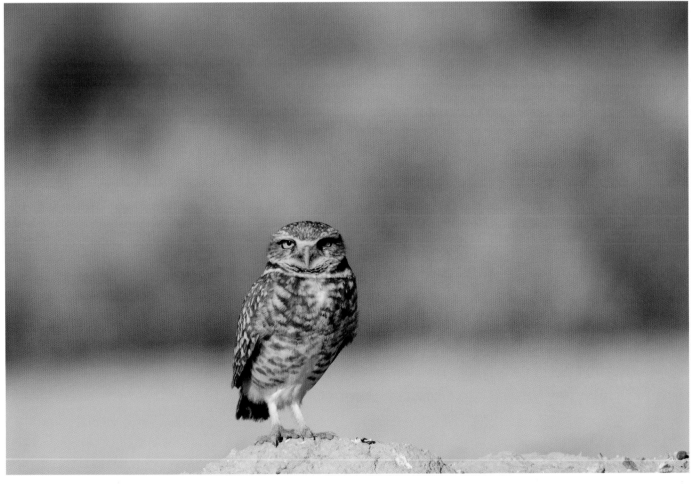

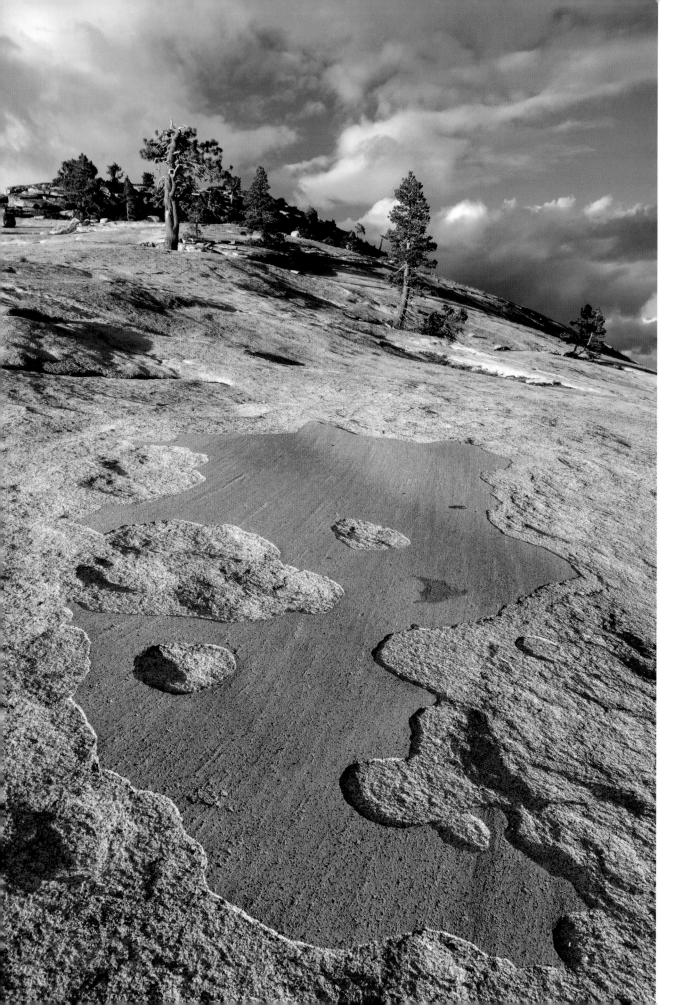

THE NARRATIVE IMAGE

"There is a creative fraction of a second when you are taking a picture. Your eye must see a composition or an expression that life itself offers you, and you must know with intuition when to click the camera."

— HENRI CARTIER-BRESSON

The best photographs tell a story rather than merely recording the scene. If a picture is worth a thousand words, how do you tell a good story, photographically? It's not that easy to do, and many images fail to ignite the interest of the viewer because they lack a strong point of view, are poorly composed, or somehow don't express what the photographer found interesting. In other words, they fail to convey the story.

OPPOSITE:
Everyone who travels over the high road in Yosemite stops to take in the impressive view at Olmsted Point and photograph the little pine tree that has grown from a crack in the rocks. On the other side of the road, though, up the slope, the rocks tell a great story about how glaciers affected the area. The puzzle-shaped piece in this photograph is actually evidence of the glaciers sliding over these rocks, polishing them where the ice made contact with the rock. The lovely clouds and the sidelight contrasted with the surface and defined the shape. While you might not know what the story is without knowing the geology of this area, this picture makes you ask the question.

📷 *24–105mm lens at 28mm, f/16 for 1/13 sec.*

Many years ago I took a few specialized photo workshops, because for a brief time, I was intending to go down the path of photojournalism as my career. Those classes turned out to be very useful, as I learned how to think in terms of "the story." I had to create a series of images, as well as find a way to tell a story with just one image. Who would have guessed that this would help me in nature photography?

Although as photographers we don't employ the exact "who, what, when, where, and why" concept that I learned in school for writing stories, we need to ask the same questions when creating a narrative image. A photograph can contain the *who* (subject), *what* (the action), *where* (sense of place), *when* (time of day or season), and even a *why*. As a photographer, it's your job to determine what the story might be and find a way to present it in as compelling a way as possible. If you use this same thought process as writers do, you can create a more complete narrative in your composition.

ABOVE:
I don't typically care for white skies in my pictures, but in this situation, the whiteness brought out the structure of the tree and the nests really well. A solid blue sky or one with a lot of clouds would have distracted a bit, whereas the black-and-white quality of this image keeps the viewer focused on the action and the story. I waited and got lucky when this heron flew in and "braked" for landing, filling that sky space perfectly to tell the story that this was an active rookery.

📷 *70–200mm lens at 155mm, f/8 for 1/500 sec.*

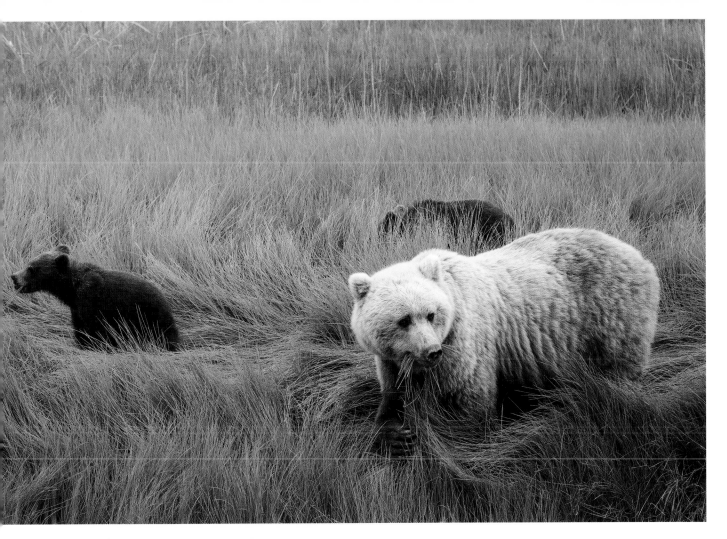

ABOVE:
Action and gesture play an important role in telling a story, and this picture shows just how a bear eats the sedges. Those claws help rake the grass toward her mouth so she can tear off a bunch at a time. We are drawn to the mom right away, as she is the brightest part of the image, and her mouth and paw, with those great claws, become the focal point. The two cubs with her tell a supporting story, as they will stick close by her and do what she does to learn how to survive.

📷 *150–600mm lens at 250mm, f/10 for 1/640 sec.*

LEFT:
Who needs the bear in your frame to tell a story? This intimate scene with the great pattern of big and little feet tells the story of an adult and baby bear without needing the bears themselves. When you stay open to other ways to express you are in bear country, it's amazing the little details you'll find! The low angle of light helps make the footprints stand out on the mud surface.

📷 *24–105mm lens at 32mm, f/14 for 1/60 sec.*

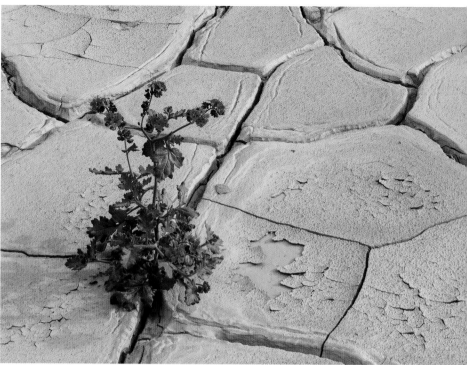

FIND THE STORY IN THE LANDSCAPE

Even a landscape picture tells a story. Begin by first figuring out what inspires you in the location. What makes the location unique? Try to establish what you want to express in the photograph. Then, look for a point of view that brings out your vision in the strongest way. Use any visual clues that help to express the story. Is there a process of nature, or some detail that will express the story strongly? What elements don't help the story that I may need to exclude? And is it the big picture or a small one, a detail that tells the story better?

If the story isn't obvious, it should at least cause the viewer to question the image. For example, in the lead photo of this chapter, the story is about the polished rock. With its unusual shape, the rock stands out, and the image is a compelling landscape composition, but if you don't know geology, you won't get the story that's presented here right off. But you *will* ask yourself, Why is that piece of rock smooth and others around it rough?

What is going on here that makes this piece stand out? The photo may inspire you to search for the answer to these questions.

ABOVE, LEFT:
Some stories in nature are sad to tell. This pond in the Sierra was in the process of drying up during the most serious part of the California drought. The cracks lead you to the grasses and the final moisture that allowed the grass to grow can be seen in the darker mud. The vertical frame accentuates the dried portion of the pond. Although the composition breaks the rule of thirds ratio of space division, the image works because the emphasis is on the dried earth.

📷 *16–35mm lens at 27mm, f/16 for 1/100 sec.*

ABOVE, RIGHT:
If you want to express the persistence of life, a flower growing up through parched earth can do it. The truth behind this scene, however, is that this area once had enough standing water for seeds to germinate and survive, even while the puddle began to dry out. Beneath the surface still lies enough moisture for the plant to live, but visually, the contrast of the plant and cracked earth suggests this plant is persisting against all odds.

📷 *90mm tilt-shift lens, f/20 for 1/25 sec.*

ABOVE:
Aerials can often tell a story in a beautiful, even artis-
tic way. Flying over the edge of Cook Inlet in Alaska, I
wanted to tell the story of glacially fed rivers and the
sediments they deposit into the ocean. I asked the pilot
to stop the plane (oh, I wish that was possible) to get
the composition I wanted. Seriously, I had to act quickly
before our position changed and the clouds below me

obliterated my story. Aerial photography takes a lot of
anticipation. You have to look ahead to see what's com-
ing so you can be ready when a scene arrives in your field
of view. Once it does, you must make as many frames as
possible until the composition is gone, as you never know
exactly how your subject will land in the frame and what
will be at the edges of your picture.

📷 *24–105mm lens at 50mm, f/9 for 1/1250 sec.*

◉ One Fine Foggy Morning

When you have the right conditions, it really pays to work the scene—to tell a story about a place, as I did on this foggy morning in an Alaska meadow. I used various focal lengths to vary my angle of view, and I chose different positions to yield an alternate point of view. I chose various apertures that gave me creative control over depth of field, and because you should always consider both, I framed both vertically and horizontally. All the while, I was asking myself what was attracting me in the scene, and what I wanted to express about it, while having a blast photographing in this meadow!

📷 *Opposite, top: 24–105mm lens at 32mm, f/16 for 1/10 sec.*
Opposite, bottom: 100–400mm lens at 285mm, f/16 for 1/20 sec.

Above, left: 100–400mm lens at 300mm, f/16 for 1/25 sec.
Above, right: 100–400mm lens at 300mm, f/5.6 for 1/125 sec.

CAPTURE THE TELLTALE MOMENTS

In a storytelling photograph, any gesture or action is an important element that can enhance the story being told. Sometimes, the action *is* the story, with the rest of the scene supporting it. Not every photograph you make has to have action, though; many nature photographs simply celebrate the passive beauty that nature offers up to us. But in a narrative image, where you are trying to tell us something more than "isn't this a pretty place," gesture and/or action can enhance the story, and make a big impact. If there's no animal or bird or exploding volcano to create action, look for other things that can imply gesture. The blurred water in a stream can be considered gesture. Dark clouds caught in the act of swirling overhead, rainbows, and the splash on a rock from a little wave are all gestures that bring your stories to life.

OPPOSITE:
Nothing elicits an emotional reaction more than an image of a mother and child interacting. Necking is a common activity amongst zebras; even the adults do it, as they are very social animals. So it was really just a matter of watching for the right necking moment to capture the connection of mother and child. The strong pattern of lines on a zebra can be dizzying, but I composed tightly to have the crisscrossed heads as the focal point.

📷 *150–600mm lens at 493mm (effective focal length), f/10 for 1/1000 sec.*

ABOVE:
Sometimes you wish you had an audio recording attached to the still file. This way, you could hear the sound of the baby as it cried for mom to give up one of her clams. Yet even without that, the submissive gesture and the eyes of the cub say it all. Although this young cub had learned how to clam from its mother, it preferred to beg for hers. I was delighted to witness and capture this special moment between mom and cub. I was ready because I had been observing the behavior of this little bear and noticed that it was definitely a beggar. When the cub started to approach mom again, I got ready for the moment.

📷 *150–600mm lens at 600mm, f/8 for 1/500 sec.*

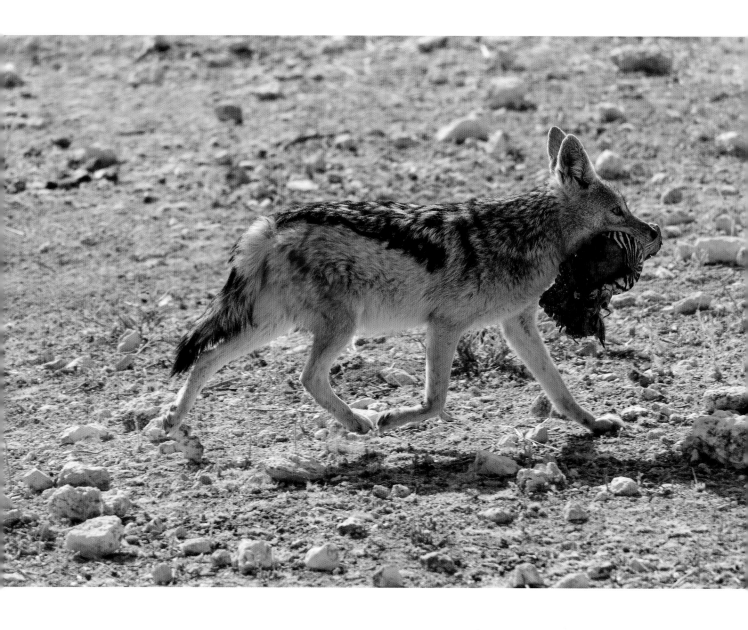

ABOVE:

Life, and death, is a common scene in nature. While driving out from the lodge in Namibia to look for animals, we spotted a kill just a bit off the road, with vultures around it. We paused for a moment while the guide observed the activity to see what else might be in on the action. Suddenly, a black-backed jackal came trotting past the van, with a sizeable chunk of zebra in its mouth, a meal for the whole family. The striped skin on the part we can see fortifies the story, although even without it, the story of foraging for dinner is still strongly told.

📷 *150–600mm lens at 600mm, f/9 for 1/800 sec.*

OPPOSITE:

While cruising slowly around this island of puffins and gulls, out from behind a rock above us we heard an explosion of squawking. I swung my lens instinctively up toward the rock, just as the gull and peregrine swooped into view. I managed to get one image! As the bloodied claw of the immature peregrine shows, it had killed a chick, and this gull was not happy. Having practiced photographing birds in flight, I was prepared not only to handle the long lens quickly, but also to follow the action instinctively.

📷 *150–600mm lens at 273mm, f/10 for 1/1600 sec.*

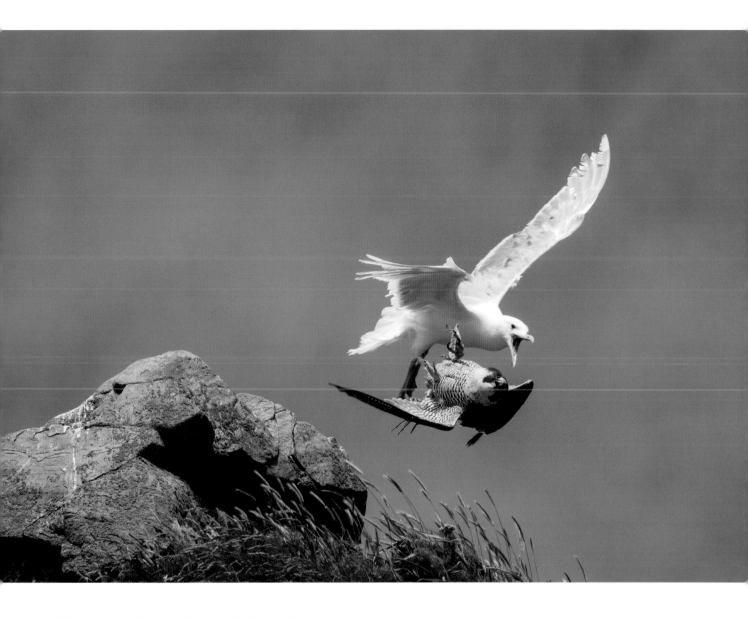

FIND THE ACTION

In photographs where animals are involved, there can be a key moment or gesture that becomes the main story line. Getting the timing right to capture the moment when a whale breaches or a bird catches a fish is essential to telling the story.

It's important to look for clues that tell the viewer something about the animal's behavior or how it interacts with its environment. The way zebras neck, for example, tell us that they are very social animals. Whales lunge-feeding tell us how these giants eat in the ocean, and a jackal making off with a piece of a zebra tells us not only what jackals eat, but how they provide for one another. Animals experience fight or flight situations, run, play, and engage in other activities that are amazing to watch and to photograph. These animal stories are not unlike those of the human condition: They eat and sleep, and

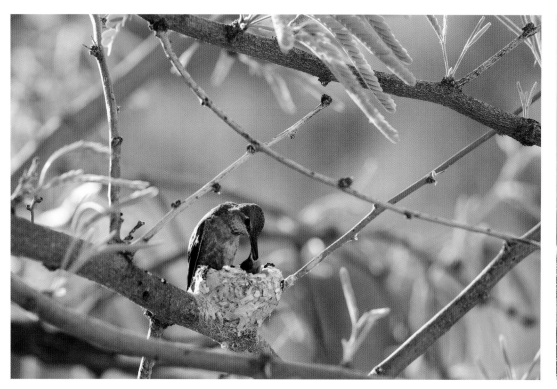

many express a bond and show nurturing to which we respond emotionally.

Portraits of animals, or what I like to call "trophy headshots," do not express stories. They are simply a study of a wonderful animal or bird. These do tell us about the subjects, in the sense of their features—such as the long bill on a honeycreeper that allows it access to the deep parts of a flower, or the markings on a butterfly wing that make it look like a huge eye to avoid predation. But even in a headshot, you may find gesture. It may be the direct contact of the wolf's eyes, staring right through you; or if the animal barks or yawns, you have gesture and you've managed to photograph *the* moment of that gesture. Gesture and moments of action simply add more expressive qualities to the picture. Look for those: Is there a moment that will express a story strongly?

Moments of nature are not just about the actions of animals or birds or humans. Lightning, rainbows, glaciers calving, sun rays striking the land through openings in the clouds—these are all moments of nature expressing itself, and special moments to experience and photograph.

ABOVE, LEFT:
You never know where you'll find moments in nature, but the stories are going on all around us, even around our houses and the guest rooms of a dude ranch in Arizona. I learned of this nest and was delighted that I could photograph the mom feeding her babies during my time there. The nest was in a very branchy acacia tree, but thankfully, the branches formed a frame around the mom and the nest. Nature pictures don't often tell the complete story, though, the behind the scenes story, such as how I was standing on tiptoe on a retaining wall, leaning against the guest room wall with my camera just back far enough to be in focus on the nest, waiting in that position for 10 minutes for her to return! Ah, but it's worth it to get pictures like this.

📷 *70–200mm lens at 200mm, f/8 for 1/250 sec.*

ABOVE, RIGHT:
I've lead photo tours in the Inside Passage of Alaska for years, but the one sighting that is most elusive is that of humpback whales feeding with teamwork. In what is technically called bubble-net feeding, one whale creates a net of bubbles under the surface of the water as it swims around the herring, forcing the herring into a tight, confused ball. The whales around the perimeter then move in and upward, with an orchestrated lunge, mouths agape, to take in as much herring as possible in one big gulp. It's the most exciting thing, short of a breaching whale, to photograph. The challenge is getting your timing right to tell the story, so you look for an open mouth, and if you're lucky you'll see a few herring flying through the air as they escape that maw.

📷 *150–600mm lens at 329mm, f/8 for 1/2500 sec.*

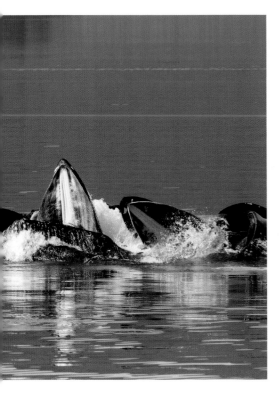

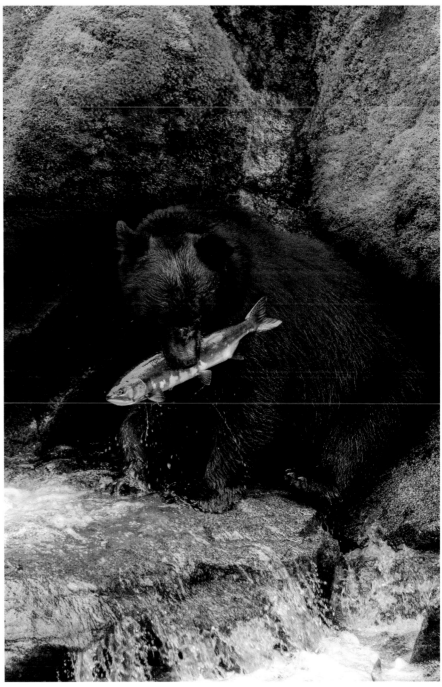

RIGHT:

Wildlife provides endless opportunity for capturing moments to tell a story, and this black bear was providing me with great image content! It would emerge from the dark cave in the rocks behind it, watch the river for a while, grab a fish, then retreat back inside the cave to eat. It did this many times, and I finally managed to capture the moment as it paused before going into the cave. The salmon was positioned beautifully, almost tenderly in the bear's mouth. I included the rocks and the water to give a sense of place.

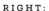 *100–400mm lens at 210mm, f/5.6 for 1/250 sec.*

OVERLEAF:

The moment of this mass liftoff at sunset was amazing, with sweet light illuminating the birds. I love photographing at wildlife refuges, as they have a concentration of birds and wildlife during the winter months in California. Having spent a lot of time in these places, I've learned to watch for signs that the birds may lift off, such as an increase in their chatter, and suddenly in an instant it's quiet and they erupt into the sky. If I can pay attention to details like that, anywhere, I'll be better off at getting a moment as magical as this one. By filling the frame with birds, this moment tells a story of the large concentration of migrating waterfowl. You can feel the energy of their flight in the chaos! How do they all manage to take off and not knock one another out of the sky?

150–600mm lens at 375mm, f/6.3 for 1/800 sec.

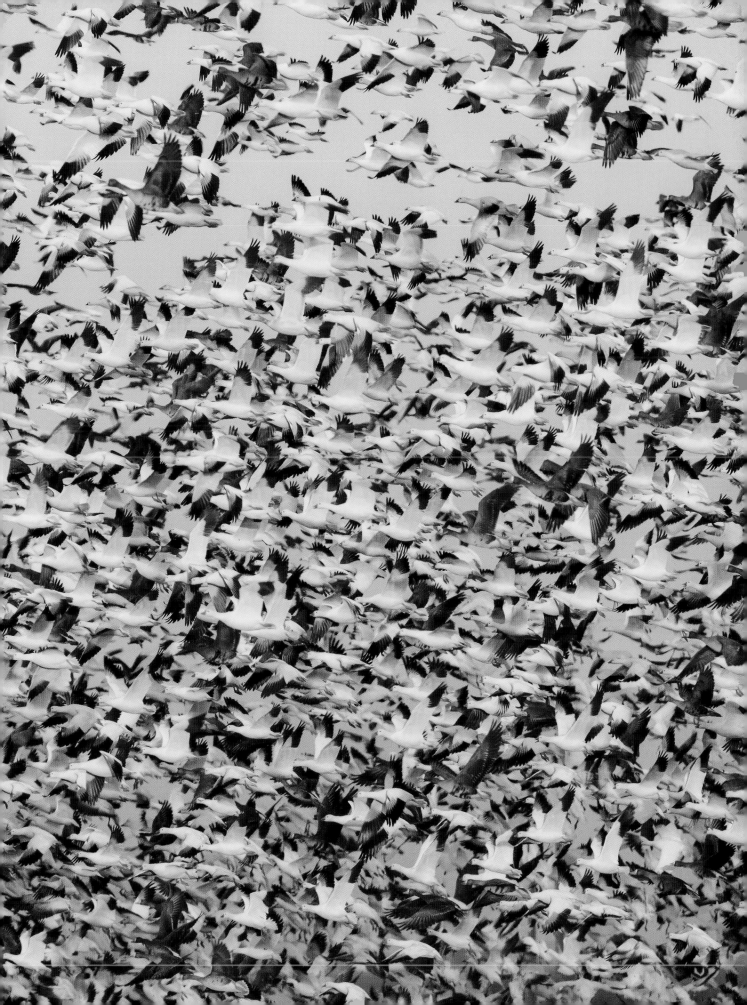

OPPOSITE, TOP:

Nature puts on a great show when glaciers are calving. When sitting on a boat watching a glacier, you can hear cracking and groaning as it moves internally, pushing forward towards the sea. The challenge is to spot the piece that is calving. When you do, there's a lot of hooping and hollering in excitement as all cameras are clicking away at the fastest frames per second photographers can muster! The goal is to capture a huge piece, and this one sure was. As it slid into the sea, a huge wave exploded, adding energy to the scene. This is just one frame of the story, but it captured the peak moment, the essence of the story. Photographers are sure an odd lot: We *celebrate* the melting of glaciers for a good photo!

📷 *100–400mm lens at 400mm, f/9 for 1/500 sec.*

OPPOSITE, BOTTOM:

It was a soupy kind of fog this morning in Lake Clark National Park, Alaska. We were combing the area for bears to photograph, although we were pretty sure it wouldn't be easy to find them. We headed towards the river, where bears often congregate looking for salmon, and as we got closer we saw this shape in the midst; it was a bear snoozing on a small hill of sand to our right, and we were closer than we'd expected to be on foot, but this bear didn't mind. It woke up when it heard or saw us, and then it did the most fun thing: it stretched, just like we stretch, and in that gesture you could feel how good it felt to the bear to do that. These images mean more to me than a headshot, as they tell a strong story about behavior.

📷 *500mm lens f/9 for 1/800 sec.*

ABOVE:

While waiting for bears to come and fish in the river, we were entertained by gulls feeding on the eggs that would float downstream from salmon that had just spawned. It took some effort in getting the timing right as this Bonaparte's gull would dip its head into the water and, when it came up, toss the egg to get it to the back of its mouth.

📷 *150–600mm lens at 350mm, f/8 for 1/1250 sec.*

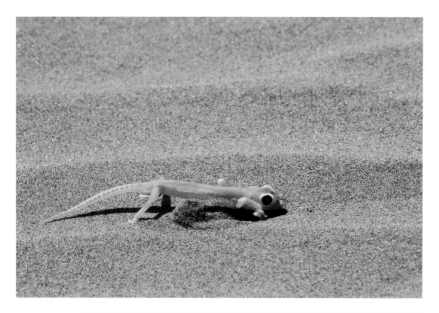

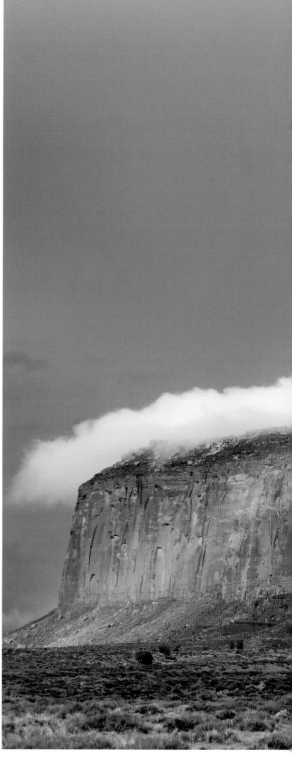

 Tip

I am very interested in geomorphology, and every-where I go I am always noticing the way the land folds, fractures, exfoliates, and tells the grand story of our earth and how it is in a constant state of change. If you are truly interested in the processes of the natural world, you will find so many stories all around you that you'll never run out of things to photograph. But to see these stories, you have to become a great observer of everything going on around you, and that's easier to do than you may think. While driving to the grocery store, do you no-tice the squirrel eating the walnut on the park lawn? Do you notice the pattern of oak trees on the hillside, or the evidence along the trail where deer bedded down for the night? Make a decision to be "in the moment" as much as possible, no matter what you are doing, to be better at observing life around you. The more you develop your observation skills, the more opportunities you will find to create great na-ture photographs.

ABOVE:
This little palmetto gecko was busy burying itself in the sand to keep cool and get away from the bright sun. After our tour guide had found it, we photographed the gecko for just a short time, as geckos are light sensitive, and then let it go back underground. The gesture of the sand in midair, and the leg blurring a bit as it digs, tells the story.

 70–200mm lens at 274mm (effective focal length), f/13 for 1/640 sec.

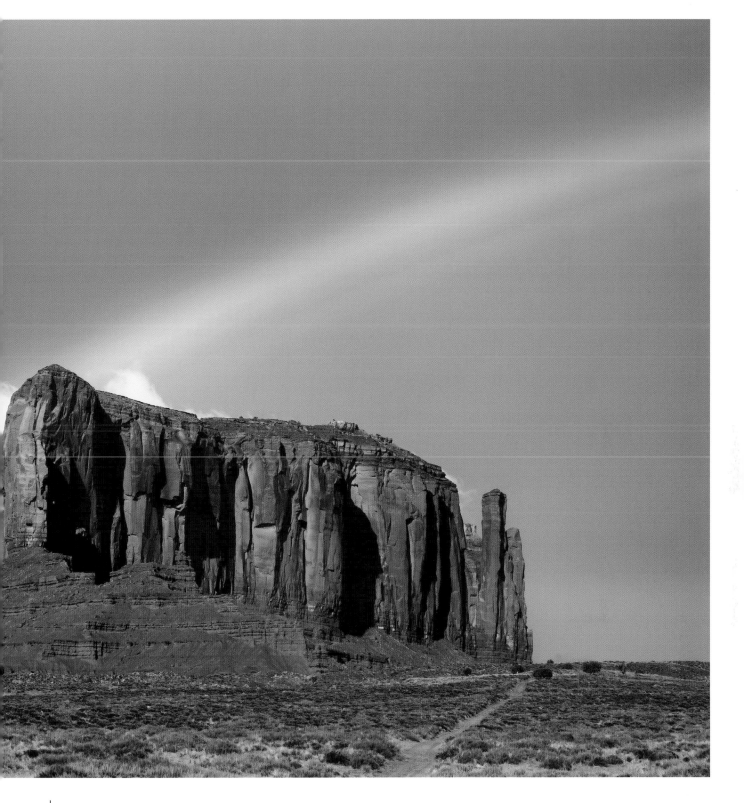

ABOVE:

I had pretty much given up on photography for this afternoon, as it had been raining all day as I drove to Utah. I had actually gotten to the entrance kiosk at Monument Valley and decided not to drive all the way in. What was I thinking? I know better: Rainy weather can lead to breaks in the weather that can be fantastic for photography. As I turned and began driving away, the sun broke through the clouds, and I screamed (truly) and turned the car around again in a heartbeat. I knew I couldn't make it to the overlook in time, as it was too far away, but fortunately, the photography gods were smiling on me. I was able to use this wonderful butte to position with the rainbow, and with that low cloud hanging on the top of the butte, and the gray sky behind it all, the story about a break in the weather was expressed. Whew! Another lesson learned about it never being over until the sun goes down.

📷 *24–105mm lens at 85mm, f/14 for 1/125 sec.*

CREATIVE SHUTTER

The shutter speed you choose can have a real impact on the story you are trying to express. Is it the explosive power of a wave breaking on the surf? Or the story of survival in a scene of birds fighting in midair, or a bear grabbing a fish dinner? Or maybe it's the fluid motion of water flowing in a stream or down a waterfall? As you ask yourself these questions, you will discover that one or more approaches regarding shutter speed may be the right answer to express the power and energy of motion and help tell your story effectively.

FAST MOTION, FROZEN

Freezing motion creates visual tension. When you freeze motion, you've stopped time, creating a chance to study the details of one piece of movement that is a moment in time—freezing the action of a bird squawking or a bear yawning, well, *that* says something. It can also give us a chance to study form and other details that we can't typically see as well while motion is happening.

So how do you know what shutter speeds to use when photographing animals and birds in movement or other action? How fast is fast enough for freezing motion? That all depends on the subject you are photographing. Experiment with different shutter speeds and learn what works for each situation. Here are some general tips:

- If you are photographing exploding waves at the ocean, you will want at least 1/1000 sec. to freeze the explosion of water using normal focal ranges. This is a good place to begin, and vary it according to your situation.
- You have to consider several variables to get flying birds sharp: the speed of the bird, the focal length you use, and size of the bird in the frame. The larger the bird is in the frame, the faster your shutter will have to be to freeze the motion. Shutter speeds of 1/1000 to 1/3200 are good for birds in flight if you want to freeze motion when using a lens in the range of 150–800mm, as a place to start. I have found a shutter speed of 1/2500 sec. to be great for photographing cranes, snow geese, and egrets in flight. Not knowing exactly where I will be in terms of focal length when I press the shutter, I want to be sure that my shutter is fast enough to stop the motion when I'm out at the longest end of the lens and the bird fills half or more of the frame.
- If you want to show the metallic quality of the surface and the reflection on a moving stream, you won't need to go high on the shutter, but you will need to work out what's best for each and every situation, as they are all different. I have typically found that around 1/13 to 1/80 will do the job, but it depends on the focal length, the amount of light you have, and the speed of the water. You need to find areas that are free of rapids to get the high-gloss reflections.
- When whales breach, you need anywhere from 1/500 sec. to 1/2000 sec. Breeching whales might seem to be in a slow-motion movie due to their massive size, but they are actually moving much faster than you think! Depending on how close you are to the action, and what focal length you're using, the shutter speed will vary. Just remember it's better to lean toward the fast side!

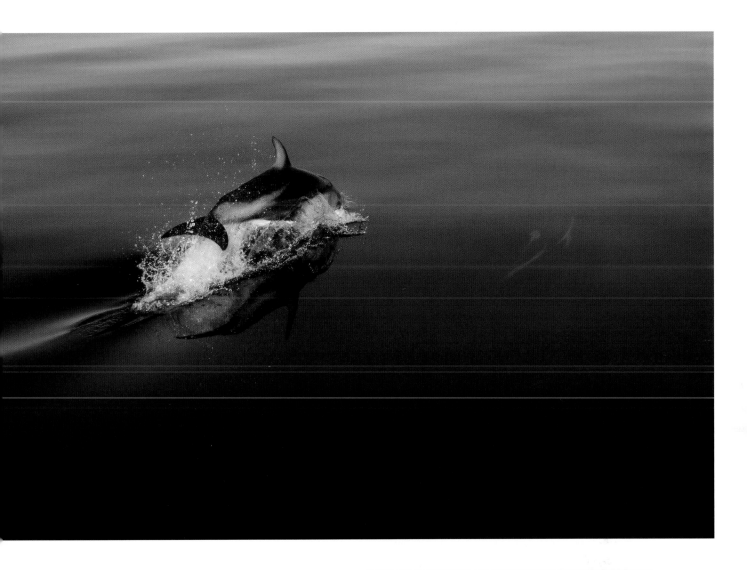

ABOVE:

You never know when the Pacific white-sided dolphins will break the surface of the water for a breath of air—and in this case, when they might leap into the air with joy and playfulness as they rode the bow wake of our boat! To capture this image I boosted my ISO high so I could use a smaller aperture to keep a better depth of field, as I knew that, if I was slightly off in the focus grab, I'd still have the dolphin in focus. (Sometimes cameras will focus on the water drops instead of the animal.) The higher ISO also allowed me to have a shutter speed that was fast enough for this speedy little swimmer. The clarity of the water allowed me to see another dolphin beneath the surface, which added to the story, and the smooth surface made for great reflections.

 17-40mm lens at 40mm, f/14 for 1/800 sec.

Tip

Consider taking a workshop specialized in photographing wildlife. When you spend a week doing nothing but wildlife or bird photography you quickly become more adept at handling a long lens, focus tracking, and choosing the correct shutter speed. Mastering the techniques will allow you to put your attention toward the animals' behavior and the nuances of gesture, to capture the moment you feel best tells the story.

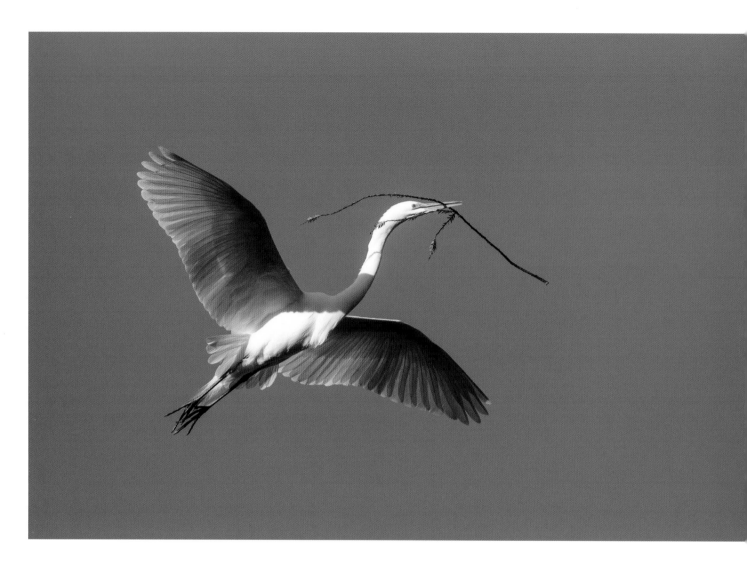

ABOVE:

Many egrets and herons nest every early spring in a suburban bird rookery near my home, so it's easy to observe them as they build their nests and rear their young. I found a clear area of sky that worked for morning light, and waited for birds to fly through that space. I still had to focus-track the birds and capture the image when they were clear of tree branches, and timing that to capture the birds' wings in a good position was a good workout technically. Since the birds are very active during nesting, I had a lot of subjects to give me practice. I kept my shutter speed very high, as from experience I've learned it's better to have a shutter that's faster than you need rather than slower. The birds were constantly bringing nesting material in their mouths, a part of courtship that continues even after the nest is finished. I waited for one egret to bring in a large branch to tell that story. With my camera set to continuous frames, I made a series of images with different wing positions and chose this one that showed the beautiful wingspan. Practice makes perfect, they say, and I've tossed away a lot of digital files from that location, but the ones that work are worth the effort.

📷 *100–400mm lens at 400mm, f/8 for 1/1600 sec.*

ABOVE:

Two images from a fresh stream in Montana show how the shutter speed can affect the results. The image at top shows more motion, created by the slower shutter speed, while the image at bottom displays a bit more "brushstroke" and texture to the water flow, because of a slightly faster shutter—although by no means fast!

📷 *Top: 70–200mm lens at 200mm, f/16 for 0.6 sec. Bottom: f/16 for ¼ sec.*

MOTION, BLURRED

There are two situations in which you can blur motion in a still image: When the camera is still, mounted on a tripod, and the subject is moving, or when you hand-hold the camera and move with the subject—known as panning, but at a slow enough shutter speed to express motion. Each expresses something different.

 Tip

Because I use a zoom lens, I typically won't handhold at anything less than 1/320 for shutter speed, even though the lens goes as wide as 150mm. This is because the physical length of the lens and weight of it at the shortest focal end are still something to consider when handholding. Image stabilization helps a lot, but I find my best results come from a faster shutter speed when handholding, and photographing action will usually require faster shutter speeds anyway.

OPPOSITE:

Sometimes you find wonderful situations where the water is flowing so smoothly over rocks below that it becomes highly reflective. Such was the case this autumn day along the Presque Isle River in Wisconsin. The deep blue sky combined with the reds, oranges, and yellows of the trees on the opposite shore reflected a great color palette in the surface of the water. I wanted to tell the story of a lovely day reflected in those waters. To get this type of reflection, you first need a shaded water surface, so it can reflect the elements on the opposite shore that are in sun. I chose a shutter speed that captured a glossy reflection of all the colors. After a few test shots to find the right starting point, I made this exposure. Then I made several more images, as the water was different in each exposure.

📷 *24–105mm at 93mm, f/13 for 1/8 sec.*

ABOVE:

Instead of photographing with a goal to capture the high-gloss effect off the stream's surface, I wanted to make an image that was painterly. I chose to slow my shutter speed down for this image to still show the shine and colors while adding an effect of brushstrokes to the moving water. After a few test runs with different shutter speeds, I settled for 1/30 for the effect I wanted. It's all about playing—er, working the situation. Each stream has it's own speed of flow and special qualities, so each time you'll find different settings give you the effect you want. Back in the film days, I didn't have any idea how things would look until I got to the darkroom. Now I can see my results and make fine adjustments to the settings before I leave the location.

📷 *70–200mm lens at 150mm, f/16 for 1/30 sec.*

A STILL SCENE WITH MOVING SUBJECT

Flying birds, a flowing stream, waves hitting a beach, clouds moving across the sky—all of these express the energy of motion in different ways. Slowing down your shutter and letting the animal or bird blur as it moves through the frame is a creative way to tell the story of motion in an expressive way. Start by framing a scene through which the subject can move, and set the camera on a tripod so you can maintain that composition. Choose a shutter speed that will allow movement of the subject to become apparent. Now, just wait for a subject to enter your frame. Just kidding: You could wait a long time for a herd of running deer to pass! You need to go somewhere where you know animals are on the move to do this. Deer, elk, even wild-horse herds or a flock of flamingos may congregate near you.

The shutter speed you use for your scene will depend on what you are trying to show, along with the speed of the animal, the focal length you are using, and how much area the animals take up in the frame. For faster-moving animals, such as running horses, shutter speeds anywhere from 1/30 and slower might work, but experimenting is key to getting the right settings.

Slow shutter speeds can create a painterly effect with a fast-moving river or a gently flowing stream, and can add an ethereal quality. Working with slow shutter speeds this way is one of my favorite things to do in nature, my idea of play. The reflections, colors, and the way the movement creates texture on the surface are all magic. Water conveys very strong symbolism, too. When flowing, it expresses energy that's very different feeling from the energy of crashing waves at the shore and embodies the metaphor of "going with the flow." In a photo of blurred water, we are blending moments in time, rather than singling out and freezing one discreet moment in time, and telling a story of how the river flows. The blur of water at the ocean is also quite ethereal and tells a

story about the ocean's pulse. In either case, the longer the exposure, the more ethereal the effect can be.

The shutter speed you use to blur the motion in your scene will always vary with the speed of the flow and volume of the water, as well as the focal length and light. Generally, any shutter speed slower than 1/15 can express nice movement. At sunset on the coast, your shutter speeds may be as long as a few seconds. At twilight, it could take many seconds. When I want longer exposures for a more ethereal effect, but the light levels are too high for very slow shutter speeds, I turn to my variable neutral-density filter, which adds from 2 to 8 stops density. With the camera locked on the tripod, I compose the picture first, set my focus and aperture, then turn the filter until I get the shutter speed I want. It's best to use manual exposure, so if the shutter goes below 30 seconds, you switch to bulb and use a remote release and timer to make the exposure. Deciding on what shutter speed will work best for blurring the motion in your scene will always vary, for the reasons mentioned above. However, after photographing water this way for a while, you will get a feeling for what shutter speeds work for many common situations. You will add that to the reference library in your brain so that you can call on your memory later when you encounter similar scenes.

OPPOSITE:
Post-sunset can be a great time to photograph flocks of birds in motion as an impressionistic way to portray flight. The color of the sky serves as a pretty background. Using a relatively slow shutter speed, I was able to record the shape of the birds, with their wings blurred to give an expressive effect. It takes a few tries to get the look you want, but after a while you have a sense of where to start with your settings, using your favorite lenses.

📷 *70–200mm lens at 200mm, f/10 for 1/50 sec.*

ABOVE:
Vintgar Gorge in Slovenia is an incredible place, best seen and photographed on a foggy or rainy day, and we had both conditions! I climbed down to the river's edge to get closer to the water and include the moss-covered edge as I liked the contrast of the textures. I slowed my shutter down using my polarizer to blur the water enough to express a feeling of it moving swiftly.

📷 *24–105mm lens at 24mm, f/14 for 20 secs.*

Tip
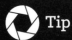

The closer you get to a moving object, the more the motion will show at a given shutter speed. The farther away you are, the more time it takes for a subject to cross the frame and apparent motion may be so slight as to have little impact. Also, the wider the angle of view, the less the motion shows, as compared to that same shutter being used with a telephoto lens, because the angle of view affects the time it takes for the object to go through your frame; both are significant factors when trying to express blurred motion.

ABOVE:
The North Umpqua River runs through some of the most incredible geological formations in Oregon. Here, it spills through a gorge cut through columnar basalt, drops into a pool, then continues down the western slope of the Cascade Range. To soften the texture of the plunging water, I tried various long shutter speeds and settled on an 8-second exposure, to hold detail where the falls met the surface of the pool below.

📷 *24–105mm lens at 73mm, f/16 for 8 sec.*

ABOVE:
In this lovely scene along the California coast in Sonoma County, the pink and blue colors provided a great warm–cool contrast, and the waves kept rolling onto the rocks. I wanted to express the ocean's energy in a different way here, rather than with crashing waves. My regular exposure for this scene just wasn't slow enough to capture what I envisioned, as I wanted enough time to pass for the waves to ebb and flow, to create an ethereal effect. If you can get two or three wave surges within your exposure time, you'll create a mistlike effect, because each surge of water comes in at a different height. Working in aperture priority mode, I chose my composition, set my focus and aperture, and then put on my variable neutral-density filter, which allowed me to select from 2 to 10 stops more density. I then rotated the filter until I got a shutter speed that I felt would work for what I wanted to express. I made a few test shots before settling on one shutter speed that worked best.

📷 *24–105mm lens at 50mm, f/13 for 15 sec.*

OVERLEAF:
I was fascinated by how fast this flock of shorebirds would fly just above the surface of the water in the wetlands in Marin, California. To express the energy of their rapid flight, I slowed my shutter down and panned with the flock. As they passed me, they made a turn, and that showed their shape as well as the nice pattern on their wings.

📷 *100–400mm lens at 400mm, f/8 for 1/25 sec.*

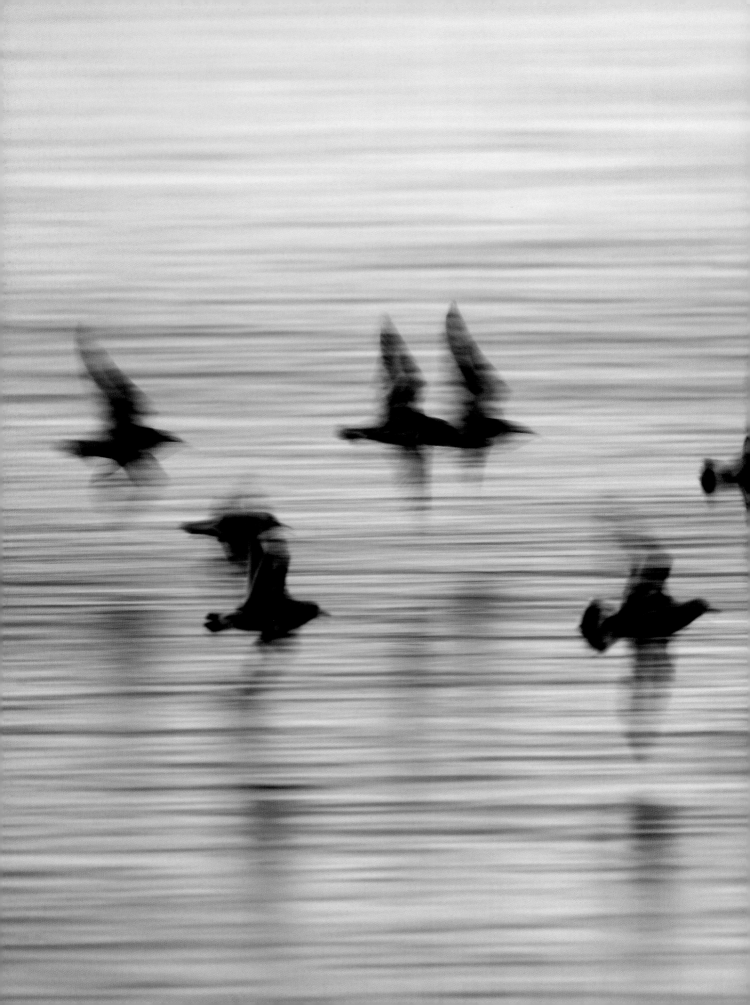

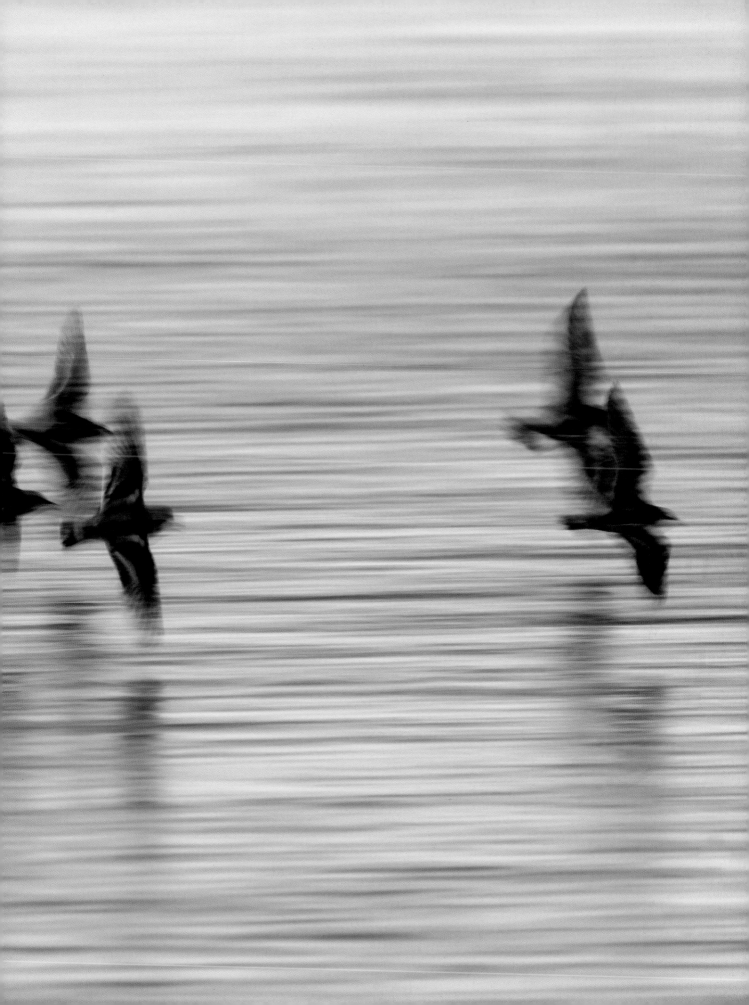

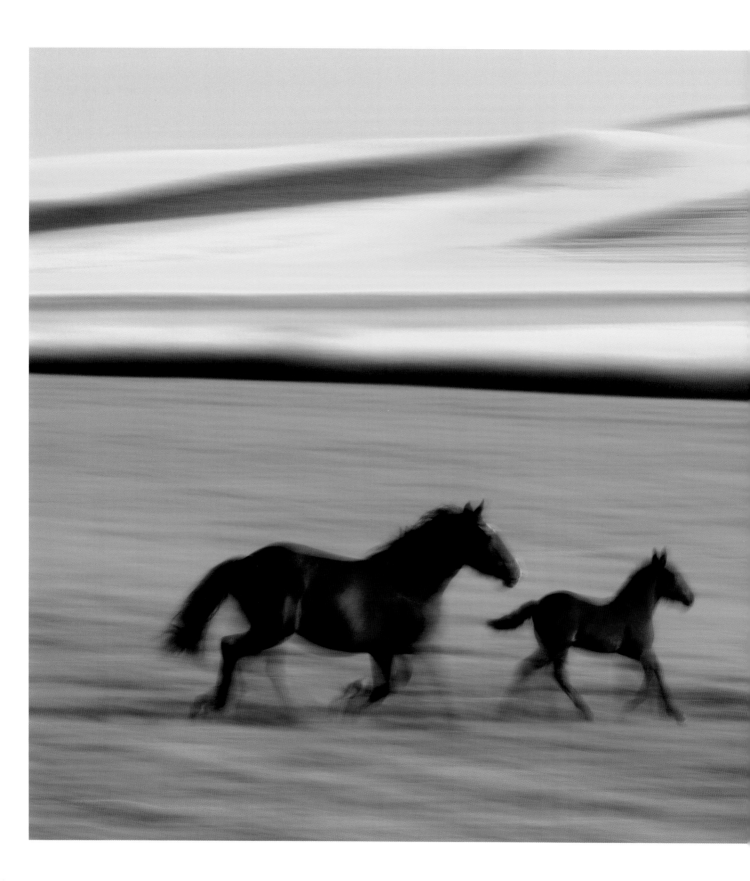

MOTION AND PANNING

This is a great way to create painterly expressions of objects that are in motion. By keeping the shutter slow, you tell the story of motion, and show the choreography of movement. Panning requires a bit of technique. You must follow your subjects through the lens to keep them somewhat defined, but using a slow shutter speed, you'll still get blur and movement suggested. The more you practice, the better you'll get. If you can control the background, try to avoid very bright or light areas, and any dark areas, as they can become distractions when blurred. Learning to pan smoothly and evenly helps smooth out the background, sometimes blending it into a wash of colors. Shutter speeds will likely be in the range of 1/2 to 1/30 sec. It's not possible to recommend a perfect shutter speed to use for this technique; as with all methods of photographing motion, the speed of your subjects and the focal length used to frame them will determine the creative choice, based on the effect you want, and it's fun to experiment.

LEFT:
This mother and her young colt were feeling the energy in the springtime air. As they burst into a run across the field, I quickly changed my settings to pan to capture the motion of their movement. I had only one chance to get it right and I was able to capture the energy and joy that I felt the horses were expressing in their run.

📷 *70–200mm lens at 89mm, f/16 for 1/6 sec.*

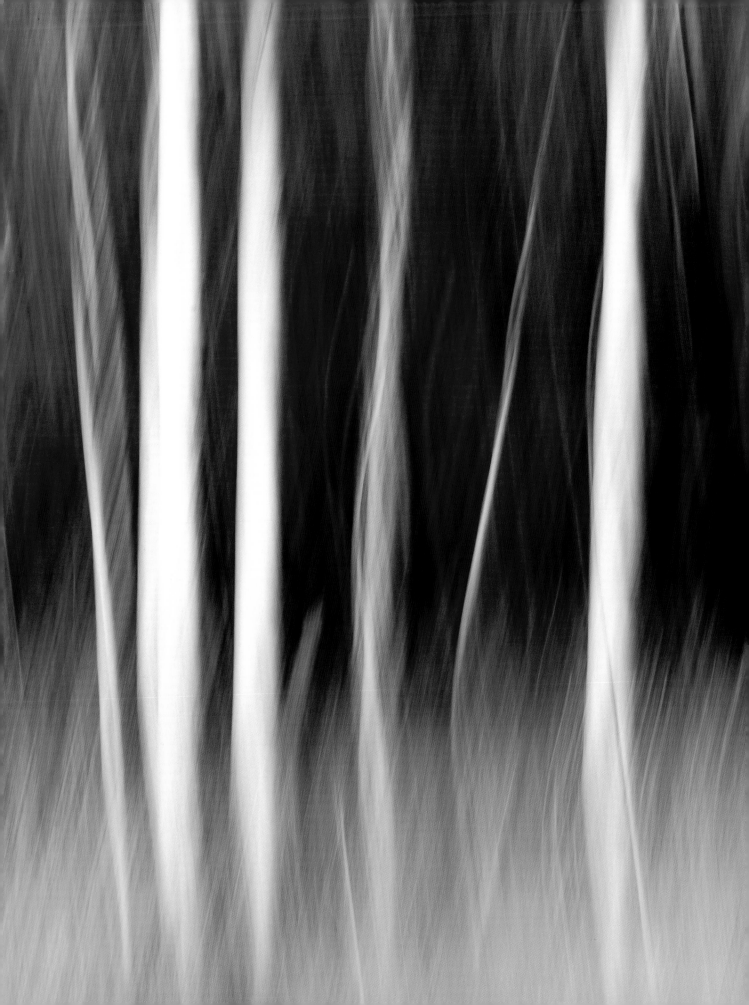

CHAPTER 7

IMPRESSIONS OF NATURE

"One should not only photograph things for what they are but for what else they are."

— MINOR WHITE

Since I don't paint well, I love to use my camera and various in-camera techniques to create painterly pictures. My goal is to distill images into expressions of light, energy, and color, to remove context, and to present a fresh vision of nature through the intentional movement of my camera. To interpret nature this way, you need only stretch your vision and think beyond the literal aspect of the subject. While the mind likes to dwell in the concrete world of identifiable objects, and that's where we are most comfortable, the techniques described below can help push you to reflect on the more abstract spirit of the world around us. Go forth, and play! Remember, it's the artistic play that keeps you fresh and loose, and also translates into creativity in other areas of your life.

OPPOSITE:
The brilliant reds of maple trees behind the stand of birches in Minnesota were stunning. The contrast was so great in full sunlight that I had to wait for the sun to go behind a cloud to keep the whites of the trunks from being too bright. I tilted my camera with a slight wiggle to make the trees move expressively in the upward blur.

📷 *70–200mm lens at 100mm, f/16 for 1/6 sec.*

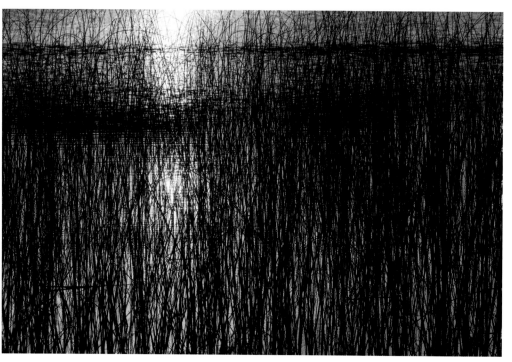

ABOVE, LEFT:
The reeds in this Minnesota pond were dense, and the effect reminded me of the type of art we used to create in school for which you scratched off the black coating to reveal the layers of color below. The scene also looked like a pen and watercolor blend, and somewhat abstract. It's the light and the contrast that make this image so arresting.

📷 *70–200mm lens at 200mm, f/16 for 1/50 sec.*

ABOVE, RIGHT:
I am always fascinated by the different patterns that emerge from wave action on water. These patterns often generate visual rhythm, and the cool color palette of this watery reflection on Frederick Sound in Alaska was different from many others that I have photographed on past trips.

📷 *100–400mm lens at 400mm, f/10 for 1/640 sec.*

RIGHT:
The light was soft and pastel-hued on this morning on Lake Superior, seen from Madeline Island. I loved how the varying textures of the water reflected the light differently and created bands of pleasing colors. I felt like I was experiencing the true essence of dawn.

📷 *100–400mm lens at 400mm, f/16 for 1/5 sec.*

OPPOSITE, TOP:
When a breeze riffles the surface of water, you get many different patterns and a stained-glass effect if your shutter speed is high enough. I liked how the shadow of the dark tree left no reflection so we can see into the water to the rocks below, while the rest of the scene is a stippled pattern of colors.
📷 *70–200mm lens at 85mm, f/10 for 1/50 sec.*

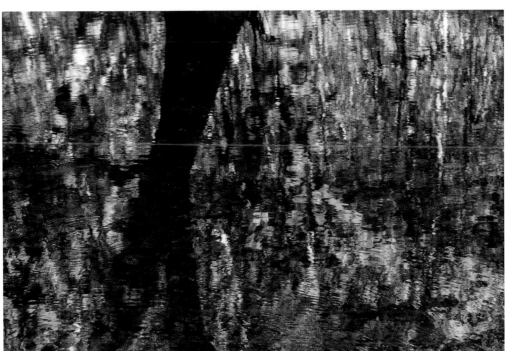

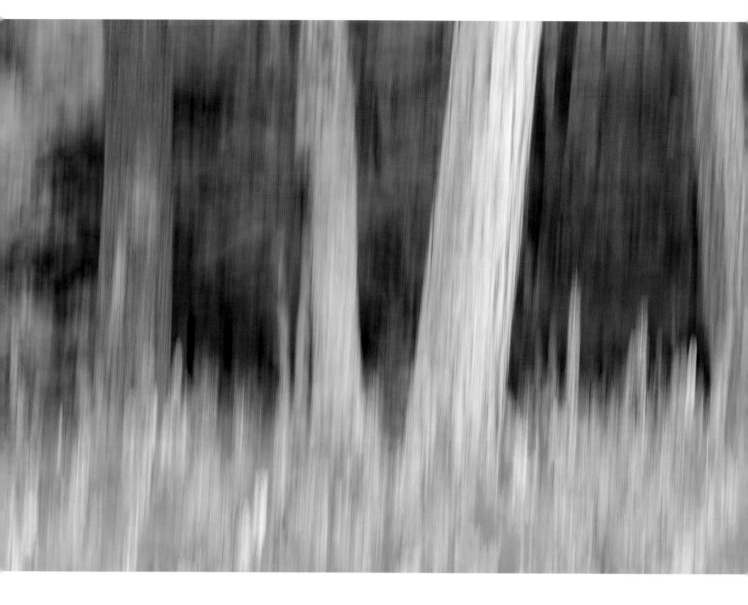

ABOVE:
The small field of lupine along the road in Wisconsin created a colorful foreground to juxtapose against the trees as I planned my composition for this blur. I chose an area with the greatest density of flowers to create a fuller band of color across the bottom of the frame. One side was a smidge empty of flowers, so I cropped the image a tiny bit afterward to resolve that issue. These types of photographs often need a little cleanup around the edges, as your movement is different every time, so your framing shifts slightly, too.

📷 *24–105mm lens at 95mm, f/11 for 1/10 sec.*

OPPOSITE, TOP:
It takes practice to get the look you want, and each situation is unique in what it presents in terms of light, color, and pattern. The best way to determine a reference point for this type of picture is simply to experiment and see what you get. I loved the fresh green of this meadow in contrast to the blue and orange. The white flowers were small and weren't an issue, but white, if too large or too dense in an image, will often be a distraction. I made this image under diffused light, which helped maintain an even contrast and let the colors come through.

📷 *70–200mm lens at 135mm, f/9 for 1.5 sec.*

OPPOSITE, BOTTOM:
If you wiggle the camera a little when tilting upward or downward, you can create a more organic feeling. Here, it feels like these trees along a road in upper Wisconsin are dancing, a chorus line of trunks with colorful headdresses.

📷 *70–200mm lens at 97mm, f/10 for 1/6 sec.*

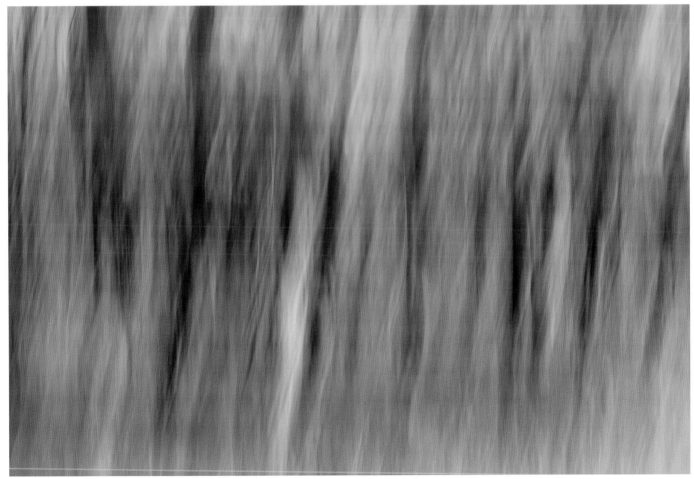

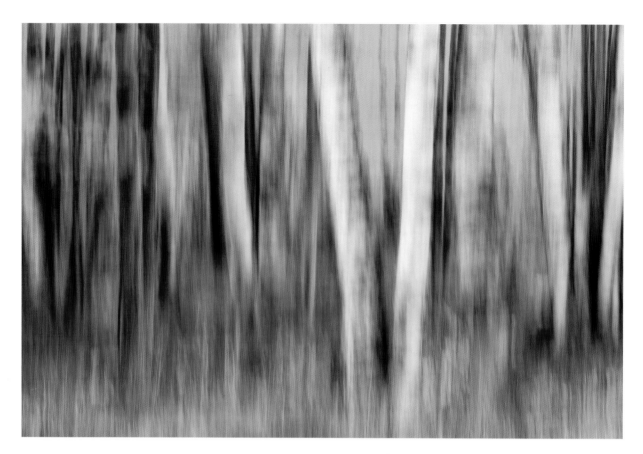

 Exercise: See Beyond the Literal

Take a walk and look at things around you in depth. To consider expressing what you see in a different way, try to figure out what the essence of something is. Can you distill the scene to an abstract? Can you remove the context of the landscape and still convey light or energy in some other way? Imagine what it would be like if what you see before you was blended together in a slow shutter speed as you moved the camera across the scene. Try to visualize what a scene might look like if you could create the stippled look of an impressionistic painting by making a multiple exposure. What would it look like if you created a structured multiple exposure, instead of randomly moving the camera around? Explore your subject with these ideas in mind and play.

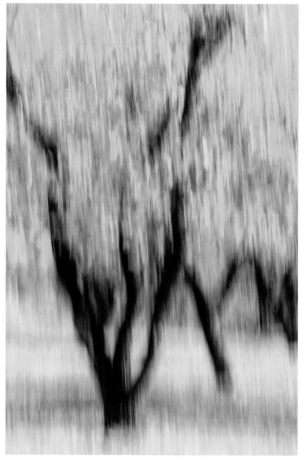

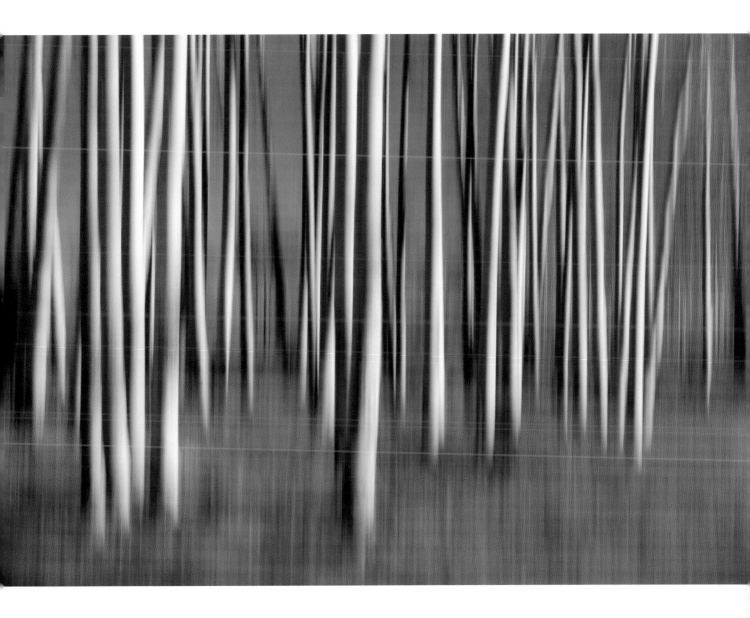

OPPOSITE, TOP:
From where I stood in the forest, the trees were large and there was good depth to the scene, even though it was all blurred with motion. I swung the camera upward as I opened the shutter. I love the warm colors from the fall foliage and the understory brush.

📷 *70–200mm lens at 121mm, f/16 at 1/5 sec.*

OPPOSITE, BOTTOM:
The leaves in this orchard had turned color, but they were still clinging to the branches, not yet ready to let go. The grasses were golden, and I was able to capture the color contrast of the scene because of the diffused light of an overcast day. I still tried to convey the shapes of the trees while blurring the scene, and created depth by choosing a position that showed the separation of the trunks from one another, making a stronger impression that this was an orchard.

📷 *70–200mm lens at 97mm, f/16 for 1/13 sec.*

ABOVE:
In this aspen grove, the meadow was a soft brown of spent grasses, with the clear blue of the Utah sky showing through the grove. I don't usually like to include sky, as most often it's overexposed between the trees when you meter for the forest, but in this case, with the grove being so open, the camera did a great job with the metering. I tilted the camera upward as I opened the shutter. I really like the addition of blue contrasted against the warm hue of the meadow and the blurred trunks.

📷 *24–105mm lens at 95mm, f/22 for 1/13 sec.*

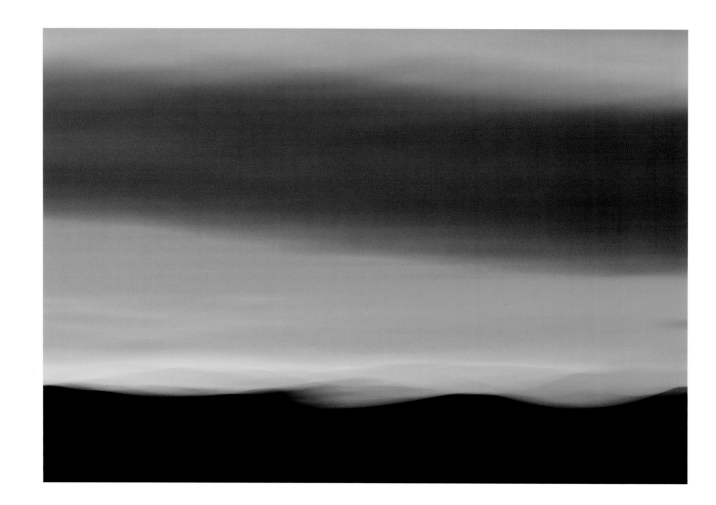

PANNING TECHNIQUE

Whether up, down, or up and down, or horizontally or obliquely, moving the camera intentionally blends details of the subject together into an impression. While there is no magic formula for creating the same exact result each time with this technique, getting the image you want comes down to how much you move the camera, what your shutter speed is, and what the field of view is. These guidelines are a starting point:

1. Begin with a shutter speed around 1/15 to 1/8 sec. if you are in the lens range of 75mm to 200mm. Slower shutter speeds are a bit harder to control when panning to get enough detail to suggest the subject. I find that I often get too much blur if I am down at a 1- to 2-second exposure, but I have been successful using those speeds if I just move more slowly.

2. Decide what the coverage will be in your movement. For example, you may want to avoid debris at the base of the trees, or not to include the sky. Sometimes, the color of the sky ends up being too light and distracting, other times it can be a welcome addition.

3. Try a few practice swipes of the camera to get in the swing of things. Make sure you can avoid areas you don't want to include, or you will be doing a whole lot of cropping. For a vertical swipe, start with the camera angled downward and swipe or tilt it upward. (This is not critical; I have seen people just move the camera straight up, too.) For a horizontal pan, you'll be moving the camera from left to right or right to left.

4. Start your swing of the camera *before* you press the shutter, and release the shutter while you are in the

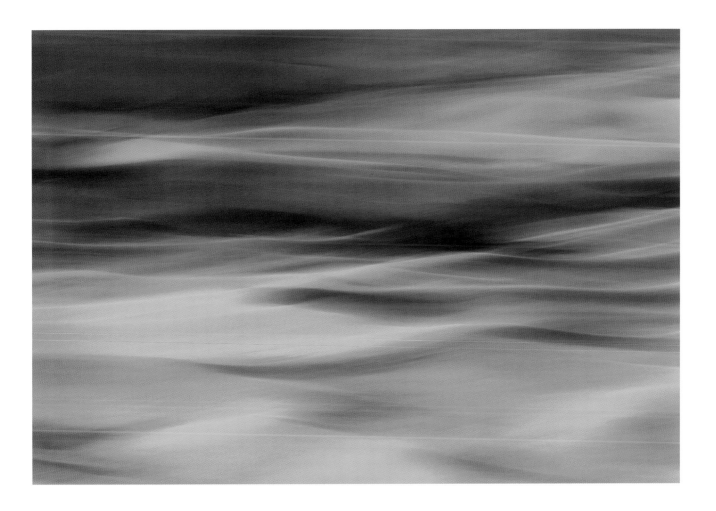

motion of the swipe, and keep going after the shutter has closed. This creates a smooth beginning and end to your movement. If you want to record a bit of detail to the scene, along with blur, press the shutter and move immediately, which results in a combination of some clarity with movement. Wide-angle lenses require a lot more movement and slower shutter speeds to record enough movement, but can be used.

5. Review the image on the LCD and preview it large, to get a sense of how blended things are, just how out of context it is or isn't, and if the scene speaks to you in the way that you want it to speak to the viewer. If you're not sure, do a few more. Don't delete, though; you may be surprised when you get them on the bigger screen at home.

OPPOSITE:
The scene of a sunrise sky and silhouetted mountain ridge in Death Valley was pretty, but it was still just a silhouette. I decided to try something different and to interpret the sunrise as an impression over the hills. I panned the camera horizontally and was delighted with how this softened the tops of the hills and blended the line between sky and land.

📷 *24–105mm lens at 105mm, f/14 for 0.5 sec.*

ABOVE:
Blurs are such impressions that they're not really about a specific place, but a sense of that place. Rolling hills of farmland lend themselves well to horizontal panning. It has something to do with the softness of the undulating hills, I would imagine. In this scene, the late summer hills were a patchwork of brown, gold, and green, illuminated by the subdued late light of the day.

📷 *70–200mm lens at 200mm, f/16 for 1/6 sec.*

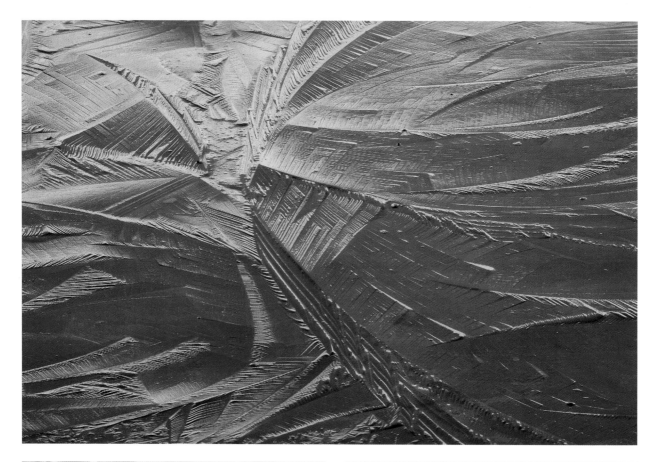

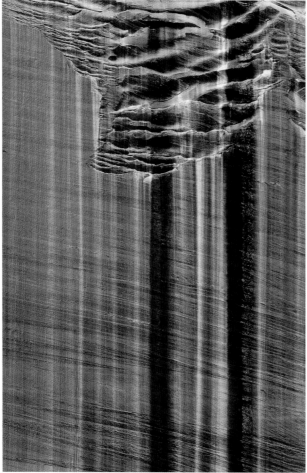

The Abstract Photograph

Photographs often take on a quality of being abstract, without special camera techniques. They, too, are impressions in their own way. It's hard to describe what quantifies an image like this; I just find mine when they present themselves to me while looking at a scene. Pictures like this often contain a lot of shape and pattern.

TOP:

Wandering around in the high country of Zion National Park in Utah is my favorite thing to do. You never know what you'll find, and I came upon this shallow puddle in the rocks that was beginning to freeze, just enough to create stress lines. To me, it sort of looks like a palm tree with fronds.

📷 *55–200mm lens at 300mm (effective focal length), f/14 for 1/20 sec.*

BOTTOM:

This wall in Utah's Grand Staircase-Escalante National Monument was amazing, and the scene became abstract for me as I composed it through my mid-range telephoto lens. Because this slice of the wall is out of context with its environment, it's less obvious what you are looking at.

📷 *70–200mm lens at 200mm, f/13 for 1/50 sec.*

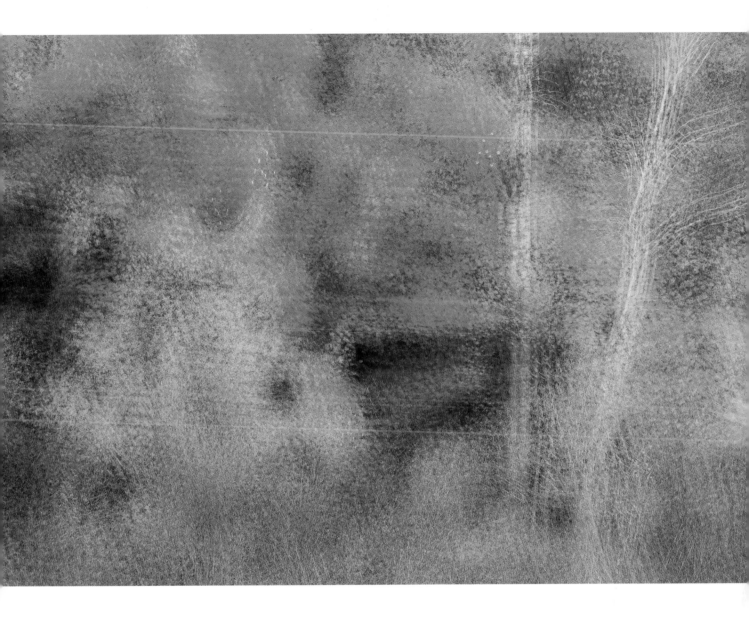

MULTIPLE EXPOSURES IN CAMERA

The stippled effect that is often seen in the works of Claude Monet and Georges Seurat is a style once called Pointillism (as opposed to stippling, which uses one color). This style branched off from Impressionism, so-called because artists were attempting to create impressions of the scenes they were painting. They wanted to be less literal and create a more suggestive look at a scene. With multiple exposures, you, too, are creating the suggestion of things. By the very overlap of light and shadow and colors, you are blending them in a different way than with a tilt-pan method.

ABOVE:
I knew from experience this forest scene would be great for a multiple, because it had a lot of details that could overlap, as well as colors. I never truly know the outcome until I try it, though! My DSLR allows me to save the originals and also combine them in the camera for a JPEG that tells me how I did; if successful, I move on to another scene.

📷 *24–105mm lens at 105mm, f/9 for 1/80 sec., 8 exposures, individually, then combined in the computer.*

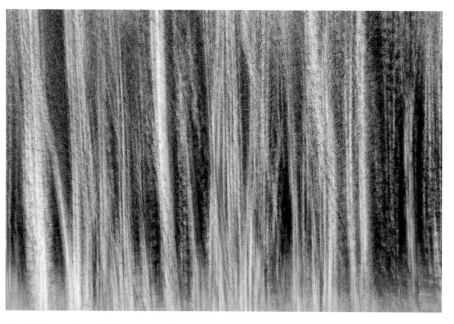

TOP LEFT:

The many branches of these aspen trees created a textural effect in the vertical multiple-exposure series I created. I tilted the camera up slightly with each exposure. You can see where I was not perfect in my vertical alignment, which in fact adds to the scene here, as the whites of the trunks blend nicely with the shadows and the tree branches to soften the overall effect.

📷 *70–200mm lens at 200mm, f/14 for 1/80 sec, for 9 exposures, combined.*

TOP RIGHT:

In this version of a vertical-movement multiple exposure, I held my alignment a bit better as I moved up the tree trunks for each exposure and used a tripod for stability. It really does take concentration to get the movement right for this type of multiple.

📷 *24–105mm lens at 85mm, f/16 for 1 sec., for 12 exposures, combined.*

HOW TO CREATE MULTIPLE EXPOSURES

You may have a camera that allows you to produce up to eight or nine images and combine them into a multiple overlay in the camera. This is a wonderful way to know that you are getting what you want in the field, rather than having to wait to see when back at the computer. Trouble is, some cameras only save the end result as a JPEG, while others allow you to produce a multiple image and still keep all the original individual image files, so you can combine RAW files later, but still see the combined JPEG on the LCD. If your camera won't do this, you'll have to resort to using the computer to combine your multiple RAW exposures. Let's assume this is the case for the purpose of describing the more common technique for creating multiples. For this example, we'll use a field of flowers, a very good subject to work with this technique.

1. Set your aperture to $f/16$ or $f/22$ no matter what lens you choose to use, as you want the most sharpness you can get.

2. Use any focal length, but keep in mind that at 200mm to 300mm you may not have a lot of the field in focus, and out-of-focus areas will not show the Pointillism effect as well.

3. Set your ISO to get a shutter speed that allows you to handhold the camera at $f/16$ or $f/22$.

4. Choose some spot in the viewfinder that you can use as a reference, a home base if you will, that you will move around randomly. If planning on a more staccato effect of movement, use that spot as a reference to keep more aligned on each exposure.

5. Make your first exposure, and moving position *very* slightly around that reference point, make another, and another, until you have the desired number of pictures.

6. Import your RAW files into the computer, and save them as TIFFs after making the same baseline adjustments (lens profiles, chromatic aberrations, etc.) to all pictures. Wait until the final image is combined for final touches of contrast, exposure, and such.

7. Open these pictures in Photoshop as layers. You can do this via Lightroom, but otherwise you'll just have to open them individually and drag them into one document file to get the stack you need.

8. Starting at the top of the layer stack, adjust the opacity of each layer using the formula of $1/x$, where x is the layer's number in the stack. The top layer is the higher number, so if you have eight layers, this top layer would be 1/8, or 12 percent opacity. Do this down through the stack. The background will stay at 100 percent.

9. Once you see the layers showing up, and you have your final overlay, you can turn off layers that may not mesh well with the others. Or softly blur a layer or two, for a different effect. The possibilities are many when you are working this way.

OPPOSITE, BOTTOM:
These two meadow scenes show you the before and after of a multiple exposure of a pretty field in Morocco. You can see that you can take what doesn't look like a very good single photo and use it for a multiple exposure that becomes interesting. I had the camera set for a fast-moving scene I shot right before I made this multiple, hence the wide aperture, and I forgot to change the settings back. This turned out to be a happy accident, as the image is still sharp where it needs to be, but is still a softer impression with the shallow depth of field.

📷 *24–105mm lens at 67mm, f/5 for 1/2500 sec.*

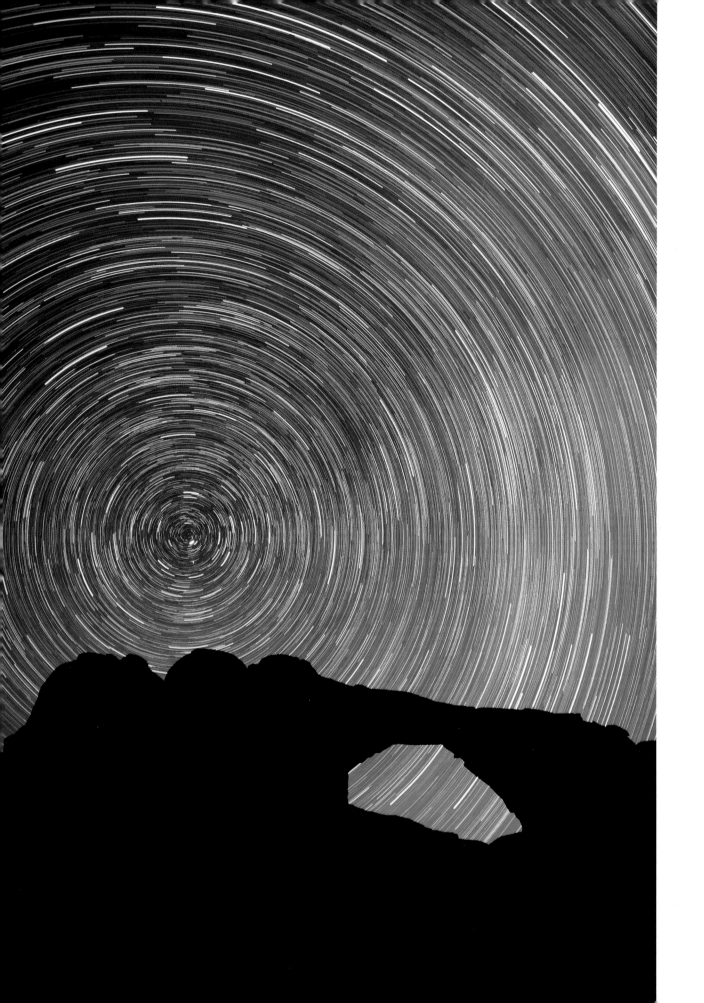

CHAPTER 8

SEEING IN THE DARK

"For my part I know nothing with any certainty, but the sight of the stars makes me dream."

— VINCENT van GOGH

Night is the new day. Just take a look online at any popular photosharing site and you'll see that the sky has become the new craze for many photographers. It appears that we've only just recently awakened to the fact that we have this amazing ceiling over our heads! One could think we've gone mad in our pursuit of the Milky Way in our compositions, but I invite you to take a step outside, when you're in a very dark area, and see for yourself what the excitement is all about.

Photographing at night is a special part of what I do as a nature photographer. When I am out in the night in a remote area, I feel the earth resting from the intensity of the

OPPOSITE:
For this image of stars trailing around the focal point of the North Star, I made 20 exposures, after I had calculated the correct exposure and determined how long I wanted the overall capture to be to get a strong circle. I placed Polaris over the rock formation to the left to offset the arch. During this exposure I heard an owl, something scurried through the bushes, and a random car threatened to ruin my series, but fortunately the lights didn't strike the rock formation after all. Phew!

📷 *14mm lens f/2.8 for 4 minutes each, ISO 400*

sun; it is to me one of the most tranquil and peaceful times. And amidst all the calculations and careful setup for making a nighttime photograph, I don't stop appreciating the beauty. I invite you to take a step outside, when you're in a very dark area, and look up in amazement at the wondrous site overhead. To *experience* the night while photographing it is simply awesome. Be ready to feel very small.

My first exposures of stars were failed attempts. I was guessing, using film, and had to factor in reciprocity, and well, I just wasn't getting great results. But a few years later in Utah's Canyonlands National Park, a very dark place, I made an eight-hour exposure, pointing south. When I awoke at 4:30 AM to close the shutter, it was 17 degrees F! Back home I had the film processed, and I finally had star trails, but they were mostly horizontal, and the film was green! The lab determined the green was likely due to the film freezing, as normal reciprocity shifts were red. And, I didn't have nice arcs in the star trails, because I had pointed south. It was an epic fail, and I had much to learn.

Undaunted, I read more articles and tried again, this time with a digital camera. As star photography had become popular, there was more information about how to do it right, along with discussions about must-have lenses, motorized tracking gear, and formulas for exposures. I was a bit overwhelmed. Did I really need tracking gear? I just wanted to make some images of the night sky when I was out camping and exploring. I knew if I was going to keep photographing stars, the process had to be easy to remember and apply without using a lot of technical gear. I started writing down formulas and laminating charts I made for what I wanted to do. It was exciting, and I discovered that you don't have to be very technically inclined to get good results. You can certainly *become* more technical about your approach, and do things like multirow panoramas, or nine-hour exposure composites, or capture an eclipse, but the simple act of

LEFT:
The skies in Namibia are some of the darkest I've experienced, and it's wonderful walking back to the hut in Sossusvlei and seeing so many overhead. With little to use as a foreground in the resort, I decided to include my thatch-roofed hut as the base, with the Milky Way overhead. Based on where the Milky Way was positioned, I was able to compose so that the stars lead you to my hut. Lamps were turned on to create a soft glow from inside.

📷 *14mm lens f/2.8 for 25 sec., ISO 4000*

getting star trails or points of light is not difficult. With a chart as a reference tool, and some notes, you can have success in getting good exposures and sharp stars. Many resources for getting much deeper into stars and moon-light photography are available on line and in books. This chapter will get you started in photographing during the night. Away we go, into the night! Bring caffeine, as you're likely to need it.

COMPOSING WITH STARRY SKIES

You can simply point the camera directly overhead and photograph a star-filled frame, but it's better to include something else in the frame, such as a tree, an arch, a mountain ridge, or a lake, to act as a visual counterpoint to the sky. If you can scout while it's daylight, look for compositions that can utilize a foreground object or find a strong landscape that will match the beauty of the sky above. To keep your star photos from being cliché, don't just make silhouettes of your foregrounds. Some of the most exciting expressive images are combinations of starry skies and moonlit landscapes.

When you include the Milky Way, especially the core of it, as points of light, the sky becomes an important element in the composition. When doing star trails, all those lines become a pattern that makes the sky a very strong component. Because of this, you need to think carefully about how to arrange your sky with your foreground, and about how much of the sky versus foreground you want to include. For example, you may want to off-center a circular pattern of star trails rather than centering it above the subject. General concepts of composition still apply for night photography, but remember to try different compositions.

 Common Sense Guidelines for Photographing Safely at Night

At a new moon, the sky is the darkest, in any area of the world, yet you still have to go somewhere without light pollution from cities and towns, to see and photograph the most stars. You might think you have to go to very remote places, but in fact, any place where you can't see an obvious glow from artificial lights (after your night vision has kicked in) may be dark enough.

- Dress warmly. Even on warm days, the nights get cool when you are standing around making long exposures. Layers are the best. Bring a hat and gloves, too.
- Bring water and energy snacks; they help keep you warm and awake
- Carry a bright flashlight for walking on trails or cross-country in the dark. Use red light if you can see well enough by that, otherwise plan to take time at your destination to adjust to your night vision again when the white lights are extinguished.
- Bring a GPS unit or some way to stay in touch in case of an emergency (let others know where/when you've gone somewhere remote).
- Load apps for night stars (see Resources) onto your phone.
- Bring a small folding camp chair or a pad to kneel/sit on for comfort while waiting for the exposures to complete.
- Bring something to read if you are planning on being out for a while. Time passes *really* slowly at night while waiting for exposures/series to finish—maybe because there's less for us to look at in the dark, less to keep the mind busy.

PREPARING THE CAMERA FOR NIGHT PHOTOGRAPHY

The checklist items below are the same for most night photography techniques.

Before you get out in the dark, set up your camera as follows:

- Use a fast lens, such as *f*/2.8, or *f*/1.4, with a lens hood (helps keep dew off the lens).
- Generally, use a focal length from 14–28mm.
- Set your camera for RAW.
- Turn off long-exposure noise reduction (use software later for this).
- Turn off high-ISO noise reduction (this only affects JPEGs).
- Turn off any vibration-reduction features on your lenses and/or your camera.
- Switch to "Manual Focus" on the lens.
- Attach a programmable remote release to the camera (or a locking one). Use a smartphone to time your exposures if you don't have a programmable release.
- Use a sturdy tripod.
- Have a rocket blower with you (helps keep dew off lens).
- Have extra batteries close at hand to switch out quickly if needed.

Calculating Exposures for Star Photographs

Let's assume you are working around the new moon, so moonlight is not affecting your exposures. Start by setting your ISO to 6400 with your aperture set to *f*/2.8 and the shutter set to 30 seconds. Focus on infinity just to have a relatively sharp picture, and make an exposure. Check your histogram. The majority of the tonal values should fall within the first and third panels in from the left side, depending on whether you have any light on the land or if your subject/foreground is simply a silhouette. If you need more exposure, increase your ISO until the exposure looks good, as changing the aperture would affect how many stars show, and changing the shutter would affect the star movement. When you achieve a good exposure for the stars, you are ready to extrapolate settings that will work for your singular star trails, and for the multiple, shorter exposures to be later composited.

OPPOSITE:
I *had* planned on photographing Washington's Mt. Rainier under clear starry skies, lit by a crescent moon, but a low cloud mass began to move in, threatening to obliterate the stars. But when I noticed the warm glow on the clouds from city lights over the mountains, I worked quickly to capture this image. The combination of stars, soft moonlight illuminating the mountain, and the warm glow added up to be an interesting picture, but soon after, the clouds covered the stars completely.

📷 *16–35mm lens at 31mm, f/2.8 for 15 sec, ISO 1600*

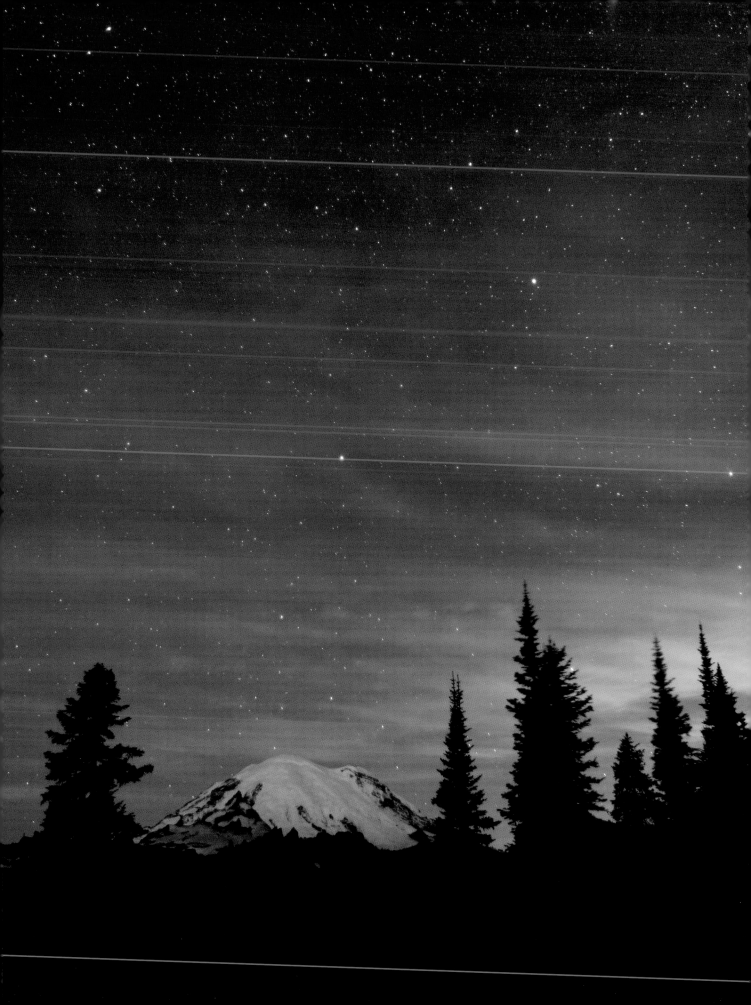

PHOTOGRAPHING STARS AS POINTS OF LIGHT

When you photograph stars as points of light, you can capture the constellations and clusters the way we see them in the sky. You are making a literal picture of the sky. This is the easiest method for photographing stars. Use wide-angle lenses (14 to 24mm) to give you good coverage of the sky and whatever land/subject you might want to include below it.

Determine beforehand where some bright constellations or planets will be in the sky, and when they'll be in position. You can see the Milky Way at any time of year, but the sun obscures the bright core from late September through early March. The galactic core, the dense part, is most in view from April through August, in the southern half of the sky, and during a new moon and at times when there is less than a quarter moon. Smartphone apps help you find the Milky Way and other bright star formations. Using this information, get in the field early, when it's still light, and compose a scene while you can still see. This way you are ready to go when darkness falls. If you can't get out there early, with a little effort you can still compose a good scene by using a bright flashlight to define the area while you look through the viewfinder.

Using the exposure time chart, select the maximum number of seconds you can expose for your chosen focal length. Next, run a high ISO test exposure (see page 220) using that exposure time, and check your histogram. For example, if you can expose for just 15 seconds, do a test exposure at ISO 6400 at f/2.8, at 15 seconds, and see how that looks. Adjust either the ISO or aperture as needed to achieve a good exposure. In this case, with points of light

 ## Exposure Times for Star Points of Light

To keep stars as points of light, not blurred from slight motion, you need to calculate the exposure time for the focal length being used. In the chart, the 500 rule is acceptable for web use and small prints, but for larger prints, further tests have shown that using 450 or even 400 as a rule is safer. Experiment for yourself to find the one that works for you. I divided the focal length into 400, 450, or 500 to arrive at the exposure times, and rounded downward for more insurance of freezing the motion. If using a crop sensor, use the effective focal length for determining the right exposure time.

Focal Length	500 Rule	450 Rule	400 Rule
14mm	35 seconds	32 seconds	28 seconds
16mm	31 seconds	28 seconds	25 seconds
20mm	25 seconds	22 seconds	20 seconds
24mm	20 seconds	18 seconds	16 seconds
28mm	17 seconds	16 seconds	14 seconds
35mm	14 seconds	12 seconds	10 seconds
50mm	10 seconds	9 seconds	8 seconds

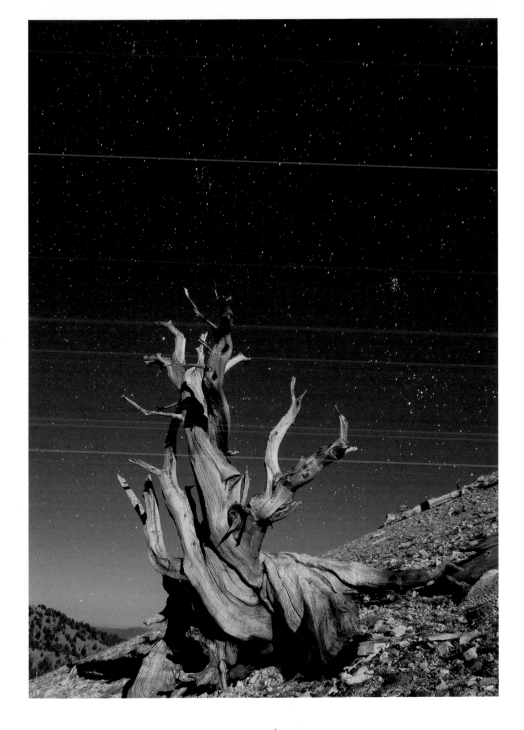

with silhouetted objects below them, a correct exposure should fill the far left two columns of the histogram. Your final settings will vary depending on any ambient light, but will typically be in the 1600 to 6400 ISO range. Just remember, adjust only the ISO or make a little shift in aperture, not the shutter speed, for this technique.

ABOVE:

This was my first attempt with a digital camera to capture the stars as points of light, using a tree for my visual anchor. While camping one night in the White Mountains of California, the stars felt so close overhead, and I set out to photograph them with a bristlecone tree in the composition. Although I was knowledgeable about the technique, I hadn't considered that I had a quarter moon in the sky! This reduced the number of stars that were visible, but it was the right amount to illuminate the tree and still capture some stars. Because my exposure was a little longer than it should have been for the focal length, there is slight movement in the stars when viewed large, but the overall effect still holds magic for me.

📷 *24mm lens f/4 for 31 sec, ISO 400*

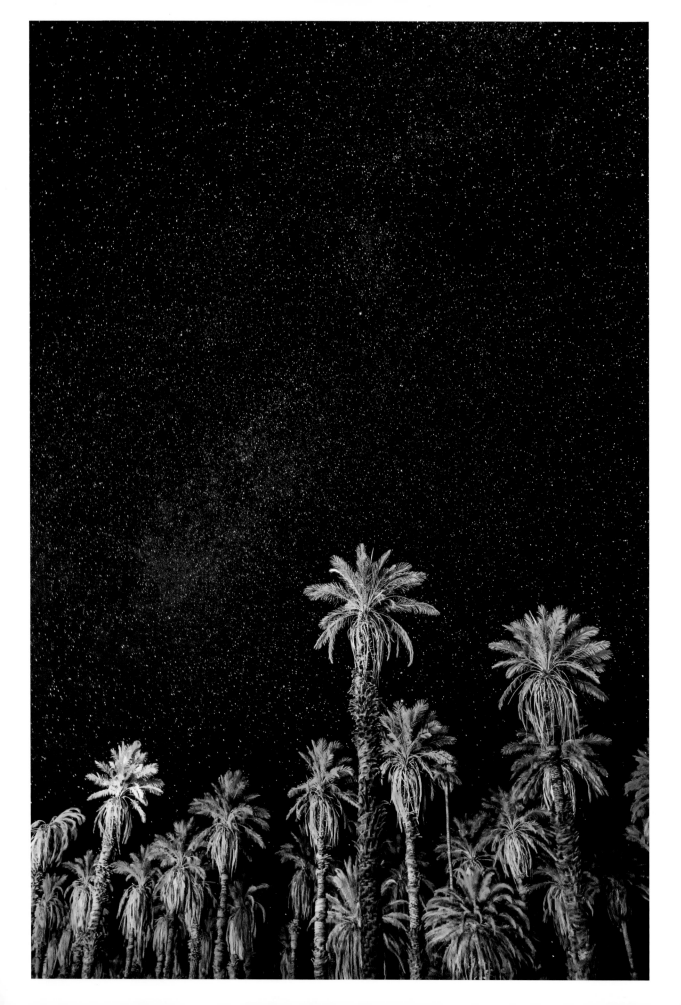

FOCUSING AND DEPTH OF FIELD IN NIGHT PHOTOGRAPHY

Once you have the exposure and shutter speeds worked out for your image, it's time to focus. If you are just photographing stars, you can focus on them using the manual method described below. But if you are doing landscape astrophotography, that is, including foreground elements *and* the night sky, you'll want to be certain that both are sharp. In most cases with night photography, you will be photographing with very wide, or fast, apertures, such as f/4 to f/1.4. These don't provide much depth of field, although a wide-angle lens will give you more to work with than you will get with a 35mm or longer focal length. To use a hyper-focal focus for maximizing your depth of field, you'll need to refer to a depth-of-field chart. As an example, for a 16mm at f/2.8, you would focus at approximately 10 feet, and everything from 5 feet to infinity would be in focus, which includes the stars. This allows you to get in fairly close to foreground elements. It's a good idea to test this, however, to be sure the stars are sharp, as both foreground and stars need to be sharp for night photographs to succeed. If your foreground isn't sharp, back up a little bit. If the stars aren't sharp, you may want to nudge your focus distance on the lens a little farther and check again. If you choose to focus instead on the stars (see next paragraph), you can still get a sharp foreground if you refer to the depth-of-field

chart. For example, once you have focused on the stars (which *is* infinity but not the infinity mark on your lens) the near-focus distance using a 20mm lens will be 10 feet. As long as your subject is 10 or more feet away, it will be sharp. The first method of hyper-focal will allow you to get closer, however. Why is all this important? Because with wide-open apertures not being the best sweet spot of focus on any lens, you want to make the most of the sharpness you have by being on-target with your focus.

To focus on just the stars, use Live View mode, and find a very bright star anywhere in the frame, and magnify the LCD to 5x; center that star in the LCD and go to the maximum magnification. Manually focus on the star, using a magnifying loupe to aid you if needed. You may find you'll go back and forth a little to get the feeling of best sharpness. There are products on the market that can help you. When you feel you've achieved focus, release the shutter and check your focus using the magnified playback and a loupe. If needed, refocus and make another picture. Once your focus is right, tape your lens in that position. You won't need to refocus on the stars again for any other exposure, unless you change focal lengths or the distance to your closest foreground

OPPOSITE:
The palm grove at Furnace Creek Ranch in California's Death Valley is lit by the surrounding area's light, at night—by just how much I didn't realize until I went out to use the palms as the base for my night sky picture. I loved how surreal the combination is, as if I had light-painted the trees, and the stars were brilliant that night. Using my wide-angle lens, I could set the focus for a depth of field that included the trees and the stars to get them both sharp.

📷 *16-35mm at 35mm, f/2.8 for 15 secs.*

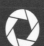 **TIP**

Learn where the buttons are to set things on your camera without looking. Practice by putting your camera in a bag, or under a towel, and locate the critical buttons for shutter release, aperture/shutter settings, ISO, battery compartment, etc. The more you can do this, the easier you can handle your camera in the dark.

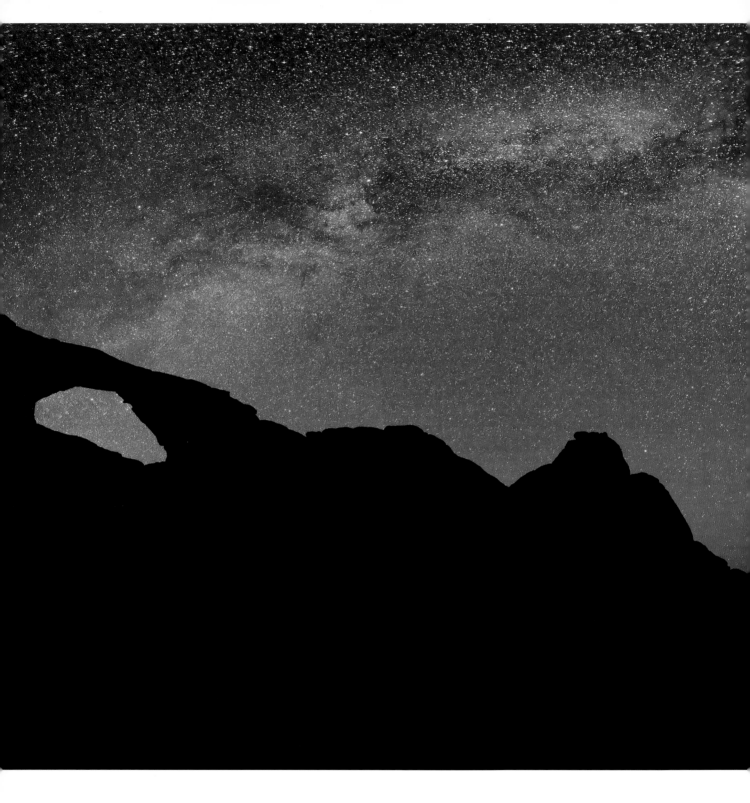

element. Now, set the self-timer for a 2- to 5-second delay, release the shutter, and capture the stars.

If this is your first time with star points, prepare to be super-excited when you get it right. All thoughts of being cold or tired get forgotten when things start working, and when you've got the technique worked out for star points of light, you can start having even more fun with doing panoramas of the star points, or painting with artificial light during the exposure, or incorporating some moonlight on the landscape.

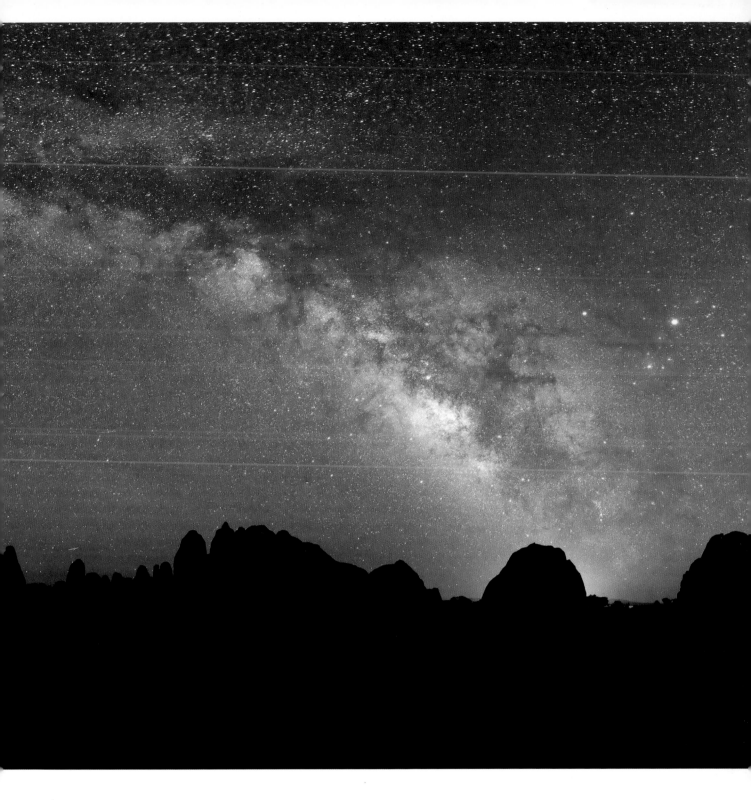

ABOVE:

This was such fun to create! I had just made an image of star trails over Skyline Arch in Arches National Park and liked it. After which, I said out loud literally, "Why not try a pano of this?" Using the same technique for making panoramas in daylight, I practiced once to get a feeling for how much to move the camera for each exposure, as I could actually see, having gotten my night vision working. I then made 9 verticals and later stitched them in the computer using Lightroom. I used the same base exposure for each frame.

📷 *16–35mm lens at 19mm, f/2.8 for 15 sec., at ISO 6400*

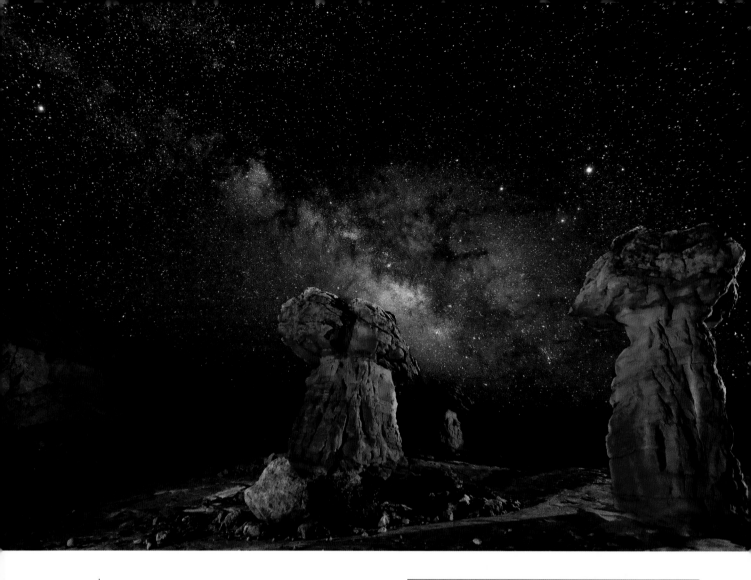

ABOVE:

In the Escalante area of Utah, there are loads of unique sandstone formations that you can use as a visual anchor for the night skies above. I discovered these hoodoos, and decided they'd make a fun foreground for the Milky Way. But with no light, and a large area to paint with a flashlight, I was delighted when a friend showed up with LED lights and stands. We turned the area into our little studio using the lights. Adding artificial light to the fore-ground and the hoodoos made this scene very surreal. It took a lot of test images to get the light balance the way we wanted, but it was sure fun!

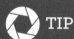 *16mm lens f/2.8 for 13 sec, ISO 6400*

OPPOSITE:

Quiver trees, actually aloes, are great photographic subjects, day or night. Armed with flashlights for painting, our tripods, cameras, and remote releases, we set out on a moonless night after the Milky Way was high enough to incorporate with the trees. We lit this one with a flashlight for a short time during the exposure, to give a more sur-real effect to the picture, and to see the tree, as without it, and no moon, there was not much visible in the land.

📷 *16–35mm lens at 19mm, f/2.8 for 20 sec.*

> ◉ **TIP**
>
> Whether you are doing star points of light, or multiple, shorter exposures, you can add light to the foreground by painting your subject with light from a flashlight or an LED light, and you can add gels to those lights to add color, or leave them as natural light. Or, just photograph around a quarter-moon to let the moon light it for you! The options are endless and many free tutorials on the techniques are available online and in books dedicated to night photography.

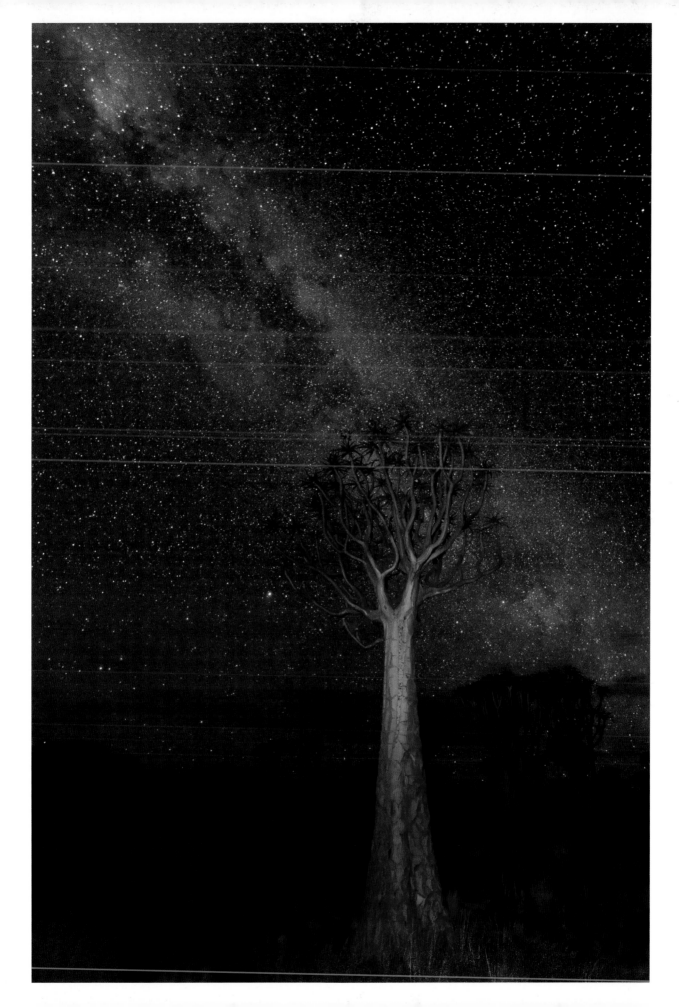

PHOTOGRAPHING STAR TRAILS

Star trails reveal an invisible force in motion overhead. You are capturing the passage of time as stars, meteors, satellites, and airplanes paint their path of movement across the sensor! Of course, we don't really want the airplanes and satellites, but sometimes it's hard to avoid them. Short of visiting the most remote places to do your photography, you just have to hope they don't show up while you're doing your long exposures. Working after midnight and before predawn, you will encounter far fewer airplanes, at least in the United States, but a satellite or two may still sneak through your frame(s). Use a 14–24mm focal range to capture the expanse of sky overhead, but you can also use slightly longer focal lengths to get different effects.

Generally, you don't want to expose for *too* long, as digital noise becomes a factor. A long exposure of 30 minutes at a low ISO won't generate a lot of thermal noise if it's cold out. But try a 6-minute exposure in midsummer heat, and it may well be unusable, depending on your camera's sensor. At best, you'll spend time cleaning up the noise on the computer. Although I have successfully exposed for 10 to 15 minutes in temperatures around 35–40 degrees F, and about 6 minutes in a temperature of 60 degrees F, my preferred method to avoid issues with noise is to make several shorter exposures and combine them in the computer using software designed to composite images for star trails.

To create a pattern of circular lines of stars, you will need to point the camera at the North Star, Polaris—or at least include it in your frame. When setting up your composition, find a position that faces northward, if not due north, that still includes your subject. Use a compass to find north. If you are setting up at night without scouting first, use a compass or an app for your smartphone that will show you the night sky and locate the North Star that way. If you face south, you typically get horizontal lines of stars, with a slight curving depending on how wide an angle of view you used; if you face east or west, you will get more oblique lines with some curving if you used a wide-angle lens. Experimenting with different directions and different focal lengths can produce some fun results.

TIP

Cover your eyepiece/viewfinder on a DSLR during night exposures. Stray light from a flashlight or passing car can ruin your exposures. If you don't have a built-in eyepiece cover, use a glove or a hat, to cover it. Also, use lens hoods to keep stray light from hitting the front of the lens.

OPPOSITE:
For this image of Balanced Rock in Arches National Park, Utah, I created a series of 16 exposures that I later stacked using a script in Photoshop. Each image was exposed for 4 minutes with a 2-second pause between exposures. I composed to put the North Star in the upper left area to offset it from the rock formation.

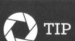 *14mm lens, f/2.8 for 4 min., ISO 400*

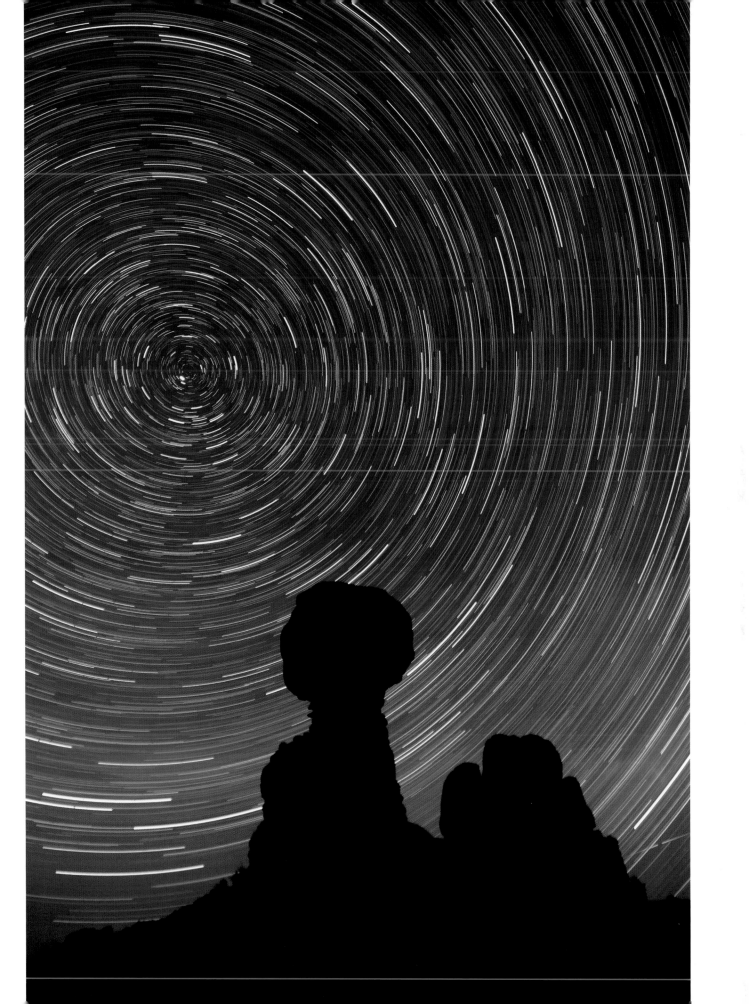

STACKED STAR TRAILS

The goal here is to create a series of identical images and exposures, where all that will have moved, hopefully, is the stars, and just a short distance for each exposure. These images will be layered using software or scripts in the computer. Using the method previously above to calculate exposure, arrive at a good exposure at ISO 6400 at $f/2.8$ for 30 seconds, and now reduce your ISO to 400, or 4 stops. This requires your exposure time to increase by 4 stops. Your final exposure, for this example, will be ISO 400, 4 minutes at $f/2.8$. You can use this baseline exposure for each individual image. If you need more depth of field, you can set your aperture to $f/4$, and run your exposure time a little longer, but keep it under 6 minutes if possible to keep noise levels low. There are a lot of variables in this part of the process, so you'll want to run your own experiments to see what works for your camera/sensor/lens.

Now, determine the number of images you want to create. This takes some calculation and knowledge of how much stars move, but once you've learned some basics about that, you can use the same formula again and again. For the two star trails images in this chapter, I used a wide-angle lens and the total number of exposures amounted to one hour. When making a series of exposures to be composited later, you need to keep the interval between exposures very short, or you will get gaps in the trails of stars. I have found that a 2-second interval works well. It's enough to help things cool down a bit before you start exposing again, yet short enough to keep the gaps from being too pronounced.

Once you have your exposure settings figured out, remember to focus manually using one of the methods discussed prior, and verify the focus using a magnified view on the LCD. Blurred star trails still need to be in focus to be effective in a photograph. When focus is achieved, program your remote release for the number of images, the length of each image exposure, and the interval delay. Press the shutter one final time, and sit back and enjoy the show overhead while the camera works!

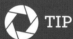 **TIP**

Use a viewing loupe to check focus on the stars. This works well even with the magnified view on the LCD. Also, if you are aiming for star points of light, the loupe can show you if there's any motion in the stars.

OPPOSITE:
The full moon finally rose high enough to light the falls and the granite walls of Yosemite, so I composed this image with space to allow for stars to trail in the sky, and exposed for about 6 minutes. This created a wonderful softness to the falls, allowed for details to show on the rock cliffs and to capture movement to the stars, all of which combined to make this image compelling.

23mm lens at 35mm (effective focal length), f/4 for 350 sec. (approximately 6 minutes), ISO 400

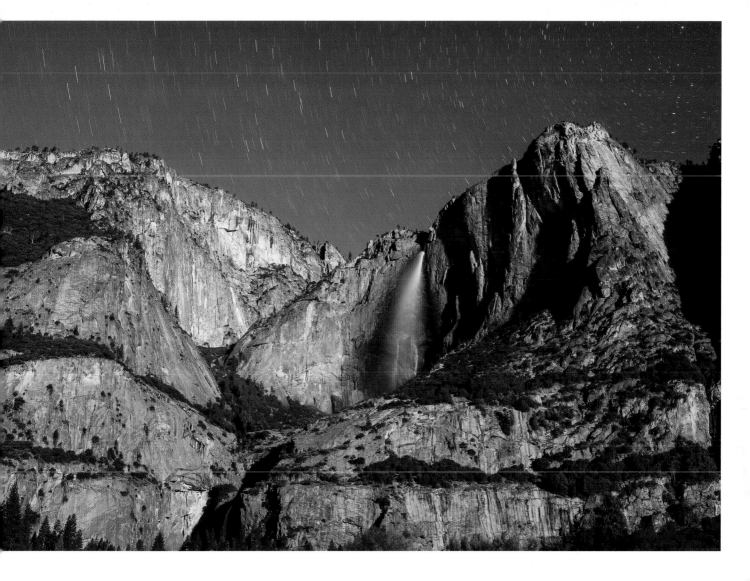

LANDSCAPES WITH MOONLIGHT AND STARS

At full moon, fewer stars show in the sky. Surprisingly, though, there are still enough to make combining stars and the moonlit landscape worthwhile. In some cases, you can make a single exposure, at other times you'll make two or three to blend in the computer later for a balanced exposure.

For the first two weeks of the moon's phase, from new to gibbous (half), it is better to photograph in the evenings after sunset, as the moon is rising or is already high in the sky, and you can make use of the moonlight to illuminate your foreground. For the second two weeks of the moon's phase, photographing in early morning hours, predawn, is best, as the moon will again be high in the sky and illuminate the land until it gets closer to sunrise.

Even without stars above, a moonlit landscape is quite interesting and otherworldly. You can expose to make it look just like daylight, but usually, a slightly darker exposure, or an adjustment to that effect later, gives more of a moonlit feel to the picture.

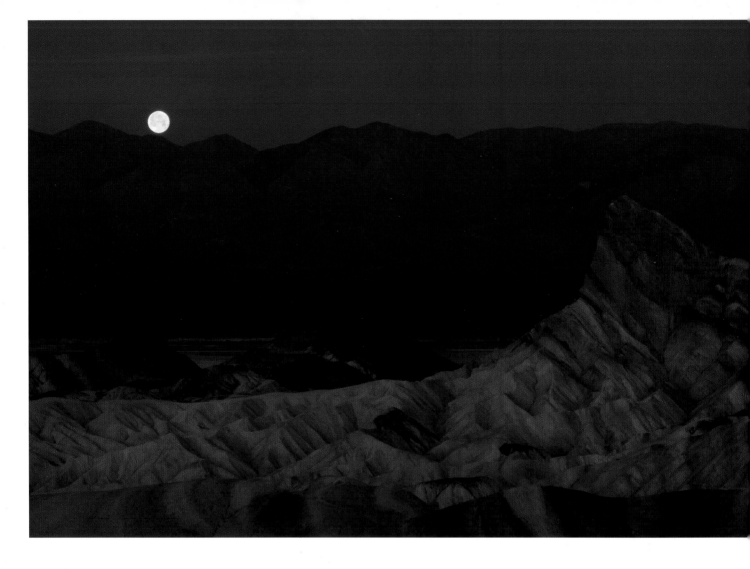

INCLUDING THE MOON IN YOUR SCENE

Photographing landscapes at twilight, whether predawn or post-sunset, can be wonderful when you include the moon. The warm glow of the moon offset against the blue of twilight or the pinkish hues of sunset/predawn creates a pleasing contrast of colors. When you are trying to get a full moon rising over land that still has light on it, in one exposure, your best option is to photograph the night before the full moon, or the morning after it's full, as those are the times when there is sufficient light on the land while the moon is up but its brightness is less intense, so the balance generally works in one exposure. Of course, that is not the only time you can photograph the moon, but when it's higher in the sky, it is much brighter than the land, so to capture both, you will usually need two exposures and have to blend them later in the computer, which isn't always easy. Accurate exposure for the moon itself is pretty straightforward. If the moon is large enough in your scene, try using spot metering, as the sky around it won't affect the exposure reading. If it's too small and you can't spot meter on the moon, you can use a chart, or a variation of the sunny 16 rule, also called the lunar $f/11$ rule, which suggests, for example, $f/11$ at 1/640 at ISO 640. However, a lot of humidity, haze, or smog can affect that guideline. And, as the moon moves through its phases from full to a crescent, the surface is less illuminated, and adjustment exposure will be necessary.

Be sure to keep your exposure times relatively short to keep the moon from blurring due to movement in your

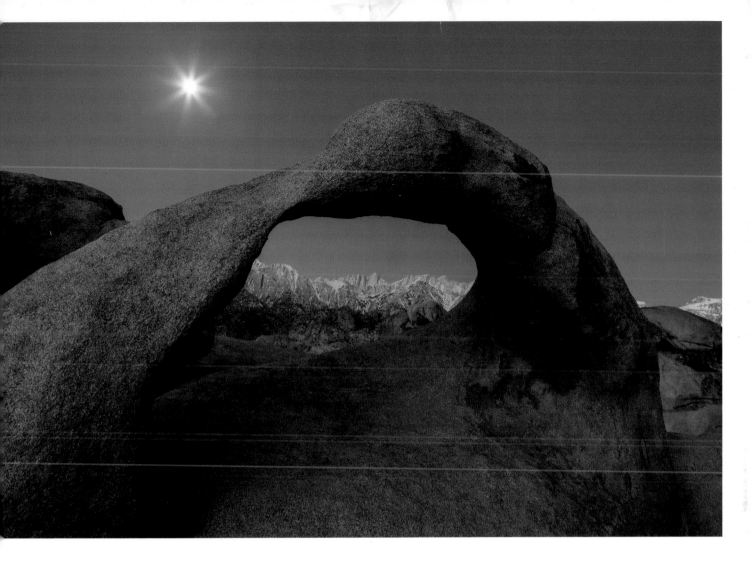

frame. As a general rule of thumb, with a 200mm lens, you can shoot for about 2 to 3 seconds before the moon begins to blur. With a 600mm lens, you can shoot for about 1/2 sec., but it's best to use a faster shutter speed for insurance.

Moon Phase	Exposure at ISO 400
Full Moon	1/400 sec. at *f*/11
Gibbous Moon	1/200 sec. at *f*/11
Quarter Moon	1/100 sec. at *f*/11
Crescent	1/50 sec. at *f*/11
Thin Crescent	1/25 sec. at *f*/11

ABOVE:
The full moon was soon setting as I arrived at this arch in the Alabama Hills in eastern California. The twilight glow of predawn was just beginning and I had to work quickly to get the composition that I had planned out the day before. I used a small aperture to get a moon burst, much like a sunburst, and it added a touch of magic to the scene for me.

📷 *24–105mm lens at 28mm, f/13 for 30 sec., ISO 400*

OPPOSITE:
We were planning to head to Zabriskie Point in Death Valley for predawn and sunrise, but because I knew the full moon was setting that morning, I suggested we head out early to try to get the moon just above the Panamint Range. We got there just in time, not bad for not having planned that until the night before! To ensure you get the photo, it's best to plan ahead, though, so you know where it will be and when it will be there! The setting moon, along with the very early blue-hour glow on the striated formations of land formed an unusual image of a well-photographed location.

📷 *24–105mm lens at 92mm, f/10 for 1/15 sec. ISO 400*

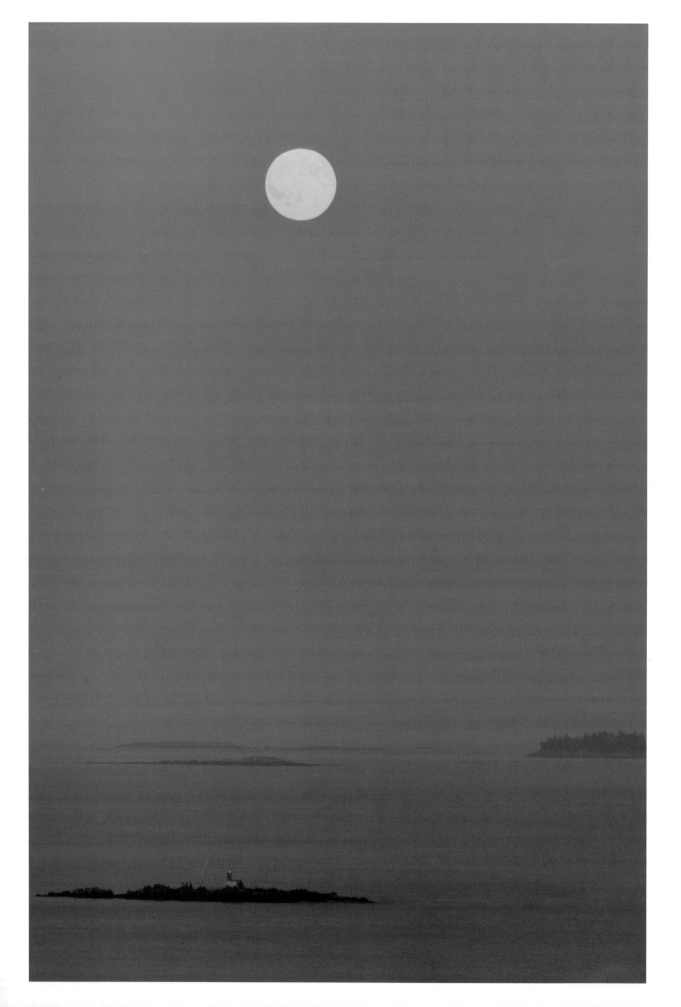

Well, it's late now, and we've been up for a while doing fun things, but it's time to pack it up, catch up on some sleep, and then process these creative night pictures!

Before you go, make a note to remember that using everything you've read in this book, and I do mean using—applying the concepts, working on the exercises and using any special techniques that appeal to you—your images will be stronger. And, if you put *you* into your pictures, and find the passion that drives you in nature photography, you'll make more expressive nature photographs.

OPPOSITE:
When this super moon rose above Penobscot Bay in Maine, the atmosphere was so humid and hazy that at first we didn't even see it. When the moon finally became visible, it still had a warm orange glow because of the atmospheric conditions, and it served as a perfect color complement to the blue of twilight on the bay. The tiny lighthouse on the island makes the moon seem even larger, adding impact to the image.

📷 *70–200mm lens at 280mm, with a 1.4x teleconverter, f/16 for 2 sec., ISO 100*

ABOVE:
Sometimes, the moon by itself is beautiful. This image of the full moon was made from my driveway in California. Using a super-telephoto focal length, I could spot meter off the moon for an accurate exposure. If I had taken an evaluative meter reading, the dark sky would have thrown off the exposure and overexposed the moon.

📷 *150–600mm lens at 600mm, f/8 for 1/640 sec., ISO 320*

RESOURCES

Whether it's smartphone apps for planning, filters, tripods, or software for later processing, these tools can help.

EQUIPMENT & ACCESSORIES

I tend to buy my brand-name equipment through large stores rather than directly from manufacturers. I have a long-standing relationship with B&H in New York City, but all major camera stores will carry the products listed here.

Tripods. I use Gitzo and Benro tripods, for different purposes. While there are many tripods on the market, the most important thing to consider when choosing one is the balance between its capacity for holding the heaviest combination of lens and camera, along with the ability to carry it. If a tripod is too heavy, no matter how useful it is, you'll likely want to ditch it along the trail, so find one that fulfills both requirements.

Tripod Heads. I use ball heads and gimbal heads, from Really Right Stuff.

Filters. I have a wonderful relationship with Singh-Ray, makers of top-quality filters for standard and creative exposures. I use Singh-Ray's Mor-Slo series of neutral density filters for making very long exposures, as well as their graduated ND filters and polarizers. There are other brands out there, such as Lee and B+W, but my go-to for filters is Singh-Ray.

Star Focusing Tool, I use SharpStar, version 2. It's a great focusing aid for photographing stars, and requires a filter holder, such as the Lee system. Visit Lonelyspeck.com for more information.

LensAlign System. This system allows you to calibrate your lenses for maximum sharpness, useful on cameras that allow you to make micro adjustments for variations. It is especially useful for lenses that are 200mm or longer. Designed by Michael Tapes, it's available on his site, michaeltapesdesign.com, or through major camera stores.

SMARTPHONE APPS

Where to begin? There are many out there that can help you learn when sunrise/sunset is, and where the sun will rise or set, and when you'll see the Milky Way, or moon, whatever. I have tried to simplify my apps collection, paring my arsenal down to just a few that I need to do what I want.

PhotoPills. This is a full-bodied app for iPhones (sorry Androids) that offers information for planning out photographs at night and during the day. You can easily determine where the sun or moon will be in your composition as it displays a tracking graph over the actual scene you see through the smartphone's camera. Sun/moon rise and set times, moon phases and position, depth of field, tutorials on how to photograph the Milky Way and create time lapse, and much more is included in this inexpensive app.

Star Walk. This app for iPhones and Androids shows the night sky with constellations, the moon, and planets as you move the phone (or iPad) around in the air, and contains information on the moon phases and rise/set times, and position in the sky. It also contains specific information about the stars and planets. I love using this app, and while my long exposures are running independently, I read about the Galaxy!

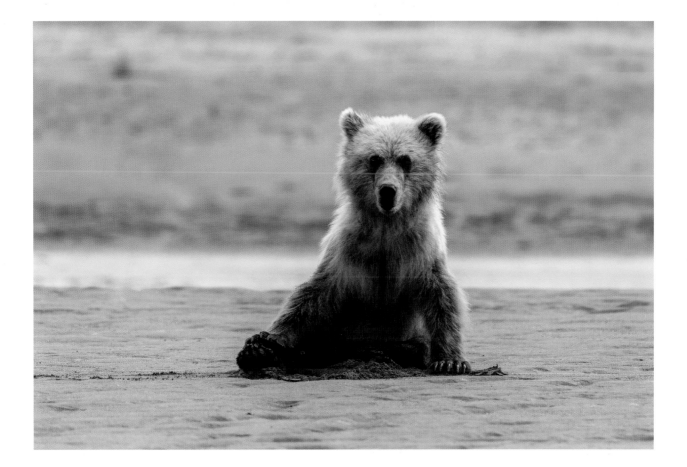

SOFTWARE

Stacking Star Trails. I use a free script, developed by Floris Van Breugel, that stacks exposures to create a composite image without gaps. It comes with instructions and works very well. You'll find it at www.artinnature-photography.com/page/startrailstacker.

There are also manual methods within Photoshop CC that you can use, such as Statistics, or you can manually load the image files as layers and blend them yourself. But the script works so well I haven't bothered.

Topaz Labs. In addition to using Lightroom as my basic editor, I also use Topaz products a lot—for further adjustments and for special effects I may want to add to an image. The series of plug-ins and standalone products can adjust, clean up, de-noise, and overall add a personal style to your photographs.

Helicon Focusing. I use this application for combining my focus stacks to render an image sharp from front to back, or to creatively control the image sharpness to keep the background blurred while making the subject sharp. You'll find this excellent app at www.heliconsoft.com. You can manually blend images with different focus, too, using Photoshop, but I prefer the software apps from developers who have thought of just about everything necessary to do the job well.

Please also visit www.brendatharp.com, where you'll find a gear page with more information.

ABOVE:
This bear sat humanlike on a beach in Lake Clark National Park, Alaska, looking very much like a cute teddy bear rather than a grizzly. I waited to make this picture for the moment it looked right at me, curious.

📷 *150–600mm lens at 600mm, f/8 at 1/800 sec., ISO 800*

INDEX